The Pacific Arts of Polynesia and Micronesia

Oxford History of Art

D0783389

Adrienne L. Kaeppler is Curator of Oceanic Ethnology at the Smithsonian Institution in Washington, DC, and was previously a research anthropologist at the Bishop Museum in Honolulu. A recipient of the Silver Jubilee Anniversary Medal given by the King of Tonga for contributions to Tongan culture, she has written, edited, and co-edited over two hundred articles and books. Her research focuses on the cultures of the Pacific and on the interrelationships between social structure and the arts, especially dance, music, and the visual arts.

Oxford History of Art

Titles in the Oxford History of Art series are up-to-date, fully illustrated introductions to a wide variety of subjects written by leading experts in their field. They will appear regularly, building into an interlocking and comprehensive series. In the list below, published titles appear in bold.

Oxford History of Art

The Pacific Arts of Polynesia and Micronesia

Adrienne L. Kaeppler

OXFORD
UNIVERSITY PRESS

OXFORD
UNIVERSITY PRESS

Great Clarendon Street, Oxford OX2 6DP

Oxford University Press is a department of the University of Oxford.

It furthers the University's objective of excellence in research, scholarship,
and education by publishing worldwide in

Oxford New York

Auckland Cape Town Dar es Salaam Hong Kong Karachi
Kuala Lumpur Madrid Melbourne Mexico City Nairobi
New Delhi Shanghai Taipei Toronto

With offices in

Argentina Austria Brazil Chile Czech Republic France Greece
Guatemala Hungary Italy Japan Poland Portugal Singapore
South Korea Switzerland Thailand Turkey Ukraine Vietnam

Oxford is a registered trade mark of Oxford University Press
in the UK and in certain other countries

Published in the United States
by Oxford University Press Inc., New York

British Library Cataloguing in Publication Data

Data available

Library of Congress Cataloging in Publication Data

Data available

Picture Research by Elisabeth Agate

Typeset by SPI Publisher Services, Pondicherry, India
Printed and bound in China
by C&C Offset Printing Co Ltd

ISBN 978-0-19-284238-1

1 3 5 7 9 10 8 6 4 2

Contents

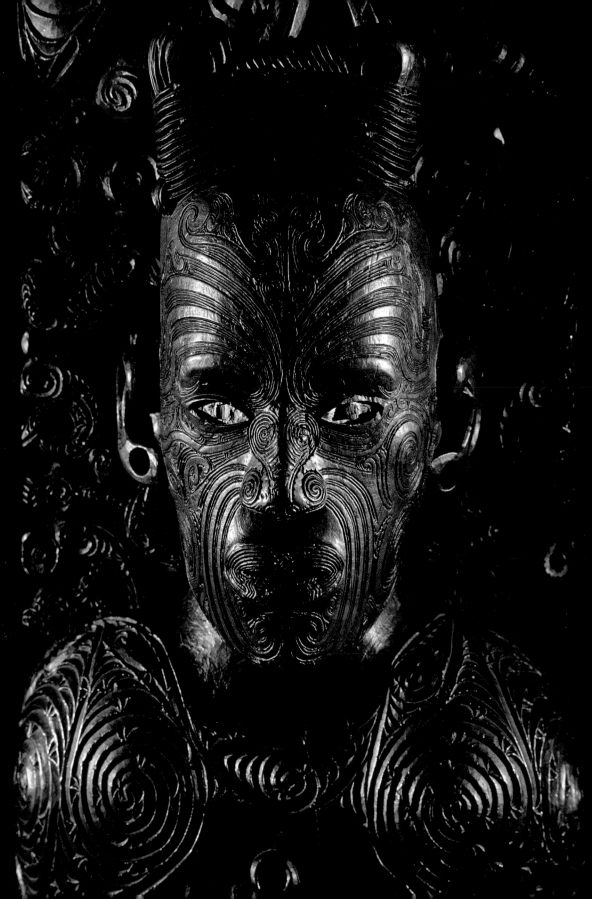

Introduction to Polynesian and Micronesian Art

1

The Pacific Ocean covers one-third of the earth's surface and is inhabited by hundreds of cultural groups. Polynesia and Micronesia cover a large part of this vast ocean. A book with a limited number of pages and photographs on the art of this area must be selective in order to explore the diversity of the arts, as well as the shared artistic conventions, in such a way that both historic and modern traditions can be appreciated. A variety of approaches will be taken, depending on the state of knowledge and detailed research in the respective areas.[1]

Oceanic art encompasses the artistic traditions of Australia, New Guinea, Melanesia, Micronesia, and Polynesia. The arts of Indonesia, although related, are in many ways separate traditions. The focus here is on the visual arts, but music, dance, and oral literature are closely related and are manifestations of similar aesthetic, social, and religious themes, which underlie the respective cultural systems.

Oceania includes some 25,000 islands, ranging from tiny specks of coral to the continent of Australia. About 1,500 of the islands are inhabited by physically diverse peoples, many of whom have mixed and intermixed. Environments range from snowy mountains to raging volcanoes, from steaming rain forests to parched deserts, from coral atolls to volcanic outcrops. More than twenty-five million people inhabit these areas today.[2] Traditionally, many lived in small, separate groups of only a few hundred people; others were part of island-wide chiefdoms, and now there are large port towns and cosmopolitan cities. The people speak hundreds of languages and dialects of the Austronesian and Papuan language families—some mutually intelligible over wide expanses of ocean, and others unintelligible to the residents of the next village.

About 50,000 years ago, people began to travel eastward from South-East Asia. When exactly they began to do so, why, in what numbers, where they came from—perhaps what is now Indonesia, the Philippines, and Borneo—and how they travelled—perhaps on bamboo rafts—are matters for conjecture and future research. It is certain that the physical conditions of the world they came to live in differed greatly from its present state. During the last Ice Age, sea

1
Detail of an interior support figure (*poutokomanawa*) of the Māori house Te Hauki-Turanga [**48**]. Carved by Raharuhi Rukupo in 1842. The house is owned by the Rongowhakaata Tribe, in Te Papa Tongarewa, National Museum of New Zealand, Wellington, New Zealand.

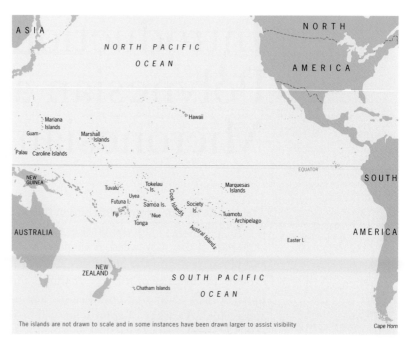

ASIA

NORTH

NORTH PACIFIC
OCEAN

AMERICA

Hawaii

Mariana
Islands
Guam
Marshall
Islands
Palau Caroline Islands

EQUATOR

SOUTH

NEW
GUINEA
Tuvalu
Tokelau
Is.
Marquesas
Islands

Uvea
Futuna I.
Society
Is.

Samoa Is.
Tuamotu
Archipelago

Fiji
Niue

Tonga

AMERICA

AUSTRALIA

Easter I.

NEW
ZEALAND

SOUTH PACIFIC

Chatham Islands

OCEAN

The islands are not drawn to scale and in some instances have been drawn larger to assist visibility

Cape Horn

levels throughout the world were lower than they are today; the islands
were larger than now, and the distances between them far less. At the
eastern end of the Indonesian chain of islands, a continent blocked the
passage toward the Pacific Ocean: Sahul Land, as it is called, spanned
what are now New Guinea, Australia, and Tasmania. Migrants and
accidental voyagers from the west reached its coasts to become its
earliest inhabitants. Over the succeeding millennia, other contacts and
other arrivals brought to the islands such treasures as pigs (possibly
10,000 years ago), dogs, jungle fowl, rats, and probably Asian bananas,
breadfruit, taro, sugarcane, and yams. These foods joined the endemic
coconut, which was already widespread in the Pacific islands.

Much later, peoples with an archaeologically defined cultural tra-
dition, now known as the Lapita cultural complex, spread from the
Bismarck Archipelago (New Ireland, New Britain) along the coast of
New Guinea, through much of Melanesia, and finally into Polynesia.
This complex—called Lapita after the site at which it was first iden-
tified, in New Caledonia—is distinguished by earthenware ceramics
with a characteristic decorative system. It is the most important pre-
historic cultural tradition for understanding the prehistory of much
of the Pacific. Over time and space, the ancestral cultures diversified
and eventually formed the historic cultural complexes now grouped
together under the terms Melanesia ('black islands'—which includes
closely related New Guinea), Micronesia ('small islands'), Polynesia
('many islands'), and Australia ('southern land').

Ethnographic objects and works of art were acquired by European
explorers during the late eighteenth and nineteenth centuries, and

especially by Christian missionaries, and taken to various European countries, where they became part of private collections and museums. Although some pieces are now in Pacific metropolitan centres, such as Pape'ete, Honolulu, Suva, and Auckland, a large proportion are in overseas collections, especially in Britain, Germany, France, and the United States. Of the many hundreds of works of art to choose from, the illustrations in this book have been selected to illustrate the richness of artistic conventions in this relatively unfamiliar part of the world. Eighteenth- and nineteenth-century works of art continue to influence the artistic works of the twenty-first century, while new artistic developments enrich the lives of artists and audiences at home and abroad.

Contemporary artists have continued and recycled many artistic traditions and have added new ones. Although modern Pacific art often involves borrowing from the West and the East, it is the incorporating traditional system that shapes products into their final forms. Thus, while the traditional incised and painted housefronts of Belau meetinghouses [10, 117] retain their traditional uses, the aesthetic aspects find modern expression in contemporary houses and in small tourist carvings. The contemporary abstract sculptures of traditional Hawaiian gods [58] by Rocky Ka'iouliokahihikolo'Ehu Jensen combine Hawaiian religious concepts with aesthetic concepts of the West, while contemporary modern Māori carvings of Cliff Whiting transform traditional themes into new ones.[3] These new works depend on knowledge of the traditional aesthetic systems in which the artists have immersed themselves, but they do not slavishly copy old products or processes; instead, they create new forms based on their own backgrounds and experiences, producing fine art that makes Pacific themes understandable in today's world.

Polynesia

The cultural and geographic area known as Polynesia includes a large number of islands and archipelagos, which vary from large, dramatic mountainous areas such as Hawai'i and the Society Islands to small, flat, coral islands and atolls of the Tongan and Cook groups. Geologically, the islands are pinnacles of basaltic lava that rose from great depths of the Pacific ocean from movements of the Pacific tectonic plate. Over millions of years, some of these volcanic outcroppings became high volcanic archipelagos, others subsided and diversified into coral atolls, and others became *makatea*, uplifted coral islands. Some islands have coral reefs with lagoons and abundant fish and shellfish; others lack coral reefs and hence this important food source. Geological and environmental diversity offered opportunities for Polynesians to adapt their cultural traditions, while they shaped and

restructured their surroundings. Although the environments placed limits on cultural technology (for example, Polynesian islands have no workable metals), Polynesians creatively changed their environments and at the same time changed themselves.

This far-flung geographic area can be imagined as a large triangle mostly east of the international dateline, with Hawai'i at the northern apex, Easter Island in the south-east corner, and New Zealand in the south-west. Culturally, Polynesian islands can be subdivided into three main groups: West Polynesia, the Polynesian outliers, and East Polynesia. West Polynesia—comprised of Tonga, Sāmoa, 'Uvea, Futuna, Tokelau, Tuvalu, Niue, and Rotuma—is closely related to Fiji, which includes a large group of diverse tribal groupings in some ways similar to Melanesia, but with artistic traditions that closely relate to those of West Polynesia. The Polynesian outliers are islands scattered outside the Polynesian triangle, but inhabited by Polynesians—Nukuoro and Kapingamarangi in Micronesia; Tikopia, Anuta, Rennell, Bellona, Nukumanu, Sikaiana, Ontong Java, and others in Melanesia. The islands of East Polynesia share similar cultural and artistic traditions, including the core area of east Polynesia—the Society Islands, the Marquesas Islands, the Austral Islands, the Tuamotu Islands, Mangareva, and the Cook Islands—and the more distant groups of Hawai'i, Easter Island (Rapa Nui), New Zealand, and the Chatham Islands.

About thirty of the islands and/or island groups have their own language, but these are closely related and share common vocabulary and grammar, each having diversified from the Proto-Polynesian language stock. Although there is a basic cultural, linguistic, and artistic homogeneity throughout Polynesia, each area is distinct. Similarly, social organizations and political structures are related, but they differ according to principles of rank and other criteria.

It is generally agreed that the Polynesians became Polynesian once inside the Polynesian triangle; that is, they did not migrate with a cultural complex recognizable as modern Polynesian. The ancestral traditions derive from diverse Lapita peoples who came from the west—specifically Fiji—in the late second millennium BCE; their first landfalls were Tonga and Sāmoa. These west-to-east population movements began about 4,000 years ago, when Austronesian-speaking peoples moved into the Pacific from Asia. Before they reached Polynesia, Lapita people had adapted to their open sea and island environments, but even they could not have predicted the vastness of the ocean beyond Melanesia or how their ancestral sociopolitical systems would evolve into the great chiefdoms of Polynesia. Although some archaeologists suggest that the settlement of East Polynesia occurred as early as the first century CE, others place settlement as late as 800.[4]

Successful migration depended on ability to sail vessels with a system of navigational knowledge based on stars, winds, swells, and

other phenomena. Successful settlement depended on understanding available natural resources, and on the use and reproduction of the domesticated animals and plants (of South-East Asian origin) that they carried with them. In addition, long after initial settlement, the sweet potato, thought to be of American origin, became widespread in Polynesia. The development of complex terraced and irrigated pond-fields for raising taro, of food-fermentation pits for breadfruit and other staples, and the construction of elaborate fishponds illustrates the sophistication of Polynesian agriculture and aquaculture.

Social and Cultural Traditions

The underlying set of principles through which Polynesians interpreted their world and organized their social lives included the concepts of *mana* and *tapu*, intertwined with ideas of rank based on descent from gods. *Mana* is a supernatural power linked with genealogical rank, fertility, and protocol; it was protected by restrictions (*tapu*). According to these principles, each society developed distinctive hierarchical traditions tied to sacred rituals in which special objects or works of art were used. Hereditary chiefs (*ariki, ali'i*), with sea experts (*tautai*), craftsmen (*tufunga*), and warriors (*toa*), became important societal statuses. Sacred places (*malae, marae*, and *heiau*) with rituals based on the drinking of *kava* (an infusion of the root of *Piper methysticum*, a tropical pepper) were characteristic, but developed differently in each area as the ancestral culture diversified.

Political regimes were long and enduring, and succession to chiefly office was by genealogical rules. Rank based on descent from the gods often resulted in pyramidal social structures with the highest chief at the apex and commoners at the base, or a series of overlapping pyramids. Relative rank within the pyramid influenced social relationships, as did gender and birth order. The arts paid allegiance to these stratified sociopolitical systems by assisting in the validation of social distinctions and interpersonal relationships. Like the social systems in which they were embedded, objects were visual symbols of prestige, power, authority, and status, and were important indicators of hierarchical order.

Polynesian society had, and in many ways still has, an important dimension of inequality based on hierarchical order, which is especially important in the arts. Although Polynesian societies treat inequality in ways that distinguish them from other social types, the specifics of hierarchy within each island group strongly contribute to their cultural traditions. The arts are embedded in Polynesian social forms and help define the dimensions of inequality. The pervasiveness of hierarchical order and inequality in Polynesian categories of thought gives rise to what we might call an aesthetic of inequality, manifested in unequal access to clothing and ornamentation, unequal distribution of

valuables during ceremonial exchanges, unequal elaboration of rites of passage, inequality of celebrity status as reflected in artistic performances, inequality of living conditions, unequal access to sacred places, and special status given to artists.[5] These dimensions are essentially contextual and reflect the position of individuals historically situated within the social order, and are intertwined with prestige, power, authority, and status. In Polynesia, the arts traditionally fostered social and cultural stratification and enhanced the position of male and female chiefs.

Interwoven with the importance of objects in rank and status was an emphasis on appropriateness for the occasion. The correct objects had to be used at the correct time—depending on the reasons for the ritual or ceremony and on who was present. Objects were chronicles of history objectified in visual form and were inherited as both form and information. Persons, places, events, and emotions were recounted and cherished and became part of the aesthetic power of objects. Artistic traditions were not primarily concerned with external static forms or products, but included the process of fabrication from appropriate materials for an object's use within the limits of prescribed form, the visual representation of status and rank within an ever-expanding symbolic system, the historic associations and sense of occasion that were enlarged through time, and the interrelationships among artistic forms.

The influence of the Western world on Polynesia has been long and profound. In most island groups new ideas, visual images, and tools were incorporated into Polynesian artistic traditions beginning in the late eighteenth and early nineteenth centuries and became inextricably interwoven with indigenous ones. Precontact fabrication is a concept of limited value in the study of Polynesian art and aesthetics. Whether or not an object was made before European contact is irrelevant to its aesthetic merit. Simply because a sculpture or barkcloth beater was carved with metal tools does not make it less Polynesian, or less authentic. Indeed, the introduction of metal tools to Polynesia made possible an artistic efflorescence that probably would not have occurred without it.

Previous to European trade, the use of metal was virtually unknown, and tools were pre-eminently cutting, incising, and filing elements of stone, bone, shell, obsidian, shark teeth, and fishskin mounted on wooden handles with fibre cordage or wooden pegs. The introduction of metal and Christianity profoundly affected the artistic traditions. The introduction of metal tools, such as nails traded from the ships' stores and mounted as incising implements, encouraged an efflorescence in woodcarving. The introduction of other European goods, such as blankets and European cloth, often led to the evolution of their indigenous counterparts into refined prestige objects. Whalers

and traders increased the availability of certain raw materials, such as ivory from whales and walruses, and spread access of traditionally restricted materials through a broad stratum of society. Trade stores, with their cloth and tin pots, changed the necessity of making bark-cloth and wooden containers for use, into making such items for trade or sale. Shifts in power owing to the introduction of guns altered the production and consumption of previously restricted goods.

Perhaps most destructive to artistic traditions was the introduction of a new and jealous Christian god, whose demands made the production of images of the old gods inappropriate, and sometimes led to the destruction and removal of those that already existed. Associated rituals became attenuated and then ceased, along with the complex associations of certain gods and their chiefly descendants with fertility of the land, the sea, and people. Although a few images of the new god were produced in a traditional style, such as the Māori *Madonna and Child* (now in the Auckland Museum), the making of religious art nearly ceased. Today, the production of images of the old gods has been revived as 'fine art' for collectors and for sale to tourists. Baskets and barkcloth, produced in non-traditional forms, have become artistic forms of high quality and are sold, not only as souvenirs, but as useful and decorative objects for modern living.

Aesthetic Traditions

Art as a separable category has little meaning in an analysis of traditional Polynesian culture. Polynesian languages do not have indigenous words or concepts for 'art'. Thus, to place Polynesian art in a meaningful perspective, we must define art broadly. In Polynesia, the arts encompass all cultural forms that result from creative processes that use or manipulate (handle with skill) words, sounds, movements, materials, spaces, or scents in such a way that they formalize the non-formal. Aesthetics can then be defined as culturally specific, evaluative, ways of thinking about such forms.[6] Although art was not a category of traditional Polynesian culture, three basic concepts help us understand Polynesian cultural forms: skill, indirectness, and the integral association of verbal, visual, spatial, and olfactory modes of expression. Words dealing with skill in Polynesian languages often refer to any work, task, feat, trade, craft, or performance that requires informed knowledge and skill or ability. Indirectness was, and still is, highly developed and culturally valued: words such as *kaona* in Hawaiian and *heliaki* in Tongan refer to hidden or veiled meanings that must be unravelled layer by layer until the metaphors on which they are based can be understood. Thus, an object or performance cannot be understood by simply examining its surface level but must be related to its underlying social and cultural philosophy and evaluated according to Polynesian aesthetic principles.

The diverse artforms of Polynesia parallel most of those found in many other parts of the world, including architecture, graphic and plastic arts, scent, music, dance, and oral literature. Sculpture was executed in wood, stone, ivory, and such unusual materials as sea urchin spines, dog teeth, wicker, cordage, and feathers. Three-dimensional forms, as well as relief carving and intricate incising, were important in themselves and did not depend on polychromed paint for dramatic impact. Graphic arts were manifested two-dimensionally by surface applications such as paint, petroglyphs, tattoo, wood incising, and overlaying coloured elements and feathers into plaited materials.

Many Polynesian creations were meant to endure. Time and energy were freely lavished on objects (such as sculptures and fine mats) that were to be passed as heirlooms from generation to generation. Occasions on which they were used became important points in history; those for whom they were made, those who used or wore them, and those to whom they were given, were remembered and included in recitations as important personages. Important events of important individuals' lives were recounted to accompany specific objects used on those occasions.

To understand the sociocultural patterns in which the arts are embedded, it is necessary to explore the interelationships of all the arts. In examining the layout of space, for example, we need to examine how one moves in space, what one wears, carries, or says while moving, and how these elements change according to contexts and activities. To understand presentation and exchange, it is necessary to understand what is exchanged as well as the processes—of fabrication and ritual—that went into making and presenting them, as well as how objects are attached to people and how people are attached to each other, the gods, and the universe.

2

Ivory hook with female figures and glass beads, Tonga. These hooks were suspended from the rafters to keep the objects hung from them safe (late eighteenth century).

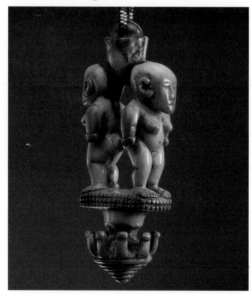

The Arts of Polynesia

For convenience, the artforms of Polynesia will be divided here into five overlapping areas: the organization of space, architecture, household utensils and interior decoration; carving traditions; fibre and textile arts; body ornamentation; and the oral, musical, and movement arts.

Organization of Space

The organization of space in Polynesian thought and practice is concerned with the creation and structure of the universe and how it is used for rituals and everyday living, giving visual validation to rank-oriented order. In exploring the structuring of space, we are faced with a conjunction of artistic and aesthetic considerations on the one hand, and social and philosophical considerations on the other, but only together can they help us understand the conceptualization of space in cultural forms such as house and village layout and the *kava* ceremony. Groups of buildings were clustered as family settlements in relation to a village centre or an important house and often oriented with regard to seashore and inland. Houses embodied the rank and status of individuals who lived and died in them and who then were buried according to spatial principals.

Household furnishings were few: plaited floor and sleeping mats, neckrests carved of wood or bamboo. Human figures were sometimes incorporated into the houses, such as in Māori houseposts. In Fiji and Tonga hooks were hung from rafters to protect the important objects hung from them [2]. Beautifully finished wooden bowls were carved with human figures in Hawai'i, humans, turtles, and birds in Fiji, multiple legs in Sāmoa, and incised designs in the Marquesas and Austral Islands; while shaped and decorated gourd containers were used in

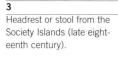

3

Headrest or stool from the Society Islands (late eighteenth century).

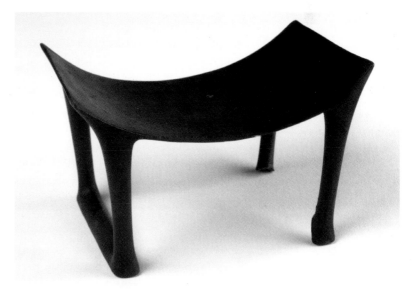

Stone figure from Ra'ivavae, Austral Islands (eighteenth century).

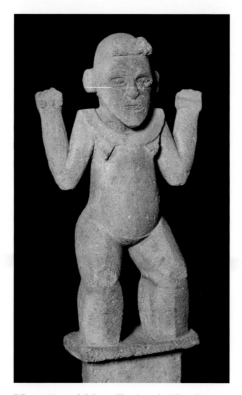

Hawai'i and New Zealand. Headrests and stools had a sleek, modern look [3]. In early West Polynesian archaeological contexts, pottery was decorated with Lapita designs. Tools used in food preparation, such as stone pounders, might be decorated with human images or take aesthetically abstract forms. Even tools and fishhooks were varied and beautiful in materials, shapes, and lashings.

Carving Traditions

The fabrication of three-dimensional sculptures of wood and other materials was usually associated with men, as was relief carving and incising [1]. Human sculpture had an uneven distribution within Polynesia, being most important in East Polynesia, as well as Fiji and Tonga, and being virtually absent in many of the low islands and most of the outliers. Stone sculptures were characteristic of East Polynesia, and included huge Easter Island figures, medium-sized temple figures from the Austral Islands [4] and Marquesas Islands, and smaller images from Necker Island in the Hawaiian chain, and the Marquesas. A similar range in size was found in wood sculpture: large temple images from the Marquesas and Hawaiian islands, medium-sized free-standing images from Tonga, Fiji, New Zealand, Mangareva [5], Cook Islands, Society Islands, Austral Islands, Easter Island, the Chatham Islands, Moriori, Taku (an outlier); and small stick images from Hawai'i and the New Zealand Māori.

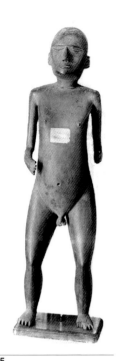

5
Wooden male figure of
Rongo from Mangareva (late
eighteenth century).

Sculptures, especially woodcarving, incorporated dynamic energy and symbolic form. The knees were often bent as if ready to spring into action; eyes were inlaid with shell in Hawai'i and New Zealand, with coral in Rapa Nui stone figures, or with bone and obsidian in Rapa Nui wood figures. The body was sometimes individualized with painted or incised designs—thought to represent tattoo or body paint. In Hawai'i, the bodily forms of the images, the stance, and especially the exaggerations and stylizations of certain features, can be related to the importance of genealogy, respect and disrespect, and *kaona*, while New Zealand Māori sculpture was often incorporated into ancestral metaphors expressed through tribal meetinghouses and storehouses. Although retaining a residual sacred quality, the sculptures were sometimes activated by attaching feathers and by calling the gods and ancestors to them with sung prayers and offerings, or they could be deactivated by removing the eyes.

Sculpture in the round was also made from wicker and feathers in Hawai'i, barkcloth-covered sedge in Rapa Nui, barkcloth-covered wood in the Marquesas, ivory in Tonga and Fiji, and greenstone in New Zealand. Relief carving was particularly characteristic of New Zealand, especially the interior carved wooden house panels and treasure boxes, while elaborate incising, sometimes with ivory inlay, was highly developed in Tongan and Fijian weapons. Carved staves, clubs, and other ceremonial objects were symbols of sacred power, rank, and prestige, as were such unusual objects as carved stilt steps in the Marquesas.

In some areas, carved canoes and their accoutrements were considered the epitome of artfulness. Māori war canoes had intricately carved prow and stern pieces, with relief-carved washstrakes, paddles, and bailers. Related carvings were used as bone containers. Society Island canoes had carved, elevated endpieces with human sculptures mounted at the termini. Large ocean-going vessels, sometimes consisting of two hulls connected by a platform, with shelter and fire-building capability, were used for long-distance voyaging, exploration, and settlement. War canoes incorporated elements of the grandeur of the chiefs and protection of the gods.

Fibre and Textile Arts

In some areas of Polynesia, the fibre and textile arts ranked equally with, or even more importantly than, carving traditions. The making of textiles was usually, but not exclusively, women's work and illustrates the important contribution of women to Polynesian art. Particularly important were coconut-fibre sennit, made by men, and feathers attached to fibre backings. Coconut fibre and the aesthetic ramifications of the sennit made from it, by braiding or twisting, were associated with gods and used by religious specialists. In the Society

6

Hawaiian feathered cloak of
chief Kalaniʻōpuʻu. Made of
ʻoʻo and *ʻiʻiwi* feathers on an
olonā netted backing (late
eighteenth century).

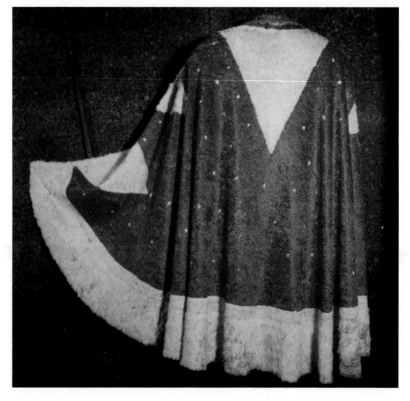

Islands, images of lesser importance (*tiʻi*) were carved of wood while images made of coconut fibre (*toʻo*) were more important and were activated by the addition of red feathers. In Hawaiʻi, human sculptures made of a basketry base and covered with red feathers were the more important images.

Clothing and personal adornment were carried to elaborate heights in Polynesia. Barkcloth wraparound skirts and *malo* (loin coverings) were decorated with complex designs. An extraordinary type of costume from the Society Islands was the mourning dress, worn by the chief mourner at funeral ceremonies of high-ranking individuals. Hawaiian feathered cloaks and capes, made of a fibre network in conjunction with chanting prayers and entirely covered with tiny red and yellow feathers from honeycreepers and honeyeaters, constitute a transposition of the scheme of society to an artistic plane. Feathered cloaks, capes, and helmets were worn during sacred and dangerous situations such as warfare and religious ceremonies [6]. Related Society Islands gorgets were made of a wicker base, and covered with coconut fibre, feathers, pearlshell, shark teeth, and dog's-hair fringe [101].

In New Zealand, the Māori used fibres of a native flax which were weft-twined (the loom was not used in Polynesia)[7] into cloaks that combined warmth with prestige. Flax cloaks with special borders (*taniko*) incorporated designs by intertwining elements of different

colours. Elsewhere in Polynesia clothing was made of barkcloth, or plaited from the inner bark of the hibiscus tree or prepared pandanus leaves, and for special occasions might be made of intricately intertwined coconut fibre overlaid with red feathers.

Mats with plaited designs were made from pandanus, flax, and other leaves in New Zealand, and sedge in Ni'ihau island in Hawai'i. In New Zealand meetinghouses, latticework panels (*tukutuku*) were constructed by women from flower and fern stalks laced together with flax and other flexible fibres. The most important valuables, especially in West Polynesia, were fine mats, usually plaited from specially prepared pandanus strips—sometimes as many as thirty to the inch—which were named and imbued with their owner's *mana*. These were used during important rituals, such as funerals and weddings, and were inherited from generation to generation. The aesthetic criteria by which they were evaluated included fineness, colour, type of leaf from which they were made, how old they were, and most importantly on what occasions they had been used in the past and by whom.

The varied basketry traditions, technologically related to matmaking, reached high points in Fiji, New Zealand, and Tonga, where a variety of forms were made from creepers, coconut fibre, coconut leaves, flax, or pandanus-leaf strips twined around bundles of coconut-leaf midribs.

Barkcloth is made by beating the inner bark of certain trees, especially that of the paper mulberry *(Broussonetia papyrifera)*, cultivated

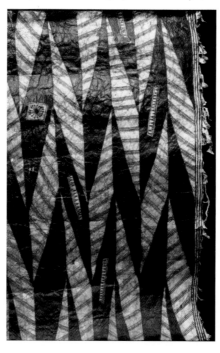

7
Detail of a *masikesa*, Fijian barkcloth, in the style of Cakaudrove. It was collected by the Methodist missionary Revd R. B. Lyth before 1854.

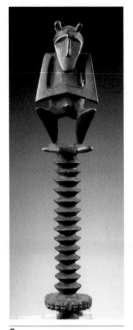

8

Flywhisk with Janus-figured wood handle, coconut-fibre whisk, Austral Islands. Flywhisks were prestige objects that indicated chiefly or ceremonial status (late eighteenth or early nineteenth century).

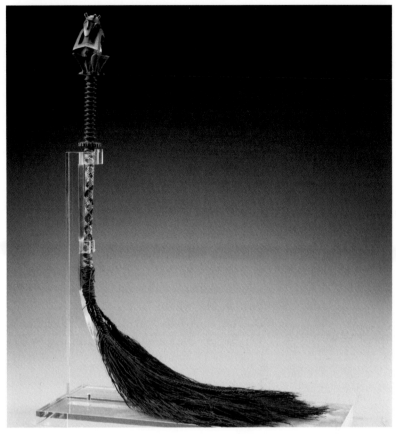

specifically for the purpose. The outer bark is removed and the inner bark soaked in water to soften it. It is then beaten, usually with a wooden beater on a wooden anvil, to make it wide and soft. The pieces may be felted, pasted, and/or sewn together to form larger pieces. An early description of the Tahitian process from Captain James Cook's journal noted that the cleaned and soaked strips of inner bark were laid out in two or three layers, with the longitudinal fibres laid lengthwise to form a collage 0.3 metres wide and 10 metres long. After sitting overnight, much of the water evaporated and the fibres began to adhere. The collage was then beaten with a four-sided wooden beater, each face incised with straight lines of different widths. By this process, the layers were felted together to form one large piece. By a different process, more characteristic of West Polynesia, each piece of inner bark was beaten separately and then several were pasted together with vegetable paste. At this stage, the cloth becomes a medium for artistic expression [7]. Decoration varies from island to island and requires another series of tools, as well as dyes and perfumes. In addition to clothing and bed coverings, barkcloth served for making kites and wrapping the dead and images of gods and ancestors, and huge pieces of it were used in ceremonial presentations, weddings, and funerals.

Body Ornamentation and Personal Objects

Tattooing was important in many parts of Polynesia, but especially in the Marquesas, New Zealand, Rapa Nui, Sāmoa, and Hawai'i. This form of permanent decoration was most extensive on men, but also used by women, and was associated with rank, status, and genealogy. Also associated with status were feathered standards, flywhisks [8], fans, and combs.

Ornaments, made of carved whale ivory, turtleshell, greenstone, carved or unaltered dog teeth, boar tusks, land and sea shells, and porpoise teeth, were worn on necks, arms, legs, and ears.

Feathered headdresses were worn by chiefs in Hawai'i, the Society Islands, the Austral Islands, Sāmoa, Tonga, and the Marquesas [9], while feathered necklaces, belts, and girdles were widespread. Flower ornaments ranged from simply strung whole flower necklaces to complex constructions of flower petals and ribbons of inner bark of hibiscus. Human hair was used for wigs in Fiji and headdresses in Sāmoa, was worn on shoulders, arms, and legs in the Marquesas, and was made into finely braided neck, hair, or waist ornaments in the Society Islands, Hawai'i, Tuamotus, Tongareva, and the Austral Islands.

9

Feather headdress, Marquesas Islands. Red seeds on a fibre and wood base, surmounted by rooster feathers, tailfeathers of tropic-birds, and human beard hair (c. early nineteenth century).

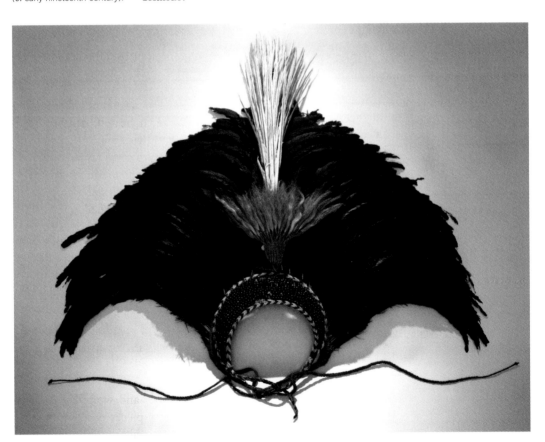

Oral, Musical, and Movement Arts

The most important universal art in Polynesia was oral—poetry, oratory, and speech-making. Besides proverbs, prayers, genealogical recitations, and historical and legendary accounts that were rendered in poetry or prose, oral literature was the basis of music and dance. Traditionally, poetic texts were intoned with a small number of pitches and in a narrow melodic range. Except for Hawai'i and New Zealand, polyphony was widespread—often in two parts (the lower part a drone), but occasionally with as many as six parts.

Musical instruments—log idiophones [38], drums [39, 40], and rattles of various kinds—were works of art in themselves. The rapid spread of the introduced 'ukulele and guitar changed the way music was conceptualized and began the tradition of what is now called 'pan-Pacific pop'. In the last decades of the twentieth century, reggae from Jamaica and other popular genres added further dimensions to this composite art.

Dance is a stylized visual accompaniment to poetry. The performers usually tell a story by alluding to selected words of the text with movements of the hands and arms, while the legs and body are used mainly for rhythm and keeping time, or are not used at all, as in sitting dances. Recently, however, dance has become more pantomimic, attempting to convey the poetry to audiences that do not speak the language (such as tourists) or no longer know the specialized language of metaphor and hidden meaning.

Polynesian Art Past and Present

Traditionally, works of art were visual and oral symbols of status, rank, prestige, and power, and were passed as heirlooms from generation to generation, gaining *mana* as they were used on successive occasions. They gave pleasure to Polynesians if used in appropriate ways on appropriate occasions, and acquired historic and aesthetic power as objectified representations of social relationships among gods and people. As social concepts based on inequality were transformed by the introduction of more democratic ideas, so were artistic concepts. Many of the traditional arts have persisted, although they have changed through time. Others have been reconstructed after decades of non-production or performance, and in some instances modern adaptations of traditional forms have been created. Some artforms have changed primarily along indigenous lines, retaining their traditional structure and sentiment, while others have used Western technology and media. Māori meetinghouses [48] are now carved with metal tools, but they incorporate the social metaphors of the tribal ancestors. Recently made Hawaiian feather capes are essentially considered works of art, while feathered hatbands are made in late nineteenth-century style to decorate modern hats of Hawaiians and non-Hawaiians. Prints made by Samoan artist Fatu Feu'u incorporating Lapita designs are modern interior decoration

[**138**]. Embroideries made by the 'Uvean artist Aloi Pilioko decorate hotels in Tahiti, while sturdy handbags and laundry baskets made in Tonga are as important to the tourists who buy them as to the economic well-being of their makers. Versions of Polynesian dances can be found as floor-show entertainment throughout Polynesia and in some parts of Melanesia and further afield, while the more traditional dance forms surface at Pacific Arts Festivals and at installations of chiefs. These dynamic forms, both traditional and modern, attest to the continuing importance and value attached to the arts of Polynesia.

Micronesia

The cultural and geographic area known as Micronesia, located west of the international dateline and north of the equator, includes several archipelagos whose environments vary from steep mountains, as in Pohnpei (Ponape), to coral atolls, like Ulithi, with its forty-one fringing islets, to the dramatic underwater Marianas Trench. The more than 2,500 islands, with a land area of less than 3,000 square kilometres, are encompassed in a typhoon-spawning area of the Pacific ocean about the size of the continental United States. The several island groupings—Caroline Islands, Marianas Islands, Marshall Islands, Kiribati, and the Micronesian outliers—have cultural affiliations within and beyond their geographic locations.

An extensive 2,000-mile east–west archipelago of nearly 1,000 islands known as the Caroline Islands supports three cultural subgroups. The Western Carolines include Belau (Palau) and Yap; the Central Carolines include Chuuk (formerly Truk), a cluster of high islands encircled by a great reef, and the Mortlock Islands; the Eastern Carolines include Pohnpei and Kosrae. Except for the Republic of Belau, the rest of the Caroline Islands form the Federated States of Micronesia, a sovereign state in free association with the United States of America since 1986.

The Marianas archipelago, north of the Carolines and nearest to Asia, includes Guam (the largest island in Micronesia, a territory of the United States) and the US-affiliated Commonwealth of the Northern Marianas, composed of Saipan, Tinian, Rota, and several other islands. The indigenous people, called Chamorros, were devastated by war and disease during the seventeenth century, and the present population is intermixed Chamorro, Filipino, and others.

East of the Caroline Islands, in two parallel north–south island chains known as Radak and Ralik, is the nation of the Marshall Islands, consisting of five raised limestone islands and twenty-nine atolls. The Second World War and its aftermath had a great impact on the Marshall Islands, ranging from military use to evacuation of some islands for atomic-bomb testing.

Kiribati (formerly Gilbert Islands), a group of sixteen low coral islands

south-east of the Marshalls, became a republic in 1979. Banaba, an outlying island of the Kiribati group, was made a protectorate of Great Britain in 1900; the mining of Banaba's phosphate has had considerable ecological consequences, and much of the population has moved to Rabi Island in Fiji, where the people continue their traditions. East of Kiribati is the tiny nation of Nauru, independent since 1968. Nauru's 5,500 hectares, composed almost entirely of phosphate, have been mined for many years, contributing to extreme ecological and cultural changes.

Geographically outside Micronesia (in the Admiralty Islands off the north coast of New Guinea) is a group of small islands sometimes called 'para-Micronesia' including Wuvulu (Matty Island), Kaniet, Hermit, Ninigo, and Luf. Their cultural affiliations seem to combine aspects of Micronesian, Melanesian, and Indonesian traditions.

Many Micronesian languages are part of the 'nuclear' Micronesian subgroup of the Austronesian family; others (in Belau, Yap, and the Marianas) are only distantly related to nuclear Micronesian; yet others from the Kiribati area and the Micronesian outliers are related in other directions.

The ancestral traditions derive ultimately from migrations from Asia. The first area inhabited (possibly from the Philippines) was the Marianas, about 2,500 years ago, at about the same time the Lapita migrations were occurring farther south. Archaeological excavations have revealed a wealth of pottery termed Marianas Redware (having a thin red slip), which is related to similar pottery in the central Philippines. This pottery tradition evolved into Marianas Plainware and later died out.

By 2,000 years ago, Palau and Yap seem to have been inhabited, with Pohnpei and Kosrae following in about 100 CE; it has been hypothesized that migration to these Caroline Islands came from Melanesia in the south. The archaeological pottery seems not to be related to that from the Marianas. The Marshall Islands have also been occupied for some 2,000 years, but archaeologists have not conjectured from whence the people came. Kiribati appears to have been settled from South-East Asia, and a second migration is said to have come from Sāmoa.

On small islands surrounded by a vast ocean, Micronesians were intimately dependent on the sea, and survival depended on knowledge of it and continual rapport with it. There were three things of primary importance in Micronesian interaction with the sea—how to get across it, how to access it for food, and what to do when devastated by it (by typhoons, tidal waves, or storms). The ever-present possibility of the destruction of resources encouraged the linking of small, low islands in a mutual economic system with high islands. Although each inhabited island with the waters around it produced the basic essentials for living, overseas trading was a feature of Micronesian

life. Nearly every island produced a speciality—fine mats, unique dyes, special shell ornaments—and exchanged it for something unusual from another area.

The Yap empire, including the high island of Yap and numerous low coral islands to the east, was enmeshed hierarchically in a political and economic grouping through which tribute, gift exchanges, and religious offerings travelled in various directions. Included were finely woven loincloths, pandanus mats, coconut oil, songs, and dances. Dances were given as tribute to Yap by Ulithi, Woleai, and other islands; the texts were in languages unintelligible to the Yapese dancers. Yapese pottery and green schist stone appear on Ulithi, Fais, and Lamotrek.

Unlike the major Polynesian groups, the Micronesian islands were closer to each other, and sailing knowledge brought neighbours into each other's consciousness. Coconuts were grown on most islands, but breadfruit, pandanus, taro, yams, other root crops, and bananas had a more limited distribution. Pigs, dogs, and chickens were few, while seafood furnished important dietary proteins with fruitbats and birds. Like Polynesians, Micronesians made changes in their island environments, and were in turn influenced by these changes. Shellfish-gathering, fishing, sea mammal and turtle hunting, and collecting crustaceans and edible seaweeds were important to Micronesian economies, and fishing equipment is one of the most important complexes in the Micronesian material world. The developed maritime technology made possible the dense populations of the Marshalls and Kiribati, where the conditions for agriculture were relatively poor. In the Marshalls, some 200 species of fish and marine invertebrates were used for food, while in Kiribati more than 400 species were exploited. The deep sea was exploited for large fish by trolling with baited hooks behind a sailing canoe. The deep water of the lagoon was used for angling with hooks and baited lines from canoes. The reefs and shallow waters were used for gathering shellfish, spearing fish, fishtraps, and nets. Dipnets and dragnets were indigenous; throwing nets were introduced by the Spanish and the Japanese.

Social and Cultural Traditions

The organization of society and the views of the universe were influenced by relationships with the sea, but each of the areas has its own social and cultural traditions. Unlike Polynesia, Micronesia does not exhibit widespread cultural, linguistic, or artistic homogeneities. Even when islands were tied together for subsistence reasons or mutual aid, the arts of the other areas were considered exotic and imported for this reason.

The ability to create economic surpluses was often an index to power. In Micronesia, it was easier for the high islands to create surpluses than the low coral islands, and social ranking within the islands was associated with ability to produce surpluses and to withstand nat-

ural disaster. In some island groups, a kind of caste system operated, with some residents of high islands belonging to a privileged caste. Leadership, as in Polynesia, depended more upon inheritance than upon the achievement-oriented social climbing typical of Melanesia.

Although some islands had stratified social systems, such as Pohnpei and Kosrae, also culturally important were complex clan systems that were hierarchically ranked (as in Yap). In Belau, social status is based on matrilineal descent, which is still influential, although this traditional social organization has been overlaid with an American-style administration. In Kiribati, groups are characterized by equivalence and political equality, with authority residing in the male elder of a group.

Spirits abounded—some as part of formal religion, others associated with natural phenomena (such as thunder and lighting, typhoons, turtles, or breadfruit), and still others being deified ancestors or associated with sacred places.

The Arts of Micronesia[8]
Material objects were fewer and less spectacular than in Polynesia, but great emphasis was placed on form. Many objects from Micronesia were concerned with sea spirits, canoes, and fishing, and reveal their intimate dependence and understanding of the sea. Micronesia is especially known within the oceanic area for its large stone architectural complexes, A-framed buildings, loom-woven textiles, tattooing, archaeological pottery, and shells that were intricately carved and strung for use as ornaments and as a form of currency.

At the time of European contact, characteristic tools included adzes usually made of shell; food pounders of coral, basalt, and wood; knives, digging sticks, and adze handles of wood; and cordage and strainers of coconut and hibiscus fibre.

Organization of Space
The high volcanic island of Babeldaob in Belau retains its dramatic sculpted hills and large stone uprights, some with carved faces, which dominate the landscape. Prehistorically, the natural hillsides were transformed into steep agricultural terraces through considerable manual labour for use in ritual, burial, and defence, while villages were closer to the shore. Historically, high-gabled, dramatic houses called *bai* were the architectural form of choice. *Bai* were prefabricated in one village and purchased by another as evidence of the ability to amass the necessary Belauan currency—or today, American dollars. *Bai* are profusely decorated with relief-carved and painted interior housebeams and gable fronts [**10, 11**], which illustrate important events and symbolize wealth.

A fringing reef encloses the four islands of Yap that face an interior lagoon. Village organization consists of a men's house on the shore of

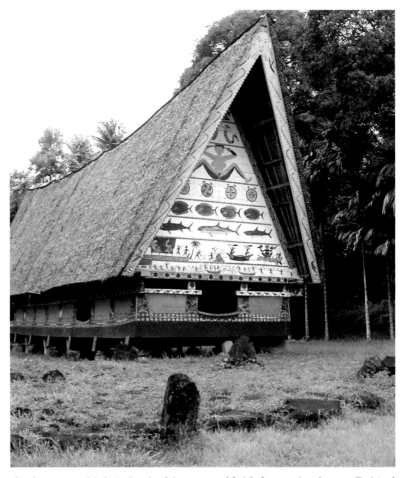

the lagoon, which is backed by a pondfield for wetland taro. Behind
this are houses, a community building, tombs, ritual areas for dancing,
display of *rai* (stone valuables), and stone platforms with slab back-
rests, all connected by stone paths. On the slopes behind the village
are swidden gardens for yam and other vegetable crops. The gigantic
rai, aragonite stone valuables, were quarried on the Rock Islands of
Belau and transported by raft to Yap.

Carving Traditions

Carving in stone, shell, and wood is associated with men in Micronesia.
Human sculpture was rare, but canoes and containers were the objects
of importance. Elaborate carved food stands and bowls in avian or
globular shapes—incised, painted, and inlaid with shell designs—are
characteristic of Belau. In Yap and its satellite communities, weather
charms in human form were made of a variety of materials, tackle boxes
and covers were cut from blocks of wood, and carved sculptures and
paint containers were carved in the shape of elegant birds.

Canoe prows and stern ornaments from Chuuk took the shape of

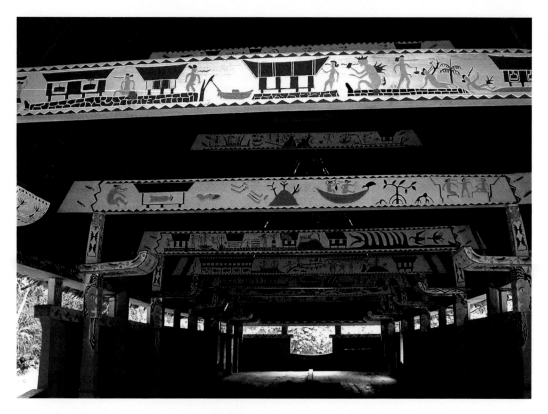

11

Interior of the *bai* at Melekeok, Belau, showing the 'storyboard' rafters, rebuilt *c.*1990.

abstract birds, whose beaks meet and tails extend. Large feast bowls took the shape of canoes, and coral food pounders were laboriously crafted. In the Mortlocks, dramatic black and white masks adorned men's houses and were worn during dances and in mock battles. Seated carved human figures with knees bent upward (the so-called 'monkey men') are also known from this area. In Chuuk, the carved pattern on a courting-stick, which was thrust through the thatch of a house, identified its owner to a woman inside who accepted or rejected him. The Marshallese were famous for their canoes and especially for their navigation charts. From the Micronesian outliers come the elegant canoes and rectangular bowls of Wuvulu, canoe ornaments from Luf, and small carved objects such as combs and lime spatulas (for betel chewing) from Kaniet, Ninigo, and the Hermit Islands. Kiribati and Nauru sculpted elaborate armour from knotted coconut fibre and worked in designs with black human hair, to protect their warriors from weapons edged with shark teeth.

Fibre and Textile Arts

The textile arts are primarily associated with women, but Yapese men loom-wove a special cloth that was a form of currency. Pohnpei and Kosrae women made fine loom-woven textiles, especially narrow belts with woven patterns incorporating shell and glass bead decorations.

Girdle from Nauru.
Pandanus leaves, frigate bird
feathers, shark teeth, shell,
and coral (late nineteenth
century).

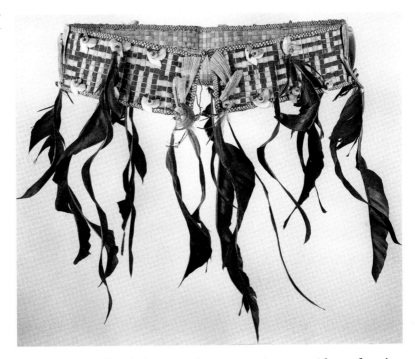

These banana-fibre belts were about 15 centimetres wide, so fine that they sometimes numbered thirty warps per centimetre. In Kosrae, the design was strung into the warp by tying in different coloured threads, while the weft primarily bound the warps together into a fabric. In Pohnpei, extra wefts added designs with a brocading technique. Marshallese woman excelled in the two-dimensional designs found in plaited dress mats that are associated with men's tattoo designs. About a metre square, with designs worked in with darker coloured hibiscus fibre forming bands around a central undecorated section, two mats formed a woman's long skirt and one formed a man's loincloth. In Nauru, men and women wore girdles and small square or rectangular mats, plaited from pandanus leaves and decorated with hibiscus-fibre geometric patterns, shells, seeds, and feathers; they indicated clan affiliation [**12**]. Women plaited fine baskets and fans. Fine baskets were used to hold personal items, such as the leaves, betel nuts, and lime used in betel chewing.

Body Ornamentation and Personal Objects
Human skin was elaborated with tattoo and made shiny with scented coconut oil. Men and women covered their bodies between the waist and knees with finely woven wraparound skirts and belts, carried plaited fans, wore jewellery, decorative combs, fresh leaves, and flowers. Shell ornaments, including belts, necklaces, bracelets, and earrings, featured orange *Spondylus*, white *Conus*, white *Trochus*, and other shells, along with coloured coral, turtleshell, and coconut shell [**13**].

Oral, Musical, and Movement Arts

Singers and dancers performed for the gods, or an audience assembled for entertainment in the contexts of feasts and competitions, or sometimes for their lovers. Body movements enhanced sung poetry with a strong rhythmic component. Pohnpei dances were performed on a platform built over a flotilla of canoes in which carved and painted dance paddles were struck on a bar in conjunction with the rhythmic stamping of feet. In the Marshalls, hourglass-shaped drums [14] show influence from New Guinea, and dance paddles painted with

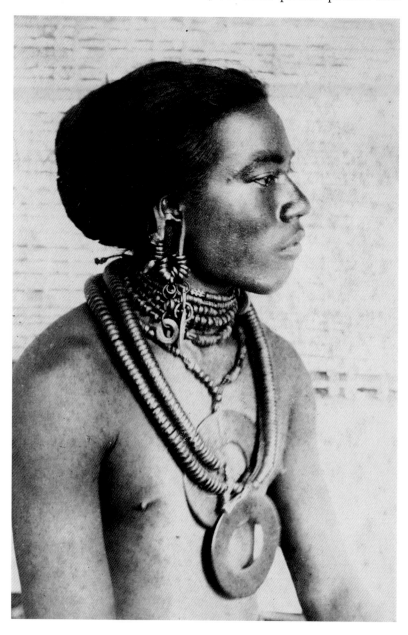

13
Man from Satoan, Caroline Islands. Photograph by Thomas Andrew (c.1890s).

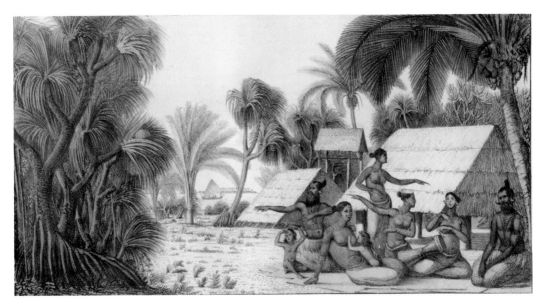

14

Tattooed musicians and
dancers in the Marshall
Islands. *Vue dans les îles
Radak* [Marshall Islands].
Coloured lithograph after
a drawing by Louis Choris.
Plate XIX in *Voyage pit-
toresque autour du monde*
(Paris, 1820–2).

geometric designs and edged with fibre show influence from Pohnpei.
Large-group stick dances are a contemporary speciality. Dancing, one
of the great artforms of Kiribati, is an important feature during all
social and political occasions. Arranged in a line in front of the sing-
ers, the stage alternates between men, women, and children dancers
attired in mats or grass skirts and adorned with crowns, neckpieces,
chest bands, and decorative girdles. Robert Louis Stevenson described
the dancing as a performance that 'leads on the mind; it thrills, rouses,
subjugates; it has the essence of all art, an unexplored imminent
significance'.[9] The performing arts of some islands are still regularly
composed and performed, while in islands with restrictive Christian
religious sects, they have all but died out.

Micronesian Art Past and Present

With new social concepts and increased contact with the East and
West, artistic concepts are also evolving. While some traditional arts
have persisted, others have been reconstructed, and modern adapta-
tions of traditional forms have been created. Technology and outside
influences evolved new artistic forms, such as portable storyboards
in Belau and watercolours depicting stories usually associated with
their relief-carved prototypes. Baskets in new forms, and colours from
imported dyes, are made for the tourist market, and decorative wall
hangings have become a new marketed artform. Artistic creativity
continues to flourish, sparked by cultural and ethnic identity as well
as tourism in response to an ever-changing world.

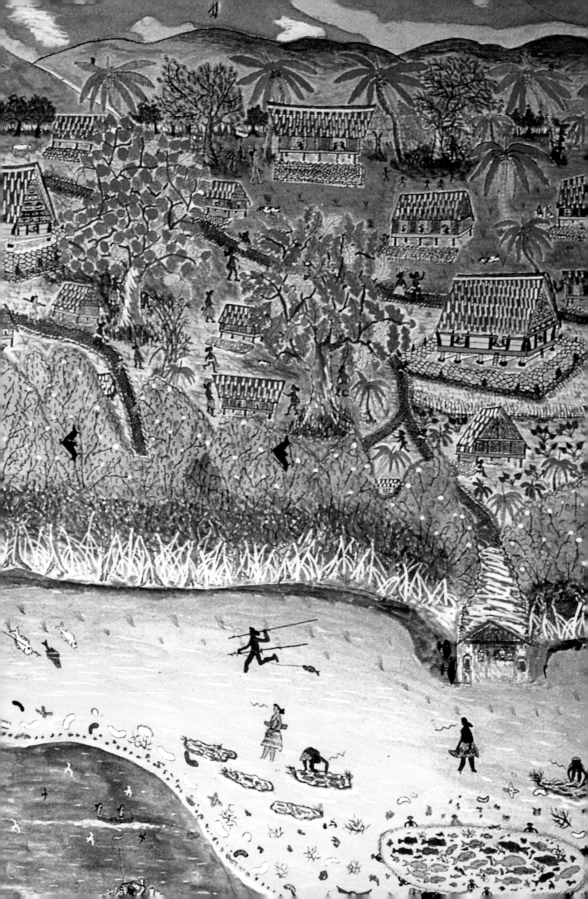

Artistic Visions, Rituals, and Sacred Containers

2

In his book *Woven Gods*, Rotuman artist, author, playwright, and performer Vilsoni Hereniko (b. 1954) explores the relationships among plaited mats, clowning, and aesthetics.[1] He demonstrates how these cultural forms coalesce into a verbal and visual aesthetic system. In Rotuma, sculpture was not an artform: instead, invisible gods were woven into the system of knowledge that was manifested in performances of clowning. Hereniko's artistic vision combines his own myth-making based on stories told by his father, the sacred qualities of fine mats as made by women who capture the gods as they work, and the performances of 'playing' and presenting the mats as sacred ritual acts. The presentation of the mats is particularly striking [15]: women walk single file and each woman grasps closely to her body the mat that she has made.

At the opposite end of the scale, the French artist Paul Gauguin (1848–1903), working in Polynesia, had difficulty in relating his memory of Tahitian sculpture to the aesthetic system he found in place in Tahiti and the Marquesas in the 1890s. His remembrance and drawings of Polynesian (and other non-Western) works in the Trocadéro Museum

15
Presentation of fine mats at a wedding in Rotuma, 1989. Pandanus-leaf mats are prestige objects used at important rituals and ceremonies.

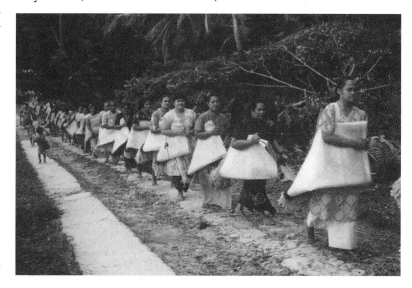

Detail of 17

in Paris and the Auckland Museum in New Zealand, the Javanese music presented at the Grand Universal Exhibition in Paris in 1889 that inspired Claude Debussy, and the journals of European explorers were amalgamated with his own European aesthetic system and his imagined ideas of a 'primitive' past. These ideas were augmented by objects from the Marquesas Islands and Rapa Nui that had been alienated from their cultural contexts and gathered into European collections in Tahiti. From these, Gauguin constructed an artistic vision of Polynesia that has little to do with Polynesian art—except that he was working in Polynesia.

Now, a century later, Gauguin's images have become ingrained as artistic icons in the minds of Polynesian artists and are embedded

16

6 Tahitians, 2 in Leningrad, 4 in Papeete. Collage by Cook Island artist Jim Vivieaere, 1990.

into contemporary works. Jim Vivieaere, a Cook Islands artist living in New Zealand, has incorporated a reproduction of one of Gauguin's paintings into his own collage called *6 Tahitians, 2 in Leningrad, 4 in Papeete* [**16**]. Vivieaere's work incorporates complex messages about representation—Gauguin's painting is in the Hermitage (St Petersburg), but the postcard could be anywhere. Vivieaere's artistic vision, prefigured in this 1990 collage, has been enlarged into museum and gallery installations in which he transforms 'found objects', such as the photograph of Gauguin's painting, into his own works of art. About his own 1996 installation at the Fisher Gallery in Auckland, he noted,[2]

The installation was to do with transactions; with institutions, shops, museum registrars, managers borrowing things, filling out bits of paper, using other peoples' work, placing it in another context, and calling it your own. The art of negotiation seemed paramount, the aesthetic was secondary.

Within contemporary Polynesia and Micronesia, there is a wide variety of artistic visions. The Māori artist Ralph Hotere (b. 1931), working in New Zealand with such modern materials as oil paint on corrugated iron and wood, incorporates formalist abstraction with poetry. Several of his works were a protest against a proposed aluminium smelter at Aramoana, near Otago Harbour. Others protested against French nuclear testing at Mururoa, and illustrate his obsession with mortality and the relationship of individuals to the world. His painted requiems often emerge as banners or screens that should be viewed from a variety of angles. He exemplifies the Polynesian artist who transforms Western concepts into a Māori world view.

17

The Ridge to Reef, water-colour of a Belauan village by Belau artist Charlie Gibbons, 1973.

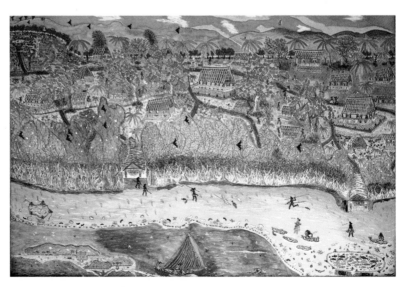

Belauan artist Rechucher Charlie Gibbons (1894–1988), using the borrowed art of watercolour on paper, depicted village scenes and transferred traditional house decorations into a new medium. His village scenes resemble engravings from the British ship *Antelope*, wrecked in Belau in 1783,[3] but the style of depiction has become thoroughly his own [**17**]. His renderings take traditional Belauan narrative depictions from the storyboards of the *bai* houses [**11**] and transform them into 'pictures'.

In Tonga, hundreds of men and women performed *lakalaka* (sung speeches with choreographed movements) in honour of the King of Tonga's 80th birthday on 4 July 1998.[4] Historic *lakalaka* texts by the king's mother, Queen Sālote, were restaged as artistic treasures, while newly composed *lakalaka* with new metaphors vied for equal praise. Among the principal dancers were the king's grandchildren, who sometimes wore creative new costumes. But the most important new composition was a verbal and visual biography of the king, sung and danced by 500 men and women, after they had placed hundreds of six-pound tins of corned beef at the front of the performing space. At the request of the king's daughter, a new text, by Mele Suipi Lātū, was composed without the usual *heliaki* or indirect references so it could be more easily understood by everyone. The tins of corned beef, however, were in themselves indirect references to historical events of the performing villages. The principal dancer, the king's eldest granddaughter Lupepau'u, wore around her waist a historic named mat, considered one of the most important treasures of Tongan art [**18**]. To the principal dancer went gifts of huge pieces of barkcloth; the cloth as well as its presentation were additional works of art involved in this composite of valuables and things made special by their presentation.

18

Tongan *lakalaka* performed for the 80th birthday of King Tupou IV. Nuku'alofa, Tonga, 1998. The central dancer, Lupepau'u Tuita, the king's eldest granddaughter, wore a historic named mat, 'Siukaufisi', and gifts of large pieces of barkcloth were placed before her.

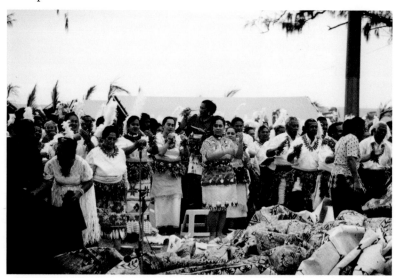

The French artist Paul Jacoulet (? 1896–1960), who lived in Japan most of his life (from 1900), depicted Micronesians in watercolours and prints reminiscent of *ukiyo-e*, which were considered decadent, sexual, and disturbing. Yet his depictions captured the beauty of young Micronesian men and women with their clothing and tattoos more engagingly than any other outside artist [19].

19

Belle de Yap et Orchidées, Ouest Carolines, 1934, by Paul Jacoulet.

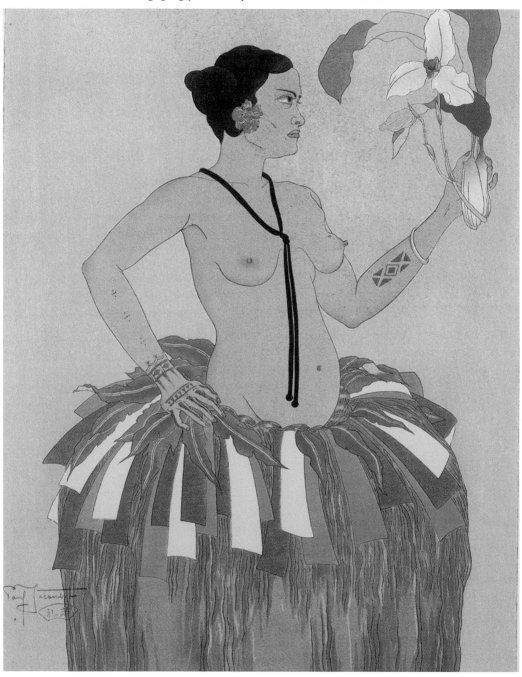

From these extremes, and every shade in between, come Polynesian and Micronesian works of art. What makes them art in the modern sense of the word is the intention of their makers and users. They are objects and performances intended to be special. They are received and admired as special objects and performances by acceptors as diverse as the King of Tonga, the Queen of England, a Cook Island boy having his first haircut, a Roman Catholic congregation in the Marianas Islands on Christmas morning, an indigenous audience at the quadrennial Pacific Festival of Arts, or an ancient storyteller seeing his story made visible in a relief carving by a Samoan woodcarver. Other treasures from the past, such as sculptures, textiles, and photographs, are in museums, archives, and private collections overseas. These treasures were collected as curios, ethnographic artefacts, and visual representations, but are now considered works of art relevant to Polynesians and Micronesians today.

We have here two manifestations of the visual: material culture/performance and the visual recording of material culture/performance. Although visual recording was often done by outsiders as drawings and photography, these artistic genres are now done by insiders. All of these arts and artists are our subject. Insiders and outsiders, the visual and non-visual, impinge on each other as past, present, and future meld into one.

The Visual and Non-Visual in Polynesian and Micronesian Art

In much of the world today what is generally considered 'art' is visual. But why should the visual be privileged over the non-visual? Indeed, can (or should) the visual and non-visual be separated? From Polynesian and Micronesian points of view, the verbal and the visual are inextricably related, and the most important art is oratory. Other arts were aimed at the olfactory sense. Scented coconut oil was laboriously produced and applied from carved wooden oil dishes in Fiji, and simple gourd oil containers were presented in elaborate baskets, sometimes lined with finely plaited hibiscus mats in Tonga. Flowers, chosen for scent rather than appearance, were formed into intricate necklaces and girdles. Verbal, visual, and olfactory arts were important individually but, in combination, became more than a sum of their parts. Such varied manifestations are a vivid indication of Polynesian and Micronesian ways of thinking about creative processes and the resulting cultural forms.

Viewed from the outside, the arts of Polynesia and Micronesia might be considered objects or works that can be viewed independently from their contexts—and they are often represented this way in museums and other collections. Another view might consider the arts as surface manifestations of systems of knowledge. Systems are, of course, invisible,

but form the scaffolding of meaning that encompasses visible, verbal, musical, or performative 'artefacts'—that is, instances of art. What is considered art is cultural and individual, and traditionally there was no canon or set of principles that identified Polynesian or Micronesian art. Instead, these are outsider's concepts, and insiders' and outsiders' points of view differ. Artistic movements from the East and West have influenced artists of Polynesia and Micronesia, while their arts have also influenced artists in the East and West. The only thing that seems to be constant is that an object or work of art is something special.[5]

To a Polynesian or Micronesian, an object or performance is special because it can be presented during a special occasion or event, or because it is a treasure from the past whose history is known or potentially knowable. To insiders, art is not just a product, but also a process of manufacture or performance. Other objects can become special by appropriation. For example, the most valuable objects in Tonga are fine mats originally made and used in Sāmoa, and the most valuable objects in Yap are large stone circular discs quarried in Belau. From a beholder's point of view, even 'just an object' involves a discovery process that places it in time and space to communicate as history, meaning, cultural identity, as art—that is, something special. Art formalizes the non-formal as process, product, or appropriation. This formalization is embedded in the definition of art noted in the previous chapter. Intertwined with art and aesthetics is the concept of ritual—a concept introduced from outside but now an insider's category. To explore these links between insiders and outsiders, the visual and non-visual, and the art of ritual, we will begin by examining containers as art objects and their uses and meanings in ritual.

Containers and their Ceremonies

The most ubiquitous works of art in Polynesia and Micronesia are containers—ranging from canoes, which move people across the sea, to canoe-like vessels, which as coffins hold human remains; from huge bowls that hold ceremonial food and drink to small elongated gourds that hold fishhooks; from carved 'trunks' that hold chiefly clothing to sculpted wood containers that hold fibre gods—and perhaps most important, plaited mats, twined cloaks, and beaten barkcloth that contain *mana* (supernatural power) and are used to wrap the living and the dead (see Chapter 4).

Kava Bowls, Centrepieces for Performance

Some of the most impressive containers from Polynesia were, and are, used for preparing a ceremonial drink known as *kava*. These bowls are always considered to be special because of the sacredness of the drink, called *kava* in Tonga, *'ava* in Sāmoa and Hawai'i, *yaqona* in Fiji, and *sakau* in Pohnpei. The bowls are usually large and shallow, with four

or more short legs, and have a tell-tale patina—a rather grey-green powder adhering to the inside of the bowl. The drink is best known from West Polynesia, especially Fiji, Sāmoa, and Tonga—where it is still important in social and religious interaction—and from East Polynesia, where it had more specific associations with the gods and the high chiefs that descended from them.

The mixing of *kava* was described from Tonga during the third voyage of Captain James Cook and illustrated [20] by expedition artist John Webber. A century later, the American artist John LaFarge, travelling to Sāmoa with historian Henry Adams in 1891, painted a sensitive picture of a young Samoan girl mixing *'ava* [21]. They, and numerous others, were, and continue to be, fascinated by the *kava* drink, the rituals that surround it, and the objects used for its preparation and serving. These include stones for pounding it, sticks for breaking it, mats for holding the kava and the utensils, cups of polished coconut halves for drinking it, and special clothing worn by the mixers, servers, and drinkers. Strainers are made of the inner bark of *fau*, a type of hibiscus tree. Vessels to add water vary from traditional coconut water bottles to plastic buckets.

20

Paulaho, King of the Friendly Islands, Drinking Kava. Original drawing by John Webber, from Cook's third Pacific voyage, 1777.

Traditionally the root was prechewed (by young people with good teeth) and placed into the bowl before it was mixed with water and drunk by the assembled group during state rituals or by chiefs at various times of the day. As the gods gave *kava* to people, it was

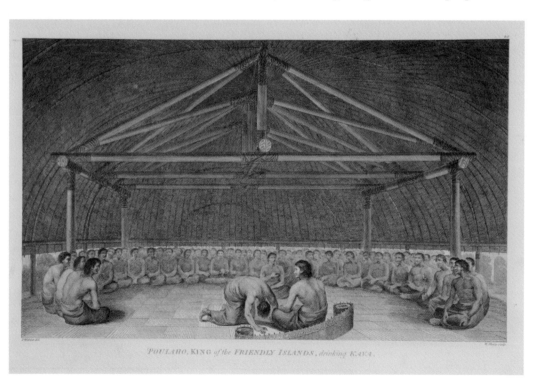

POULAHO, KING of the FRIENDLY ISLANDS, drinking KAVA.

Girls Preparing Kava, Sāmoa.
Watercolour on paper by
John La Farge, 1891.

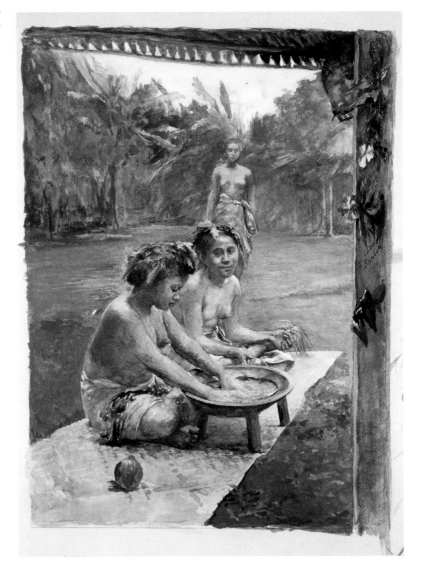

appropriate for people to offer it to the gods. European disgust at ingesting something that someone else had previously chewed influenced most *kava*-drinking societies to find a new way to prepare it—namely by crushing it with one stone on another. At various times during the past two centuries it was thought to be similar to alcohol, then it was thought to be closer to a narcotic, but it is now generally considered a relaxant and soporific. It is essentially a 'downer' and encourages agreement rather than violence. Its chemical properties vary according to how it is prepared and by how much water is used in its dilution. In many islands, it was thought to have sacred powers and to promote sociability. The mixing bowls are usually shallow to enable the mixer to knead it and then further crush it in the bowl,

The Origin of Tongan *Kava*

According to Tongan mythology, a high chief arrived unannounced at a small Tongan island in the midst of a famine. Lack of food to feed the chief led the couple living on the island to kill their leprous daughter, Kava'onau, bake her in an earth oven, and serve her to the chief. He refused to eat the girl and directed the couple to bury her instead. From her interred body grew the first *kava* plant (named after the daughter) and the first sugarcane plant. A rat eating the *kava* plant became disoriented (or drunk) and then ate the sugarcane plant and was refreshed. The sacrifice of Kava'onau and the plants that derived from her body embed Tongan values of social interaction and hierarchy—that is, the importance of hospitality, the use of certain food and drink to acknowledge an individual's rank, and the elegance of preparation and presentation. Based on these values, a ceremony became institutionalized as an important ritual that expresses the relationships among gods, chiefs, and people. At the centre of this ritual is the *kava* bowl.

where it is wrung with a fibre strainer to remove the leftover bits of the *kava* root.

The mixing and serving of *kava* and its associated rituals vary according to the culture in which the ceremony is embedded and vary from informal drinking, to ritual, to theatre, to spectacle. Myths, histories, rituals, and covenants are found in many kava-drinking societies.

Kava *Drinking and the Arts of Ritual and Theatre*

Polynesian and Micronesian languages do not have special terms that convey the concept of 'ritual'. Instead, there are numerous events that could be described as ritual but are simply part of the cycle of life. In contrast, the study of ritual as a category has long been of special interest to anthropologists and others.[6] The term *ritual* usually refers to events that include specialized speech, music, movements, and objects of art and material culture; the term, however, has been used indiscriminately in such a wide variety of ways that it has become a catch-all. Thus, an analysis of a *kava*-mixing container leads to a larger exploration of *kava* ceremonies which considers ritual as art in a contemporary perspective [**22**]. What is ritual? what are the relationships among ritual, theatre, and spectacle? and what are the relationships of the performer and the beholder in ritual, theatre, and spectacle?[7]

Following Roy Rappaport, an anthropologist who worked in New Guinea, ritual can be defined as 'the performance of more or less invariant sequences of formal acts and utterances not encoded by the performers'.[8] That is, these formal acts and utterances are learned/memorized (or read) from the teachings of ancestors and do not originate with the performer. A ritual is 'a form or structure . . . [having] a number of features or characteristics in a more or less fixed relationship to one another' that can exist only in performance. 'The medium [i.e., the performance] is part of the message; more precisely,

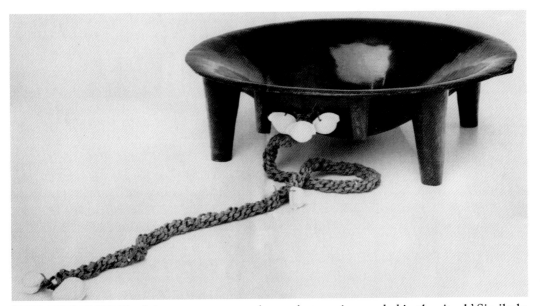

22
Fijian *tanoa*, bowl used for mixing *yaqona*. *Vesi* wood (*Intsia bijuga*). The bowl was presented at the ceremony that lifted the mourning for Cakobau, high chief of Bau, Fiji, in 1884. The suspension lug is fitted with a sacred cord of coconut fibre sennit and embellished with white cowrie shells, symbols of divine fertility. The cord was extended towards the principal chief present, forming a line that could not be crossed.

it is a metamessage about whatever is encoded in the ritual.' Similarly, Vilsoni Hereniko notes that 'traditional rituals and ceremonies . . . did not make sense to me . . . [because] no one explained to me the reasons certain rituals had to be performed on special occasions, or why these rituals had to follow a prescribed order . . . I did not feel it was appropriate to ask or probe into the reasons or meanings of these acts or actions.'[9] That is, participants may not fully understand what they are doing, only that it is necessary to do it; the process of performing is primary, and certain objects (such as *kava* bowls and fine mats) are necessary for its performance. *Kava* ceremonies have become a ritual art, and the bowls have become ritual art objects.

It is appropriate to relate ritual to the more inclusive category of performance, which also includes theatre and spectacle. Theatre has roles for performers and audience that vary greatly between cultures and even within a culture, depending on context. In theatre the acts *are* encoded by the performers: rather than the performance itself being the message, the audience must derive the message from the performance, such as Hereniko's plays and films. In theatre, performers and audiences understand the languages of speech and movement, as well as the objects and cultural values embedded in the performance. A viewer who is not engaged with understanding these cultural values or who does not know how to decode what is being conveyed can be considered a spectator. Nevertheless, objects and performances need not be understood to be appreciated. It is what the beholder brings to viewing an object or performance that determines how it will be decoded and whether he or she will be a ritual supplicant, an engaged audience member, or an appreciative spectator. A work of art may be decoded differently depending on an individual's background

and understanding of the art as well as the individual's mental and emotional state. Artists and viewers are socially and historically placed individuals who operate according to sociocultural conventions and aesthetic systems. Like all symbolic systems, art creates new meanings by combining old forms in new ways. Product and process, verbal and visual, interact dialogically, relying on shared understandings among artists, performers, and viewers.

A Tongan Kava Bowl: Art Object for Ritual, Theatre, and Spectacle

How do these concepts help make sense of Tongan *kava* ceremonies? The *kava* mixers, servers, and drinkers carry out 'more or less invariant sequences of formal acts and utterances' not originated by them; the ritual sequence was handed down by ancestors, and today a *kava* ceremony generates and regenerates a covenant between chiefs and people. Performers are usually men who sit in a specified layout in a sacred performing space and are served in a specific order, depending on their place in the hierarchical order of chiefly lines. The viewers include the gods, who were traditionally concerned with the process, and humans, to whom the ritual is relevant. The medium—that is, the performance—is the message; it is a metamessage about what is encoded in the ritual.

Performing a *kava* ceremony in Tonga is necessary to the political order—a social contract among chiefs, people, and the gods. The chief (who descended from the gods) directed the old couple in an act that originated the *kava* plant. This supernatural origin indicates that the plant should not be used indiscriminately but used in the service of the chiefs and the gods in an elegant way. The chief gave *kava* to ordinary people, who sanctify it with their labour and then give it back to the chiefs and the gods, forming a ritual covenant among them.

The *kava* ceremony can also be considered a form of theatre. The audience does not just witness the event, but is engaged. The message cannot be derived from simply observing a *kava* bowl or performance, but must be derived from the knowledge of historic cultural traditions about *kava*. Tongan *kava* performances differ from other kinds of Tongan theatre such as *lakalaka* (group speeches with choreographed movements), in which indirectness and aesthetic evaluation are prominent. It is the context, the audience, and the intention that make these *kava* theatrical performances different.

A *kava* ceremony can be considered a 'classical' traditional performance—'classical' in the sense of standard or authoritative— which need not necessarily be understood to be appreciated. In theatre, performers and audience have 'communicative competence', whereas, if the beholder does not have communicative competence, the performance should be considered spectacle and the beholder a spectator. While many of the beholders at the various events in which

kava ceremonies take place *are* knowledgeable audience members, some beholders only spectate: they do not have the competence to be engaged by understanding how to decode what is being conveyed by the performance. *Kava* spectacles include performances for tourists, presentations of *kava* ceremonies as ethnic or cultural identity-markers at festivals and on cultural tours, and ceremonies in transplanted communities, where individuals may not have the cultural background to understand the ceremony in all its historic richness.

A Tongan *kava* ceremony is a sociopolitical, religious ritual process performed in an outdoor sacred space; the audience is the (old) gods and a congregation of believers; the intention is to carry out the traditions that derived from the pre-Christian gods, who will look favourably on the performers and the congregation. The hierarchical structure of the society is encoded in the process. At the same time, it is sociopolitical theatre, in which meaning is aesthetically encoded in the product and must be derived by a culturally knowledgeable audience that is engaged by the objects, words, and movements. A recent *kava* ceremony (in November 2006) called *pongipongi tapu* installed King Siaosi Tupou V as the new King of Tonga, as well as the new crown prince, Tupouto'a, and the latter's two sons as 'Ulukalala and Ata, showing that ritual kava ceremonies are still alive and well in West Polynesia.

All viewers, observing a performance or simply the bowl that has been abstracted from its ceremony and recontextualized in a museum setting, can appreciate the *kava* bowl itself as a work of art, but although a *kava* bowl is indeed an art object, its meaning derives from ritual. It is used in a *kava* ceremony that takes place within specially marked interpretative frames, through (or within) which they can be interpreted or understood so that meaning can be derived from them. If the frame is not understood, the ceremony and the bowl can be incorrectly interpreted, but whether the beholder is a ritual supplicant, an engaged audience member, or a spectator is in many ways irrelevant to the art objects and performances.

Also important in recent years is the presentation of *kava* ceremonies as an aspect of cultural identity conveyed at festivals and cultural tours, and for tourists. Along the way, the frames for the ceremonies were enlarged; the ceremonies were recategorized, and their meanings were negotiated to make them appropriate to new performing venues and events. Traditionally, *kava* ceremonies promoted prestige, power, status, and social distancing, but in the wake of Christianity and influence of the Western world, they have also been renegotiated as a traditional artform. Art both follows and leads society, and it is now widely understood that knowledge and competence in traditional cultural forms such as *kava* ceremonies is valued as an important ingredient of ethnic identity.

Focusing on objects, socially constructed movement systems that use them, the activities that generate the objects and the performances, and how and by whom they are judged, are means to illuminate how objects and performances, as part of activities and events, help us understand art in all its societal dimensions. Although I have focused on *kava* bowls, other objects require similar exegesis. A huge piece of Tongan barkcloth becomes a spectacular object when it is presented, and it may be decoded simply as a skilfully made beautiful object or as ritual, theatre, or spectacle, depending on the beholder's knowledge and background. A mat that is ragged and full of holes may be decoded to unravel an individual's genealogy and relationship to an event and as an object of reverence and power in the sociopolitical theatrical event in which it is worn or presented (see Chapter 4).

Art objects are part of ritual, theatre, and spectacle which are themselves arts. Understanding and appreciation comes from the context, the process, and the product.

Fijian Yaqona *Bowls and the Organization of Space*

The above narrative, focusing on a Tongan *kava* bowl as a centrepiece of ritual, can be contrasted with a perspective that uses a Fijian *yaqona* bowl as a locus for understanding spatial organization. While in both Tonga and Fiji the order in which people are served is important, the emphasis in Tongan *kava* ceremonies is on the mixing, while the emphasis in Fijian *yaqona* ceremonies is on the serving. After the ritual mixing is completed, an elaborately dressed server lifts the cup high, then to mid-level, and presents the cup to the drinker, who drinks while other participants clap and utter a collective sound. Such ritualized presentations take place on state occasions as well as gatherings to welcome guests in villages.

Spatial organization in Fiji is oriented by opposing sea and land in hierarchical arrangement, with 'people of the sea' considered higher than 'people of the land'. The high chief of a village is historically related to an ancestor's (often mythical) arrival from the sea to marry a woman of the land. Houses have their lengthwise axis parallel to the shore, and inside the house, people face each other in reciprocal arrangements reflecting sea foods and land foods. In *yaqona* arrangements the high chief sits with his back closest to the sea and facing the bowl; he and other men of importance are 'above the bowl'. 'Below the bowl', and facing the back of the mixer, sit those of lesser importance. Today, women may also sit in the circle, but were traditionally excluded from *yaqona* ceremonies.

Representational depiction of spatial organization was not a traditional Fijian visual category, but visual representations are now characteristic in the Fijian island of Gau. Here textile reproductions of Leonardo da Vinci's *The Last Supper* are interpreted in the context

of Fijian spacial organization. Leonardo's disposition of Christ and his disciples evokes the Fijian arrangement of important men above the bowl and facing those of less importance. The depiction also evokes the 'seating positions of clan chiefs in church: they are seated "above" and face "down" the congregation which is seated "below". . . . In kava-drinking, the status of chiefs (and especially of the high chief) is similarly ratified by association with the *mana* of the ancestors *and* with the power of god.'[10]

The Last Supper has been incorporated into the Fijian aesthetic system in Gau; it was, however, not just borrowed, but rather interpreted and evaluated within the borrowing system: it has become Fijian. The bowls, too, have been borrowed, apparently from Tonga along with the *kava* ritual. They have now become Fijian art objects and the adapted ritual has become one of the cornerstones of Fijian culture. A classic Fijian bowl was presented at the ceremonies to lift the mourning for Cakobau, high chief of the Fijian island of Bau, in 1884 [**22**]. A sacred cord plaited from coconut fibre is attached to the suspension lug and fitted with white cowrie shells at its far end. These shells symbolized divine fertility and were extended toward the principal person, forming a line that it was forbidden to cross.[11]

Perhaps the most elegant Fijian *yaqona* bowl is the double-turtle in the Field Museum in which the two bowls and a connecting piece are joined, all carved from a single piece of wood [**23**]. A turtle-shaped bowl in the Metropolitan Museum of Art is a more naturalistic rendering. It has no legs and may have been placed on a circular fibre-covered ring to raise it above the ground. Other Fijian containers were

23
Double container of two turtles from Fiji. It is carved from a single block of wood, including a ring that links the two halves (early nineteenth century).

made of pottery [**24**], apparently women's work, and remnants of this flourishing art have persisted until the present day.

Ritual Vessels of Fijian Priests

Before Tongan influence that brought *yaqona* drinking into the chiefly sphere, *yaqona* was used by Fijian priests when possessed by the gods and while invoking them. Special shallow containers, placed on the floor of the spirithouse, held the beverage. The priest, possessed by his ancestral god, knelt in front of the dish and drank the *yaqona* through a straw, making sure he did not touch the bowl. The lips and hands of the possessed priest were sacred and could not touch food or drink. The containers were occasionally sculpted in the form of humans or birds [**25**] and entered missionary collections only after the chiefs and priests had converted to Christianity. Other shallow containers were used by priests as palettes for mixing coconut oil and paint when preparing themselves before invoking their gods.

Feasting and Sakau-Pounding Music as Arts of Pohnpei

In Pohnpei, feast days activate an entire district, with its ranked clans. Unlike Polynesian bilateral hierarchical social structures, however, Pohnpeian social structure (like many Micronesian societies) is matrilineal. Male chiefs, culminating with the Nahnmwarki (paramount chief), trace their lineage affiliation through their mother. Competitive feasting, which incorporates the ritual presentation of huge yams, kava plants, and pigs, culminates with the preparation of *sakau*. The feasts, which focus on the aesthetic evaluation of the presentation and preparation of the food and the food itself, as well as oratory based on the recitation and discussion of proverbs, are integral to political

25

Two priests' inspirational
yaqona dishes in the form
of a man and a flying duck,
vesi wood (early nineteenth
century).

advancement. *Sakau* plants are carried, presented, and stacked at the centre of a feasthouse while a master of ceremonies sings part of an ancient recitation—today one of the few occasions when these old forms are voiced.[12]

The feasthouses were, and are, the most important houses in the villages. In 1872, feasthouses and their occupants preparing *sakau* were depicted by William Wawn, an agent for the Godeffroy firm in Hamburg. He illustrated a feasthouse from the outside, showing the typical Micronesian A-frame construction (see Chapter 6), and diagrammed the inside showing the seating plan with the placement of the head chief and important women, as well as the placement of the *sakau*-pounding stones. Another illustration shows the activities of pounding the *sakau* as the central activity in the house. The art of pounding the *sakau* and its 'music' was a purposeful aesthetic activity. In the 1960s, Saul Riesenberg described the final phase of *sakau* pounding as having seven rapid beats, a pause, two rapid beats, a pause, two long beats, a pause, two rapid beats, and a long beat.[13] In 1963, Barbara Smith recorded the men of Metalanim Municipality performing on eight large *sakau* stones brought from the mountaintop before 1800.[14] The most important artistic elements here are the pounding stones themselves—evaluated according to their history and sound—and the skill and knowledge of the 'musical system' through which the *sakau* is pounded. Each stone usually has four pounders who syncopate their rhythms with up to seven other pounding groups, who work together to generate a uniquely Pohnpeian work of art. The feasthouses with their decorated interiors serve as a suitable artistic setting for these arts of presentation, oratory, music, and movement.

Shell-Inlaid Bowls: A Belauan Artform

The shipwreck of British Captain Henry Wilson on the *Antelope* in 1783 brought Pelew (as it was then known) to the attention of the

Macao artist known as 'Spoilem'. Three Palauans, a young man, known as 'Kockywack', and two young women, one of whom holds a shell-inlaid container. Oil on canvas, 1791.

outside world.[15] Belau is known for its elaborate A-frame houses (see Chapter 6) and its wooden containers that were incised, painted, and inlaid with shell designs. Several bowls and a food stand, given to Captain Wilson by the king, are now in the British Museum.

Before the King appeared, some of the natives were sent down with refreshments; they first brought a large tureen made of wood, in the shape of a bird, and inlaid with shell, this was full of sweet drink; they also brought a painted stand, about two feet in height, inlaid in the same manner as the tureen, upon which were sweetmeats garnished with seville oranges . . . and they were then served with the before-mentioned provisions, by a man

27
Shell-inlaid container from Belau (late eighteenth century).

who seemed to act as a butler, and gave to each a portion, by the King's directions.[16]

This tureen held thirty-six English quarts and was presented to Captain Wilson by the king. Other containers were made of tortoise-shell. 'The natives of Pelew had discovered the art of moulding it into little trays or dishes, and into spoons, from which, on particular occasions, they eat their fish and yams.'[17] These dishes are known as 'women's money', are the property of women, and are considered particularly valuable.

Two containers, one with inlaid shell, are depicted in a painting of three Palauans, two young women and a young man, known as 'Kockywack', who were taken to Macao by Captain McCluer aboard the *Panther* in 1791. McCluer engaged a Macao artist, known as 'Spoilem', to paint them. At least two, slightly different, paintings were made and sent to London. One is now in the British Museum, the other, with the two containers, was given by Sir Joseph Banks to the German scientist J. F. Blumenbach of the Institut für Völkerkunde, Göttingen, Germany [**26**].

Shell-inlaid containers are among the most important valuables of Belau and appear to have been a specialty of canoe-makers. They were rare and made for high-ranking chiefs to be used in ceremonies of importance. Those that survive incorporate the artistic visions of the past and the artistic inheritance of today [**27**].

Baskets: Containers of Metaphor
In addition to useful functions of carrying and holding, Polynesian baskets were containers of metaphor. According to a Māori tradition, three baskets of knowledge were collected by the god Tāne and contained all the sacred knowledge that was taught to the priests. The first basket, *kete aronui*, contained the myths of creation; the second, *kete tuauri*, contained knowledge about rituals, charms, and chants; the third, *kete tuateu*, contained black magic.[18] And in a Māori migration story, sweet potato was brought from the ancestral homeland by a female ancestor named Whakaotirangi. This *kete* is depicted in modern meetinghouse carvings.[19] Even today Māori women embed their *mauri* (life force) into their baskets as they plait them. These *kete* are made of flax or *kiekie*. Formerly, the designs were primarily black, but today are made in colours to match the clothing of the carrier [**28b**]. Baskets feature designs found on other Māori arts including those on mats and *taniko* borders of cloaks. Some designs, especially those with vertical steps [**28a**], may have genealogical significance based on *whakapapa* (genealogical counters).

Baskets reached a high point in Tonga, where several named types were produced. Designs focus on a genealogical metaphor called

Two patterned baskets (*kete whakairo*), New Zealand Māori.
(a) Collected on the US Exploring Expedition, 1840.
(b) Made by Eva Anderson, 1991.

(a)

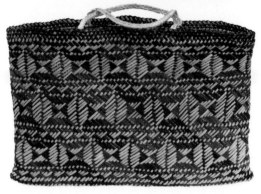

(b)

manulua. This design, found in *kato mosi kaka*, *kato alu*, and basketry-covered buckets, is formed by three or four triangles that meet at their points [**29**]. The motif represents two birds flying together (*manu* = bird, *lua* = two), which is a metaphor for a high-ranking person whose parentage is equally high on both sides. *Kato mosi kaka* were made of *kaka*, threads from the fibrous integument at the top of coconut palms. These threads were dyed black and intertwined with those of natural colour into geometric designs, which were outlined with shell beads. They were made for chiefly individuals, who used them to carry personal items. *Kato alu*, made by encircling a vine called *alu*, usually dyed black, around a coil of coconut-leaf midribs, are still necessary accoutrements for weddings and other ceremonies. They are used to hold personal items, such as gourds that contain scented coconut oil.

In the Polynesian outlier of West Futuna, baskets are metaphors for life. Plaiting elements are identified as male and female, and their plaiting is a metaphor for sexual intercourse.[20]

29

Two Tongan baskets with *manulua* designs collected during Cook's voyages (eighteenth century).

Māori Containers: Food, Valuables, Bones

Food and its consumption had special significance in Māori society in that food was used to remove or neutralize *tapu* (prohibitions), making them *noa* (unrestricted). Feasting and the presentation of food were specialized activities and were always separated from ritual areas. Historic accounts and illustrations show great quantities of food that on special occasions was presented and piled in ritually significant

Bowl known as 'Te Riukaka' from Te Puke in the Bay of Plenty, New Zealand (eighteenth century).

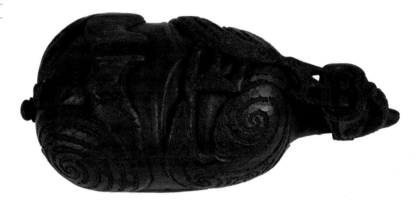

ways. Today, after a traditional ceremonial welcome and speeches on a *marae* (ceremonial space), food is offered in a separate area with incantations and prayers to the Christian god.

Historic food bowls for serving chiefs, and their people, took a variety of forms, ranging from specially mounted gourds for holding preserved pigeons to beautifully finished and carved vessels in the form of dogs and humans. A bowl that is said to combine features of dog and human is a bowl from the Bay of Plenty in the North Island and now in the Auckland Museum [**30**]. The carving has male indications, which, if the carved individual were unfolded, would show tattooed buttocks and shoulders, feet, phallus, and the characteristic three-fingered hand placed uncharacteristically at his mouth—perhaps a metaphor that food is for the living.

Māori containers for storing valuable objects include two types of carved portable boxes, *wakahuia* and *papahou*, for storing feathers, ornaments, and other small treasures [**31**]. These were hung from the house rafters and elaborately carved on their undersides. These boxes, although originally used for storing valuables, have become valuables in themselves. The relief carvings incorporate the significant elements of Māori art, including the visual entangling of male and female, illustrating the importance of both sexes to continuation of the tribal lineages and the importance of gender in all aspects of Māori society. The importance of the human head is shown in the sculpted handles, from which the ropes were strung or which were carved as faces that extend from the box. The spiral and geometric designs carved in low relief are important 'fill-in' elements, which illustrate tribal affiliation and can be related to the 'fill-in' arm movements that alternate with the narrative movements of Māori dance. Many treasure boxes incorporate different carving styles on the bottom of the box and the lid, and occasionally the lid is painted rather than carved. These differences are reminiscent of the pairing/mating of the differing sexual essences of the sky-father and the earth-mother in the origin of the gods and people (see Chapter 3).

Two treasure boxes, *waka-huia* and *papahou* (late eighteenth century). These containers were used to hold feathers and other ornaments, such as those in [**95**], for safe keeping.

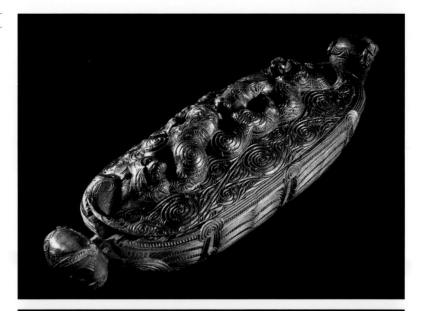

Portable containers are small versions of elaborately carved storehouses, *pātaka*, important structures on or near the *marae* for storing food and valuables of the tribe. *Pātaka* were elevated above the ground and carved with metaphorical symbols of plenty and fertility, such as whales being hauled ashore or copulating human couples. One of the classic illustrations of whales as a symbol of plenty, and arguably the most important extant piece of Māori art, is the façade remains of an eighteenth-century *pātaka* from Te Kaha [**32**]. Although a whale is not really visible, the spiral indication of the tail and the effort shown in the depiction of those pulling the whale illustrates the Polynesian preference for indirectness in the aesthetic depiction of cultural values. These *pātaka* (which were often named) enhanced tribal prestige and were judged on their carvings and on how well they were stocked. During the nineteenth century, *pātaka* became more elaborate and larger. One of the largest is 'Te Puawai o Te Arawa', now in the Auckland Museum but owned by the Ngati

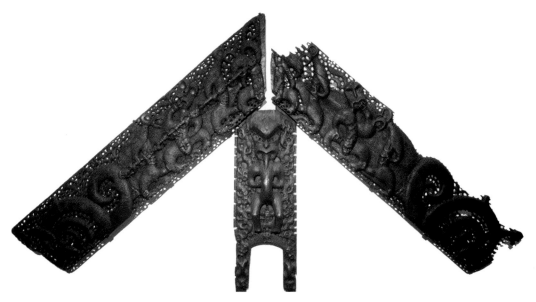

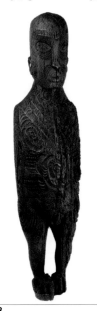

Pikiao, a subdivision of the Arawa tribe. The central figure over the doorway, carved by Wero of Ngati Tarawhai in the 1870s, is Tama te Kapua, captain of the Arawa canoe from which the Ngati Pikiao traces its ancestry. Tama te Kapua and the figures above him hold *whakapapa* genealogy counters that trace relationships among past and present members of the tribe.

Containers for holding the bones of important ancestors are among the most sacred containers to the Māori [**33**]. Burial chests were found primarily in the northern part of the North Island, usually in burial caves, and are thought to have been used for the secondary burial of the bones of an important member of a tribe to distinguish such a person in death from the rest of the tribal members. The symbolism is often female and thought to represent Hine-Nui-Te-Po, goddess of death, who presided over the afterworld. Death was surrounded with *tapu*, and it is instructive to contrast the burial chests to the food bowl mentioned above [**30**]. The male symbolism of the food bowl and the female symbolism of the bone chests correspond to the Māori conception of the male association with life and the female association with death. Carvings on bone containers often show tattoo designs and the characteristic three-fingered hand, placed at the front of the body. The main difference is that death is symbolized by the female essence.[21] Food and bones, valuables of the highest order, are depicted by the cultural symbolism of life and death as males and females.

A similar figure, probably used for a secondary burial for bones,[22] is from Rurutu. Said to be the god A'a, it has several small images carved in relief, and a removable back [**34**]. Another association with death can be found in the female representation of Hikule'o and Sakaunu, Tongan goddesses of the afterworld [**35**].

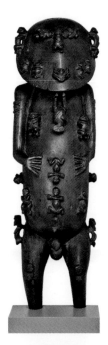

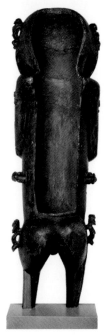

34

Male figure with small figures carved in relief known as A'a, Rurutu, Austral Islands (late eighteenth or early nineteenth century). Probably a container for bones.

Containers for the Gods and Other Valuables

Valuables were stored in lidded gourd containers in Hawai'i and carved wooden trunks in Tahiti. But it was in the transport of god figures that sacred containers were especially important. The Tahitian god 'Oro was transported in a special receptacle, *fare atua* (godhouse), the first of which was made by the god Ta'aroa:

It was a neat little ark made of sacred polished wood, with arched roof covered with *fara* thatch, square at each end and having a level floor. Its dimensions were about four feet long, two and a half feet wide, and three feet high, varying in size according to the form of the god that was placed in it. One end was closed. The other end had a circular entrance for the god, with a close-fitting stopper of sacred cloth. To this ark were attached cords of sacred sennit, which were passed under it to either side, forming a loop at each corner, through which polished poles of miro wood were passed that extended far enough for two men at each end to bear upon their shoulders. The ark containing the god rested between.[23]

A godhouse carved from a single piece of wood is now in the British Museum, and was probably used to house *to'o* [**36**]. These figures consist of the assemblage of a piece of wood, wrapped in a complex covering of coconut-fibre sennit and red feathers. Some have anthropomorphic features delineated by the addition of strips of sennit which create a face, arms and hands, and a navel. These *to'o* were periodically activated or renewed in a ritual called *pa'iatua*,[24] during which the gods were assembled, uncovered, and re-dressed at a national *marae* for an important occasion such as the installation of a high chief, seasonal ritual junctures, or at times of crisis. The *marae* was cleaned, the sacred white *pu'upu'u* barkcloth was prepared, and cordage sacred to the god Tāne was readied. The essence of the ritual was the renewal of the activating ingredients of the *to'o* and to give sanctity to the lesser gods. *To'o* were carried to the *marae* in their godhouses, and then at the most sacred moment were revealed. The lesser gods (of medical practioners, canoe-builders, fishermen, and sorcerers) were presented to the *to'o*, along with offerings of red feathers; the *to'o*, in turn, gave feathers to the lesser gods. Newly made images were also brought to be inspired by the *to'o* and their priests.

The old vestments of the *to'o* were removed, placed in a sacred spot on the *marae*, and left to decompose. The wood part of the *to'o* was rubbed with scented coconut oil and the sacrifice of a sacred male pig was made. The *to'o* was dressed in its new vestments of fine sennit and red feathers and reactivated with incantations by the priests. Thus, all the images, *to'o* and *ti'i* (wooden images), were renewed to enable them to carry out their duties until the next *pa'iatua* took place. These rituals were necessary in order to renew the established relationships among the gods, the universe, and the people, while they displayed hierarchical

35

Wood sculpture of a Tongan
goddess (late eighteenth
century).

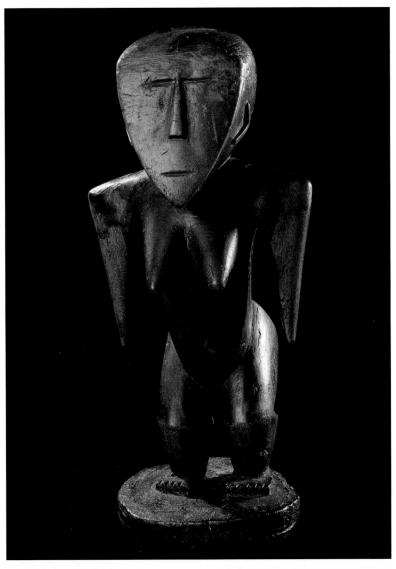

36

Godhouse, *fare atua*, with
'Oro figure in place, from the
Society Islands (late eight-
eenth or early nineteenth
century).

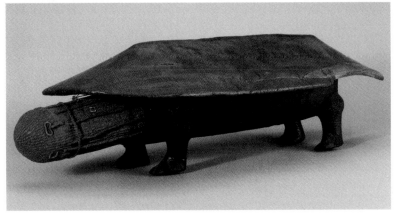

37

Godhouse, *bure kalou*, made from coconut-fibre sennit and reeds, from Fiji (mid nineteenth century).

37

Godhouse, *bure kalou*, made from coconut-fibre sennit and reeds, from Fiji (mid nineteenth century).

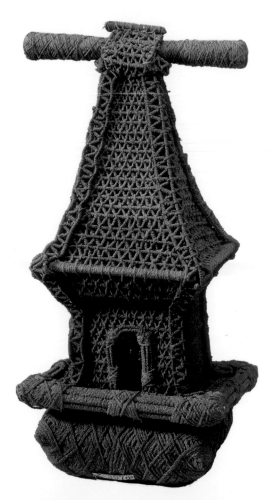

38

Log idiophone from the Cook Islands (early nineteenth century).

principles related to heredity and power: although anyone could gaze upon a *ti'i*, only those of certain status could gaze upon a *to'o*, and only the highest could touch and renew them. At the highest level, renewal was done with sacred fibres and red feathers.

Portable Fijian temples made of sennit [**37**] are thought to contain the sacred essence of the gods. They may have contained small god figures, thereby functioning as both contained and container. Reeds or perhaps midribs of coconut palm leaves are wrapped with many

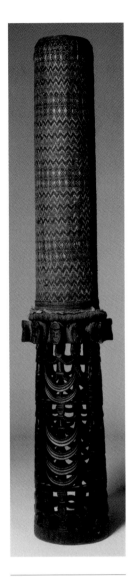

39
Drum with pandanus-leaf
sleeve and sharkskin mem-
brane. Ra'ivavae, Austral
Islands (early nineteenth
century).

40
Drum with human images
and sharkskin membrane.
Hawai'i (late eighteenth
century).

metres of sacred sennit cord in a shape modelled after full-size
godhouses, *bure kalou*.

Musical Instruments: Containers for Sacred Sounds
Musical instruments from Polynesia and Micronesia are primarily
drums, flutes, and shell trumpets.[25] Log idiophones are found in West
Polynesia and the Cook Islands, where they are decorated with relief
carving [**38**].

Skin drums, membranophones, are widespread in East Polynesia,
where a hollowed cylinder stands on a footed base often carved with
crescents, which are thought to have housed the drum's spiritual
strength and *mana*.[26] The skins are bound to the base with sacred
cords of braided coconut fibre. The drums, called *pahu* or *pa'u*, were

41

Bamboo noseflute with incised designs, including a sailing ship, Fiji (c.1840).

41

Bamboo noseflute with incised designs, including a sailing ship, Fiji (c.1840).

42

Māori flute, *putorino* (late eighteenth century).

played to announce important births, open and close wars, and mark funerals. Ritual movements of priests used their rhythm and they were used in association with dancing. In the Austral Islands, the cylinder is sometimes covered with finely woven pandanus leaves, which incorporate geometric designs, and the carved bases incorporate human figures and crescents that echo the joined arms of the figures [**39**].[27] In Hawai'i, the base carving often portrays a series of upturned crescents, which appear to be abstracted representations of upstretched arms [**40**].

Aerophones include nose-blown flutes and shell trumpets, both of which are widespread in Polynesia, and various Māori end-blown flutes. Noseflutes, made of a length of bamboo with incised decoration [**41**], give a mellow sound. Māori *putorino* and *koauau* were carved with faces and geometric designs [**42**]. *Putorino* could be used as trumpets or flutes, and the *koauau* may have been played from the nose. Shell trumpets had carved mouthpieces and were adorned with human hair [**43**].

Marshall Islanders used an hourglass-shaped drum [**14**], which may have derived from similar instruments in New Guinea.

Art objects from some areas of Polynesia and Micronesia are primarily containers. The sophisticated modern appearance of bowls

43

Māori shell trumpet (eighteenth century).

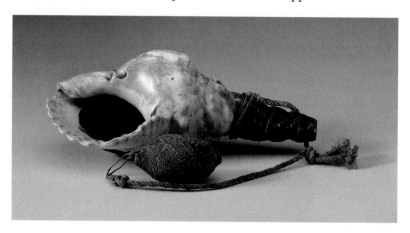

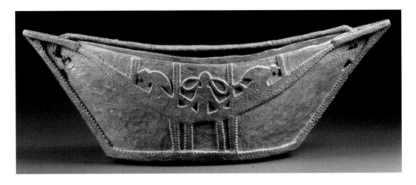

45

Wooden bucket for fishing equipment from Tokelau (early twentieth century).

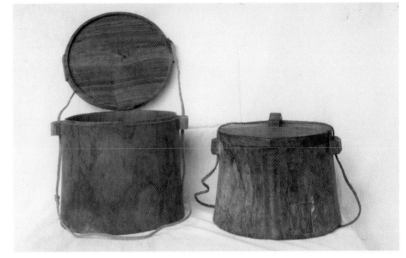

from Wuvulu and Kaniet [**44**] attracts collectors of modern art, and the wooden covered buckets of Tokelau [**45**] are still used today in traditional ways—to carry fishing equipment. Containers are some of the unsung artefacts of Polynesian and Micronesian pasts. They are still being produced by artists from these areas as functional bowls and works of art, adding artistic creativity to historic continuity.

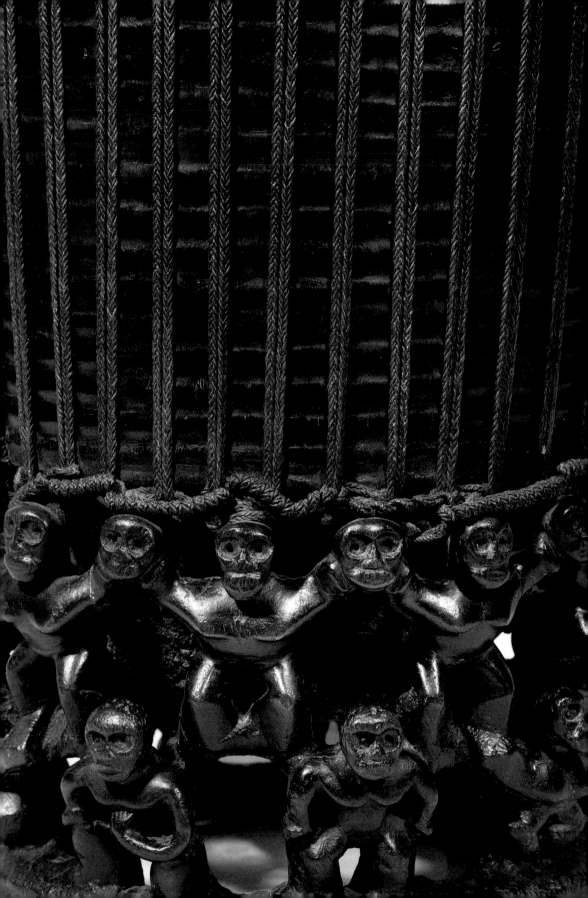

Aesthetics, Carving, Metaphor, and Allusion

3

The New Zealand Māori academic, artist, and author Sidney Moko Mead noted that 'we treat our artworks as people because many of them represent our ancestors who for us are real persons. . . . They are anchor points in our genealogies and in our history. Without them we have no position in society and we have no social reality. We form with them the social universe of Maoridom.'[1] In equating works of art with the ancestors and contemporary Māori people, Mead expresses the importance of traditional and modern art as part of the Māori cosmos. This cosmos is based on values and concepts that are rooted in ancestral traditions brought by ancestors of the Māori from central Polynesia. These traditions are based on the migration stories of a series of named canoes with named captains and navigators. Evolving over time into a variety of cultural and aesthetic traditions, these values and concepts place high value on art, and especially the art of carving [46].

In Chapter 2, discussion centred on how the European concept of 'art' fitted with Polynesian and Micronesian categories and concepts. It concluded that 'art' in these areas focuses on objects and performances intended to be special because they can be presented or used during special occasions and events or because they are treasures from the past. In addition to the artistic product itself, which can be of local fabrication or appropriated from elsewhere but assimilated into the local artistic system, the process of fabrication or performing was also found to be significant.

Here I want to add aesthetics to this mix and to explore how art and aesthetics are social constructs that are embedded in the cultural precepts of specific groups of people. My concern is to find a conceptual framework that makes sense in Polynesia and Micronesia and from which a variety of objects and performances can be examined. Many studies of art and aesthetics are still conceptually tied to Western ideas, which are inadequate and inappropriate for analysing these concepts in other societies, especially as Western aesthetics is still concerned primarily with beauty and connoisseurship.

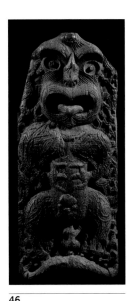

46

Carved figure from a door-way of a Māori storehouse, *pātaka*, from the Hauraki gulf, Ngati Paoa tribe (*c.*1700).

Detail of 40

An aesthetic or aesthetic system is a socially constructed evaluative way of thinking that is part of a larger belief system that underlies social action. Objects, architecture, songs, dances, poetry, and oratory are part of society and the structure of reality, and society cannot be completely understood without them. Art and aesthetic structures are social structures and communicate societal meanings in different ways. Symbolic action is social action.[2] Art is not something separable from the rest of life operating in separate categories, but part of social action and interaction. Individual understandings of aesthetics are part of a larger understanding shared by a group of people who hold certain ideas in common as part of a belief system or culture.

Implicit in much early work in art history, as well as anthropology, philosophy, and aesthetics, is that (1) we know what 'art' is and therefore it is not necessary to define it, and (2) 'art' is universal. This treats art as a Western concept, but asserts a universality of something for which we do not have adequate cross-cultural concepts. If language helps structure the way we think, how can we speak about art in societies that do not share the concept? Anthropologists have long recognized the inappropriateness of applying Western concepts to non-Western art. Sidney Mead notes, for example, that 'applying the definition of Western art and aesthetics to Melanesia will produce predictable results: it will be found that the Melanesians have no art and no aesthetics.'[3] As the evaluative element of social action, aesthetics partakes of cultural 'values', that is, something of importance to a particular group of people that is usually associated with good, something that is desirable, and has merit or worth. Groups of values or ratings of values affect cultural configurations and their patterned expression saves an 'individual from the necessity of constantly making choices'.[4] These choices and the values from which they derive are part of an individual's social heredity or culture and are part of what Ralph Linton called the 'universal human tendency to amplify culture and constantly enrich its content'.[5] Linton attributes this amplification to the human capacity for being bored, rather than to man's social or natural needs.[6]

'Aesthetics' derives from the Greek word *aisthetikos*, which deals with 'sense perception'. When brought into English and other European languages in the nineteenth century, 'aesthetic' was used to indicate the response to art and was especially concerned with beauty. Although still used in that way, aesthetics is also considered a philosophical system, often stated as the philosophy of beauty and good taste. A philosophical system is derived from a set of principles; thus a philosophy of aesthetics must be based on aesthetic principles. Depending on the context, the word *aesthetic* can refer to a response, a principle or set of principles, or a philosophical system. The common element in this paradigm was beauty. When one decides whether

something is beautiful or not, a value judgement is being made. Beauty, of course, is not inherent in any object or thing but is a mental construct of an individual that may or may not be shared by others. The basic concept here is evaluation (that is, whether something is beautiful or not) and how this mental construct is part of a system of thought.

Focusing on evaluation makes it possible to separate specific facts or ideas from the concepts, and to conclude that aesthetics refers to *evaluative ways of thinking*, thus enlarging the concept to include non-Western cultural forms. My thoughts on this subject go back to my fieldwork in Tonga in the 1960s when I noted,

Ways of thinking about cultural forms, including the standards by which they are judged, are largely determined by the cultural tradition of which they are a part. Each society has standards for the production and performance of cultural forms. These standards, whether they are overt and articulated, or merely covert, can be said to constitute an aesthetic for that society. An individual cannot be said to understand the aesthetic principles of another society unless he or she can anticipate indigenous evaluations of artistic performances or products. To do this one must be aware of the essential criteria for forming judgements (unless he or she has been assimilated to the point where these are sub-cognitive). The language used in talking about such products and processes provides some guidelines, but it is not sufficient to rely upon semantic analyses alone. Only by repeatedly relating aesthetic evaluations to actual performance or products, under a variety of conditions, can an investigator approach a reasonable level of comprehension.

Members of different cultures simply do not react in identical ways to the same stimuli, artistic or otherwise. Canons of taste arise out of cultural values, and indeed, often intensify the values which serve as guides in everyday life. Despite these limitations, which have long delayed serious attempts to develop the comparative study of aesthetics, much can be done to illuminate the nature of aesthetic judgments and experience in non-Western cultures. If we are to understand (rather than just appreciate) an aesthetic, or a society's cultural forms, it is essential to grasp the principles on which such an aesthetic is based, as perceived by the people of the society which holds them. This underlying organization is more important for understanding human action than an analysis of the content of the item itself. Only after the principles of organization have been deduced can we decide that any specific item either conforms to or fails to meet the standards recognized by that society. Further, I propose that aesthetic experiences are realized when fundamental cultural principles are made specific in works of art (that is, when the deep structure is manifested in a cultural form resulting from creative processes which manipulate movement, sound, words, spaces, or materials) and are understood as such by individuals.[7]

Thus, aesthetic principles are cultural values. Although usually applied to a specific range of cultural forms ('the arts'), the evaluative mode

is applicable to all of social and cultural life. To derive or understand what can be called an aesthetic system for a group of people, their entire way of life must be examined to find systematic relationships among cultural forms and the social actions and mental constructs in which they are embedded. Important cultural values and social ideals are evaluated, and it is the concepts or principles used in evaluation that reveal ideas about the arts and aesthetics. Ideas about art and aesthetics—evaluative ways of thinking about a variety of cultural forms—will here be examined in the context of woodcarving among the Māori of New Zealand and the Hawaiians.

Māori Carving: An Art of Social and Religious Metaphors of Ancestors and Gods

Traditional Māori arts are alive and well. They include the making and use of cloaks and baskets, the composition and performance of music and dance, the presentation of oratory and ritual encounters, the carving of portable objects, and the carving, weaving, and erection of meetinghouses as the central buildings on traditional ceremonial grounds (*marae*). Māori woodcarving is the consummate example of continuity, change, innovation, and variety within a tradition of Polynesian art. From the time of the first European encounters, house carvings were admired and collected. Some of these carvings are in overseas museums, but many are in urban and local museums in New Zealand and held in private collections at home and abroad. This large corpus of carving has been the subject of several international exhibitions and catalogues.[8]

If artworks, and especially carvings, are equated with Māori

Māori Society

Māori society was based on the principles of primogeniture, seniority of descent lines from the founding ancestors, sanctity of chiefs, and the importance of the male line. Aristocratic heredity was most important, and little prestige could be acquired by achievement. *Tohunga* were priests of specialized activities, such as war, agriculture, seafaring, fishing, and woodworking, and were descendants of the chiefly lines. Hereditary rank was related to the concepts of *mana* and *tapu*, much of which was acquired at birth, depending on genealogical descent from the tribal ancestors. The chief was the guardian of the tribal land, metaphorically an exten-sion of his body. It was important that the chief have the ability and resources to entertain lavishly to acquire prestige for himself and his tribe. Māori were not politically centralized. The largest social grouping is the *waka*, the ancestors of which are believed to have come on the same migration canoe. The largest descent group is the *iwi*, concerned primarily with land. Smaller segments called *hapu* were concerned with residence and the regulation of marriage. Warfare sometimes took place within and between tribal groups which were associated with the ancestral canoes mentioned in myths, legends, and historical accounts.

47
Canoe prow, *tauihu*, and front section showing rafter patterns, of the famous Māori war canoe, Te Toki a Tapiri. This last of the great war canoes was built about 1836 for Te Waka Tarakau of Ngati Kahungunu, who lived near Wairoa in Hawkes Bay.

ancestors, as Mead contends, how does this equation work? And how are carvings the surface manifestations of a deep structure from which this equation arises? Artistic and aesthetic principles can be derived from Māori traditions about the origin of the universe and the origin of carving.[9]

From the primary void or chaos, the sky-father, Rangi, and the earth-mother, Papatuanuku, lay together in a warm embrace. Their offspring were the four great gods, Tāne (god of the forests), Tangaroa (god of fish and reptiles), Tū (god of destruction), and Rongo (god of cultivated foods), and two specialized gods, Haumia (god of uncultivated foods) and Tāwhiri (god of the winds). Cramped in dark quarters, the children debated how they could separate their father and mother and bring light to the world. Tāwhiri disagreed, but the others attempted to separate their parents. Tāne succeeded but, finding his arms too short, he placed his head against mother earth and pushed his father up with his feet. Tāwhiri rose with his father and sent his offspring—the four great winds, small violent winds, clouds of various kinds, and hurricanes—against Tāne. Tāwhiri's brothers and their offspring were terrified. Tangaroa's fish offspring plunged deep into the sea, but the reptiles sought safety in Tāne's forests. Rongo and Haumia hid themselves in mother earth. Tū withstood Tāwhiri's wrath and finally defeated him. But Rangi and Papa have never been reconciled to their separation and, even now, Papa's sighs rise to Rangi as mist, and Rangi's tears fall to Papa as dewdrops.

This Māori creation story is often depicted as part of meetinghouses and *pātaka*, raised storehouses. Rangi and Papa might be depicted in their pre-separation embrace. Tāne might be depicted as the personification of the sun and fertilizer of the land and its creatures, and Tangaroa might be depicted as an embodiment of the sea and its creatures.

Although traditionally the *pātaka* was the more important building on or near a *marae*, today the meetinghouse is the large important structure. In earlier times, the most important communally owned object was a war canoe, but these became nearly obsolete by the mid-nineteenth century. The war canoe [**47**], as well as the chief's dwelling house and his *pātaka*, were superseded by the carved meetinghouse [**48**]. Funerals that drew large groups of mourners were moved from outside on the *marae* to the porch or inside. Tribal

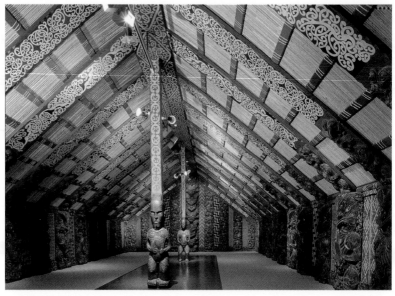

meetings, sleeping accommodations for those attending, and religious gatherings honouring the new Christian god took place inside these metaphorical aesthetic representations of tribal pride.[10]

The carved A-shaped bargeboard with a carved human figure or human head placed at the apex beckons its users into a recessed entry way and through a door situated off-centre to the left and surmounted by a carved lintel. Upon crossing this sacred boundary into the house—marked by the doorway lintel—one enters into a horizontally

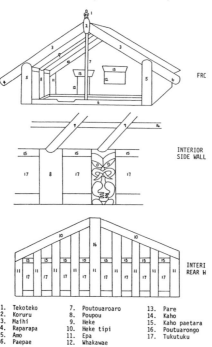

1.	Tekoteko	7.	Poutouaroaro	13.	Pare
2.	Koruru	8.	Poupou	14.	Kaho
3.	Maihi	9.	Heke	15.	Kaho paetara
4.	Raparapa	10.	Heke tipi	16.	Poutuarongo
5.	Amo	11.	Epa	17.	Tukutuku
6.	Paepae	12.	Whakawae		

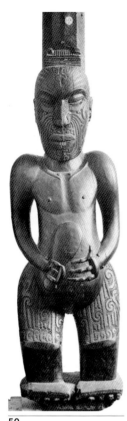

50
Central housepost, *pouto-komanawa*, from a Māori meetinghouse in Tikapa, Waiapu Valley (mid nineteenth century). It depicts the Māori carver Iwirākau, showing facial and thigh tattoo.

and vertically ordered space conceptualized as a model of the cosmos and a metaphor of the history and embodiment of the ancestors of the group. The sky-father encloses his progeny as he embraces the earth, and like the primary void, it is dark inside. Tāne, god of the forests, also personifies the house, as the building materials are taken from his domain. Inside, the carved ancestors express the corporate status of the group and the wider symbolic and genealogical relationships among its members [**49**].

But in addition to Rangi, Papa, and their offspring, the house is a metaphor for the prostrate body of an ancestor, who may be the captain of a founding tribal canoe or the founder of the group. This ancestor is carved with his head (*tekoteko*) at the apex of the bargeboards (*maihi*), which represent his arms and fingers. A ridgepole (*kaho*) runs the length of the ceiling at the centre of the house; this represents the ancestor's spine, replacing the earlier carved metaphorical hull of the war canoe. Painted rafters (*heke*) run from the ridgepole to the sides representing the ancestor's ribs. Ridgepole supports, often with a human ancestral figure carved in the round at the base [**50**], reach floor to ceiling. The carved slabs along the sides of the house (*poupou*) represent the more recent ancestors of the group that owns the house and allude to its genealogy. These *poupou* alternate along the sides of the house with plaited wall panels (*tukutuku*). Plaited floor mats cover the floor. The right side (as viewed from outside the doorway) is considered *tapu*, the important side, and, depending on context, is reserved for visitors and men; the left side, considered less important, is used by local people and women. The right side can be associated with death and is where coffins are placed; the left side is *noa*, and associated with life.

Doorways symbolize passage from one state to another—creation to dissolution, birth to death. The porch is a transitional zone, associated with sex and reproduction. Rangi and Papa may cohabit on the ridgepole extension over the porch, and the ridgepole inside the house indicates the main line of descent to the ancestor of the tribe. Door lintels (*pare*) sometimes show women giving birth, or represent Hine-Nui-Te-Po, goddess of death, or allude to the separation of Rangi and Papa [**51**]. Female symbolism relates to the role of women in absorbing and removing *tapu* so that any visitors who may have harmful intentions are neutralized.

Many houses honour a male ancestor, but occasionally a house is associated with a female ancestor, and sometimes female ancestors are carved as part of the house. A well-known female carving is said to represent Hinematioro, 'a high-born woman of kindly disposition' who died in 1823.[11] This carving is a side panel (*poupou*) from a house, found in a swamp at Whangara, between Gisborne and Tolaga Bay. It is one of the few surviving *poupou* carved with stone tools.

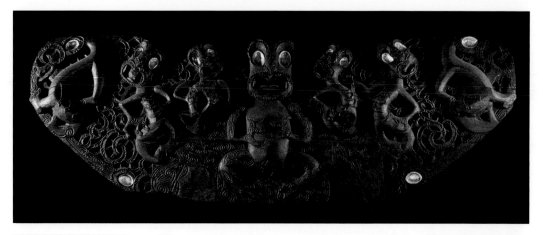

51
Māori lintel, *pare*, from an island village in the Hauraki swamps. It was carved with stone tools in the early part of the nineteenth century. The central figure represents Hine-Nui-Te-Po, the goddess of death.

The metaphor of the ancestral spine carved as a ridgepole continues in the ridgepole supports. The central housepost (*poutokomanawa*) from a meetinghouse at Tikapa, Waiapu Valley, depicts the famous carver Iwirākau [**50**], who is said to have lived ten generations before the 1890s. The supporting post is an extension of Iwirākau's spine, and his tattooed buttocks show his chiefliness and tribal affiliation with Te Whanau-o-Pokai, Ngati Porou. He is depicted holding a greenstone weapon, the original of which has been preserved as a *taonga* (treasure), now in the Auckland Museum.

The Origin of Carving

The act of carving has a mythological origin, often associated with Tangaroa, god of the sea. According to one story, Tangaroa was offended by the son of a chief named Rua and took him to the watery deep, setting him up as the *tekoteko* of his own house. Searching for his son, Rua discovered this house, and heard the carvings talking to each other. Rua set fire to the house, but rescued his son and some of the other carvings and took them back to this world. Using the carvings, Rua taught people to carve. Unfortunately, the carvings could not speak, but instead had to communicate visually and thereby set the stage for the importance of visual metaphor and allusion to refer to important cultural values of the group. Carving became a sacred act and was embedded in *tapu*. Rua's carving knowledge was transmitted for many generations to famous named carvers, including Hingangaroa, Tūkaki, and Iwirākau. The descendants of Tūkaki carved the Te Kaha *pātaka* [**32**] and Iwirākau is featured in the meetinghouse at Tikapa [**50**].

Carving Augmented by Painting in Colonial New Zealand

The values communicated visually by the carved meetinghouses metaphorically allude both to the origin of Māori society and to specific tribal genealogical descent. The metaphorical representation of the larger society is alluded to outside the house, while the importance

of the family is metaphorically represented inside the house. Roger Neich has noted that the metaphors and allusions embodied in the house structure and the genealogical importance of its parts were so ingrained that, even when the parts of the house were not carved, they carried the same symbolic meanings. Thus, when paintings were introduced and even began to replace carvings in meetinghouses, they acquired the same meanings and significance that the carvings had originally conveyed by the implied structure of the house.[12]

After the 1870s, however, in some areas new ideas based on local identity and history were introduced, and in some cases even replaced group identity based on descent. Distinctions between Māori and *pakeha* (Europeans) were visually expressed by the paintings, as were distinctions between related (and not so related) Māori groups. Painting was not associated with the *tapu* that regulated the sacred act of carving and could be used to express the new religious and political ideologies brought about by colonial realities. Meetinghouse artists and their patrons selected the aspects of history that they wanted to emphasize. Metaphor and allusion became more and more related to a specific group's identity based on specific events.

As noted in Chapter 2, art objects were objects considered special and valuable because they were used during specific events. Along with oral history, painting began to record these events, but like the carvings they emulated, they too could not speak. Unlike oral history, without knowledge of traditional metaphors and allusions and specific events, visual history cannot easily be unravelled. Sometimes oral and visual arts tell the same story, sometimes they augment each other, and sometimes they tell different stories. But no matter which of these combinations is used, the metaphors and allusions from which they draw their symbolism must be known and understood.

Painting is an indigenous Māori artistic medium. Rock paintings, primarily in the southern part of the South Island, are associated with the earliest migrations to New Zealand. The depictions of human figures, birds, and other animals are painted black (and occasionally red) and include prototypes of spirals and curvilinear designs, characteristic of later Māori art. Painting in the so-called *kowhaiwhai* style decorated a variety of objects, including house rafters [48], canoe paddles, and lids of treasure boxes, some of which were seen, depicted, and collected during Captain Cook's voyages. This painting style did not include figurative painting of humans, animals, or plants, but focused on complex curvilinear motifs, which have been analysed primarily for their symmetrical and asymmetrical design placement on meetinghouse rafters.[13] These designs can also be found in tattoo [86] and on decorated gourd containers, which may be specific to chiefly individuals and perhaps families.

The introduction of figurative painting into Māori meetinghouses,

however—rather than relating to these indigenous painting styles—can be seen as influence from the West and as a reaction to the colonial situation. The famous early house Te Tokanganui-a-Noho was designed by Te Kooti Rikirangi, the famous rebel, war leader, and religious syncretizer. He was the leader of the Ringatu Church (which combined Christianity with local values of the importance of ancestors and their traditions) and an artist. This meetinghouse was aimed at reconciling the tribes that descended from the Mataatua canoe (one of the legendary migration canoes) and distilled the essence of the new colonial realities combined with Te Kooti's version of Christianity. Here, the two ridgepole supports are leaning posts (rather than an extension of the spinal column) for a male figure and a female figure, who represent the ancestors whose marriage united two important tribal groups. The carved side panels depict an ancestor of each major tribe of the area—identified with his name written on his chest and with carved details alluding to an event in his life. The paintings that adorn this house include naturalistic plant forms, naturalistic figures playing cricket and soccer, and *marakihau* (sea monsters) transformed into mermaids. The influence of this house and its innovations by Te Kooti eventually spread throughout the North Island.[14]

One of the most interesting houses in this new painted style is Rongopai, built at Waituhi near Gisbourne in 1887. This house combined the innovations of Te Kooti with descendants of *kowhaiwhai* styles of painting [52] into a colourful visual history of the Te Aitanga-a-Mahaki tribal group, and especially its leader, Wi Pere. This house was truly a bicultural artistic product that honoured its bicultural leader and his bicultural religion. Wi Pere was the son of a European settler and a chiefly Māori woman. Wi Pere, elected to Parliament in 1884, was a follower of the Ringatu Church. He is depicted in formal European clothes with his parliamentary chair in the background and his mother at his shoulder. His full facial tattoo artistically indicates his rank and prestige, but in reality he was not tattooed. Also depicted are male and female tribal ancestors from the remote and recent past in a variety of clothing, contemporary interests of the group, such as horse racing, and plants symbolic of land and its produce. Wi Pere took responsibility for building the house to fulfil part of a prophecy of Te Kooti—which indicated that four elders were to build meetinghouses in their home villages. The builders of the Rongopai house were Wi Pere's son and others of his Whanau-a-Kai *hapu* (subtribe) of the Aitanga-a-Mahaki tribe. Rongopai functioned as a Ringatu church for some time, thereby making its innovative use of artistic history available to Māori from near and far to influence their own meetinghouses.[15]

Although much of the figurative painting of Māori meetinghouses is difficult to decipher, Rongopai clearly presents the important

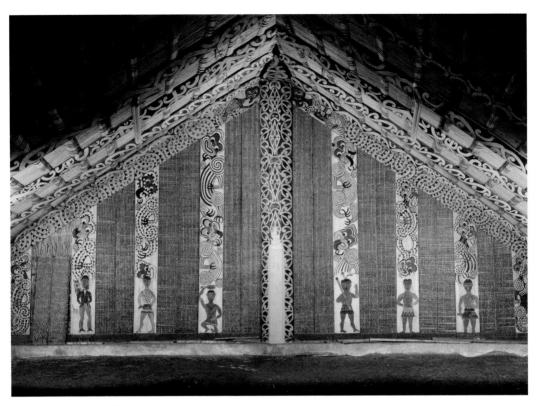

52

Rear wall of the interior of Rongopai meetinghouse at Waituhi, New Zealand (1887).

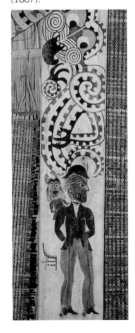

identity features of Wi Pere and his tribal history in the emerging late nineteenth-century Māori aesthetic.[16] This bicultural aesthetic would soon be rejected in favour of the re-emergence of carving in a more standardized form derived from the Te Arawa carvers at Rotorua. Essentially, the rejection of the narrative painting style was a political statement rejecting tribal fragmentation and individual tribal histories and favouring a more cohesive national Māori identity. An idealized view of the Māori past was promoted with carvings at the 1906 Christchurch International Exhibition and at the model village at Rotorua, which included a carving school that produced portable objects for sale to tourists.[17] Most meetinghouses built in the twentieth century incorporate the metaphors and allusions embedded in the pre-1870s house structure and the genealogical importance and symbolic meanings of its parts.

In the meantime, however, Māori artists adopted and adapted other Western ideas and artistic media and made them their own. Cliff Whiting took Māori myth, legend, and history in new directions with his carvings, mosaics, and collages, culminating in his installation at Te Papa Tongarewa, the new National Museum in Wellington. As the Māori co-director of this museum, he encouraged the purchase of Māori contemporary art and commissioned major new works for innovative installations.

Māori entranceway, 'Whakamarama' (To Be Enlightened). *Totara* wood, aluminium, copper, oil stain, wax. By Māori artist Ross Hemera, 1998.

Carving Plus Painting Plus Carving in Postcolonial New Zealand

Although some would say that 'postcolonial' in New Zealand is a descriptive, emotional, wishful-thinking category, others feel that colonialism is truly over. But, as part of the British Commonwealth, and embroiled in the continuing controversy over the Treaty of Waitangi and its concept of a shared nation, the status of the Māori is

Hawaiian Society

The Hawaiian social system consisted of a series of rank-oriented groups of individuals, related and unrelated, organized into chiefdoms that might be thought of as a series of pyramids. At the apex of each was a paramount chief, *ali'i nui*. Below him were lesser chiefs (*ali'i*) and retainers. Commoners (*maka'ainana*) made up the base. Sacred individuals at various steps in the pyramid had prestige and/or power depending on the closeness of blood and social rank of their parents. Prestige and power often did not coincide, and *ali'i* with the highest prestige were not necessarily close to the paramount chief in power. The distinction between chiefs and commoners was basic, separating an aristocracy from the people in general. There were gradations of rank among the *ali'i*, and a hereditary group called *kaua*, from which human sacrifices were usually drawn. Marriage depended on rank and often included more than one mate. For chiefs, it was socially necessary to marry a close relative in order to produce children of the highest possible rank. A suitable partner for a high chief was his own sister, half-sister, or niece. Lesser chiefs married more distant relatives. After a child was born to a high-ranking union, husband and wife could take second partners of their own choice. Besides the state gods (*akua*), worshipped on open-air structures, an important group of ancestral gods known as *'aumakua* were concerned with sorcery, crafts, or special functions.

a work in progress. Māori artists explore this status and their contemporary world views in a variety of innovative ways, harking back to the creative inventions of Te Kooti, his predecessors, and his followers.

A recent representative exemplar of combining Māori artistic concepts with available modern materials and technology is an entranceway called 'Whakamarama' (To Be Enlightened) installed in Te Papa Tongarewa [53]. The artist Ross Hemera (b. 1950) sees his 1998 creation, made of *totara* wood and aluminium, as 'a time of new beginnings and understandings'. Like crossing the threshold of a traditional Māori doorway—symbolizing passage from one state to another—crossing this threshold welcomes the visitor into the Māori world.

Hemera's inspiration is from two-dimensional South Island Māori rock paintings, which he renders in three dimensions. His entranceway symbolizes the moment when light first reaches the land after the separation of Rangi and Papatuanuku. On the central post, Tāne is depicted upside down with an aluminium head and rippled backbone as he struggles to separate his parents. Others represented in the geometric cross-sections are Rongo, Haumia, Tangaroa, Tāwhiri, and Tū. Also included are Ruaimoko (culture hero who brought carving to this world), and Hine-Nui-Te-Po (goddess of death). Their juxta-position illustrates relationships between parents and children and the interactions, jostling, and struggles among their offspring.[18] Like the shared-nation concept of the Treaty of Waitangi, Hemera shares with the viewer his synthesized distillation of the Māori view of creation in a late twentieth-century aesthetic.

Hawaiian Carving: Metaphors of Genealogy and Disrespect

In Hawai'i, there were no buildings comparable with Māori meeting-houses or carved storehouses. Instead, outdoor temples (*heiau*) were religious precincts that held carved images of the gods. Hawaiian state gods were local versions of the four great East Polynesian gods, borne to the sky-father (known as Wākea in Hawai'i) and the earth-mother (Papa). Rather than being separated by their children, however, Wākea and Papa (with each other and various partners) gave birth to the individual islands of the Hawaiian chain. Starting with the island of Hawai'i and moving west, Wākea and Papa gave birth to Hawai'i, Maui, and Kaho'olawe. Wākea with Kaula bore Lana'i, and with Hina bore Moloka'i. Papa with Lua bore O'ahu. Then Wākea and Papa bore Kaua'i, and Ni'ihau was an afterbirth. The first gods to be born were Kāne (Tāne) and Kanaloa (Tangaroa); later came Lono (Rongo) and Kū (Tū). The first man and woman were Ki'i and La'ila'i. After some generations, the goddess Haumea bore a number of children to the god Kanaloa. Later she took a husband among men and became the goddess of childbirth. Other gods, such as Pele, the volcano goddess, were also immigrants.

In Hawai'i, Kāne and Kanaloa were not usually represented in tangible form. Kāne, the ultimate ancestor of the other gods, was associated with the upper atmosphere, while Kanaloa, in paired opposition, was associated with the sea and its creatures. Lono and Kū were less distant and abstract. They were concerned with agriculture, plants, rain, pigs, peace and war, forests, canoes, houses, and crafts and were represented in human sculptural form. Many attributes of Lono and Kū were interrelated and depended on each other as complementary opposites.

As noted above, Māori meetinghouses visually communicated allusions to the family inside the house, while outside the house the allusions were to the larger society. The hosts often had a competitive relationship with the visitors, which was demonstrated by a ritual challenge by the hosts. The guests had to indicate whether they came in war or peace. If they came in peace, they could enter the meetinghouse. In Hawaiian visual representations, sculptures of Kū allude metaphorically to the larger society, while sculptures of Lono allude to the genealogical family. Like the ancestral backbone, which as a ridgepole runs the length of the Māori house and connects to the spinal column of the ancestors represented at the base of the ridge supports, the carved backbone on Lono figures is a genealogical metaphor, which connects Hawaiians to their remote ancestors. In complementary contrast, carvings of Kū, as god of war, and of the plants used for weapons, were metaphors for competing groups. I have characterized these opposing social forces as 'genealogy and disrespect', which can be visually symbolized by the spinal column of Lono and the mouth of disrespect for Kū.[19] Like the metaphors and allusions embedded in the Māori house structure and the genealogical importance of its parts, Hawaiian carvings of Lono and Kū need only to suggest the backbone or the mouth of disrespect to carry these symbolic meanings.

It is through an understanding of such social metaphors as expressed through *kaona* (layered or hidden meaning) that the bodily forms of the human sculptures become understandable. The importance of genealogy, respect and disrespect, and social stratification all existed in a tension-filled atmosphere in a social and natural environment concerned with aspects of culture and nature that needed to be explained and interpreted.

Hawaiian religion was concerned with social relationships among people, the gods, and the environment. Hawaiian sculptures rendered some of these concepts into visual form. As social metaphors, sculptures transformed underlying principles into surface manifestations. These figures were not considered the gods themselves, nor were they portraits, but the symbolic physical qualities were probably calculated to lure the spirits of the gods invoked. Gods rendered into visual form were Lono

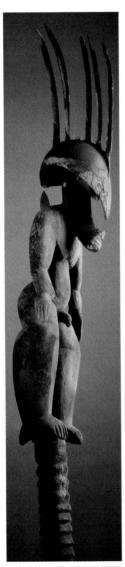

54
Hawaiian figure, probably representing Lono, from a cave on Maui (late eighteenth century).

and Kū, usually characterized as gods of peace and war, respectively, and several lesser gods. It is Lono and Kū that are the key to understanding paired opposition and, by extension, social rank. Like men and women as paired opposites, chiefs were paired in opposition with non-chiefs (by *mana* and *tapu*) as necessary opposites and as aspects of each other within the society as a whole. Lono gods were useful social metaphors for the importance of genealogy and of the family that works together in peace and harmony, manifested in agriculture and other peaceful pursuits. Kū gods were useful social metaphors on a larger scale in contexts that emphasized competing groups. Competition often involved degrading others in order to elevate one's own group and was often manifested in warfare and sacrifice. In short, there was an intimate association between two competing social forces manifested metaphorically as gods. Lono and Kū were symbolic of fundamental cultural principles that were opposed to, but also depended on, each other—manifested visually as the genealogical backbone of Lono and the mouth of disrespect of Kū.

The word for backbone is *iwikuamoʻo*, which also means family. One traces genealogy in steps, just as one can follow the steplike vertebrae of the spine. An image that has a definite association with Lono and a specific ceremony is the pole image of Lono-makua illustrated by John Webber during Cook's third voyage. The only existing pole image (now in Bishop Museum) has joints carved at intervals and a head carved at the upper end, exactly as described by the Hawaiian historian David Malo for use during the harvest festivals (*makahiki*):[20]

This Makahiki idol was a stick of wood having a circumference of about ten inches and a length of about two fathoms. In form, it was straight and staff-like, with joints carved at intervals . . . and it had a figure carved at its upper end.

An abstract backbone, along with an abstract head, were all that were necessary to symbolize the essence of genealogy and of Lono. This social metaphor was found in other images, such as the carved spinal column of the Cook-voyage figure now in Edinburgh and the displaced backbone of a figure now in Dublin.

In addition to the backbone, the top of the head, and especially a chief's head, was sacred. It is still *tapu* to touch the top of a Hawaiian's head, and chiefs wore helmets to cover their head in sacred or dangerous situations. Some Hawaiian sculptures have elaborate extensions of the backbone that curve up and over the head. Some of these resemble vertebral extensions, some become crested overhangs [**54**], and others become more and more abstract until the head disappears or acquires a second face. In its most elaborate form, the

backbone extension becomes an elongated headdress known from a Cook-voyage drawing and a sculpture now in Salem, Massachusetts. Finally, Lono could assume the form of the pig-man Kamapua'a, and was associated with lizards by way of their prominant backbones. There were strong associations among Lono, land, agriculture, pigs, lizards, genealogy, notches, backbones, and the sacred top of the human head: all had interrelated functions and could be substituted for each other symbolically. Carol Ivory has suggested that 'similar conceptual and metaphorical relationships existed in the Marquesas, linking the face, eye, and skull with objects (knots, nets, containers) and living creatures (turtles) and the spirit world. These interchangeable concepts and associations were embodied in circular motifs in general and representations of the face, skull, and eyes in particular.'[21]

Hawaiian images and conceptualizations about them can be said to express metaphorically some of the fundamental principles dealing with the importance of genealogy, the family, and the elevation of individuals by virtue of their descent from specific ancestors.

In contrast to these features of the Lono gods, the distinguishing features of the Kū gods are the mouth of disrespect and its extensions [55]. In the mouth of disrespect, the chin juts forward and the mouth is opened wide ('ole'ole). To push the chin forward (hō'auwae) indicates scorn, indifference, and disrespect. The mouth of disrespect is open, distends backward, shows teeth, and sometimes displays a protruding tongue. The mouth has concentrically carved fluting, the eyes are elongated and non-human in appearance, and the nostrils are flared. These images project the essence of disrespect, permissible in Hawaiian culture only by those at the very top, or by enemies in war.

The concept of hierarchical ranking and the desire to be of high rank or to trace relationships to those of high rank seems to be related to warfare and gods of war. Rival claims arising from the interweaving of senior and junior lines resulted in warfare that bestowed power and attracted support. In socially stratified societies, some individuals are more elevated than others, and clashes are inevitable. The Kū gods could function as a social metaphor for degrading others, especially on the battlefield. Tripping an enemy with a tripping club, scaring him with a shark-tooth weapon, or showering him with stones may have offered more satisfaction than killing him, and prisoners were appropriate for human sacrifice. One way of degrading chiefs conquered in battle was to make them servants. Such an occasion was commemorated by a superb serving dish [56], in which the conquered chief Kahahana and his wife Kekuapoi are carved in a servile position to the victorious chief Kahekili and are given an inappropriate status in society, symbolized by the serving of food. The mouths of the images are condiment holders, and although one of the mouths has some of the elements of the mouth of disrespect, it is evident that this

55

Hawaiian figure of the war god Kūkāʻilimoku (early nineteenth century) and *pahu* drum of Kamehameha the Great (*c.* late eighteenth century).

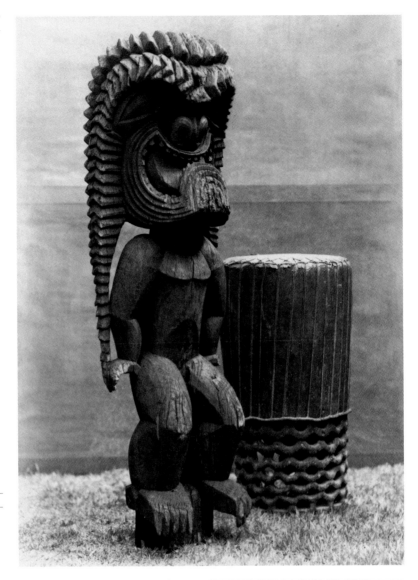

56

Hawaiian serving dish with human figures (late eighteenth century), with a Niʻihau mat in the background.

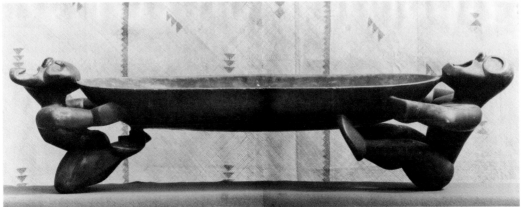

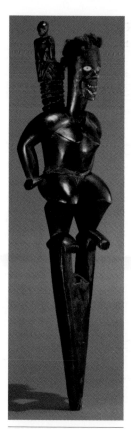

57
Hawaiian figure of Keolo'ewa
and a secondary figure (early
nineteenth century).

chief's disrespect has symbolically transformed him into a servant. In spite of the associations with specific individuals, the figures are not portraits but social metaphors.

The Hawaiian concept of degrading others in order to elevate one's own status can be associated with the Kū gods, who are often associated with elevating—and by extension its opposite, degrading. One of the Kū gods was the god of feather workers, and feathers could be worn or used only by elevated individuals. The ultimate way to degrade a group of people was by waging a full-scale war. Kūkā'ilimoku (Kū, snatcher of land) became the most famous of the war gods known in historic times. The large images that are thought to be receptacles for Kūkā'ilimoku were probably carved during the time of Kamehameha I (late eighteenth and early nineteenth centuries). Kamehameha's greatness in warfare was paralleled by the greatness of his war god Kūkā'ilimoku, visually manifested by great size and disrespect (symbolized by an extreme mouth of disrespect), especially in his representation on outdoor temples. In contrast, the leader of the Kū gods, Kūnuiākea, was simply represented on temples by a block of freshly cut 'ohi'a wood.

Kūkā'ilimoku's physical rendering in size and in the extreme mouth of disrespect reflects Kamehameha's disrespect not only for his enemies, but also for his society's genealogical rules. It was necessary for him to set aside genealogical respect in order to attain his elevated position. He was not the son of the high chief of the island of Hawai'i, and to achieve power he had to dispose of his cousins because they were in a more senior line than he was. As he rose to power, he emphasized temples associated with his own war god, Kūkā'ilimoku, and placed more emphasis on power than on rank. Like some of his powerful ancestors before him, he downplayed the importance of high genealogy and *mana* as prerequisites for power and authority, and substituted strength and ability. The elevated genealogy of his ranking wife, Keōpu'olani, made it socially possible for his son (Liholiho, who became Kamehameha II) to disrespect his father's god and ultimately to overthrow this god in his own dramatic act of defiance when he abolished the state gods in 1819. The mouth of disrespect in Kū form was carved no more.

The mouth of disrespect reappeared in a slightly altered form in sculptures used for sorcery. Although the state gods were overthrown, other, lesser gods remained a vital part of the Hawaiian world, and sorcery flourished, essentially replacing warfare. A sculpture of Keolo'ewa (or Kūkeolo'ewa) represents a powerful sorcery and war god from Maui [57]. It carries a small human figure on its back, representing one of Keolo'ewa's malign powers as an *akua noho* (a class of spirits who possess living people), which could be sent to do a sorcerer's bidding and injure by possession. It is catalogued in the Bishop Museum as a 'goddess of rain'.

Over time, the prestige and power of the gods waxed and waned,

individual gods becoming more or less powerful. The gods' prestige depended on the prestige and power of the chiefs with whom they were associated. Sorcery and war gods arose from benign ancestral spirits, but gods, like humans, were not all good or all bad. Good and evil were used selectively to elevate and give power to some individuals at the expense of others. Paired oppositions, such as good and evil, were important concepts of Hawaiian culture and religion. Good was directed to a god's guardian and descendants, while evil could be directed at others; respect and disrespect were functions of genealogical relationships.

Hawaiian sculpture exists in a dialectical relationship with social structure, each modifying the other in response to contexts. Sculptures changed as Hawaiian social concepts changed, and they assisted in the acceptance of that change. Lono and Kū, as social metaphors, were appealed to and even blamed for human vanity. Religion, human sculptures, and social structure were intricately associated with genealogical concepts and with respect and disrespect. Sculptures incorporated social metaphor and could be evaluated by their successes or failures, as well as by the skilfulness with which the sculptor created his product.

In addition to facial features, there appears to be a relationship between the stance of the sculptures and the incorporation of layered meaning that manifests human movement in visual form. Hawaiian wooden sculptures, especially those used on outdoor temples, are characterized by a combination of the knees thrown forward and the disposition of the back. This position emphasizes a straight back with the weight placed quite far back. This stance does not lead to strength—with this placement of the weight, the individual could easily be thrown off balance—but to vitality and alertness. It is through this bent-knee position that the lower body was moved in Hawaiian rituals.[22] Some sculptures even depict this movement. Ritual movements, performed for the gods on outdoor temples by movement specialists, could take permanent form as carved wooden images in bent-knee stance. A ritual supplicant's movements could be abstracted and through *kaona* serve as a visual metaphor for a poetic text and the ritual movements that accompanied it. Carving a sculpture in the bent knee position would serve as a permanent metaphor for a ritual performance itself and as a visual abstraction of the sacred text it accompanied. This type of visual objectification of texts was also found in other parts of Polynesia. For example, the carved *rongorongo* boards of Rapa Nui are thought by some to be objectifications of genealogical chants. In the Tuamotu Islands, the wearing of a coconut-leaf bracelet that had been braided during a prayer protected the wearer after the verbal prayer itself had finished.[23] As will be explored in Chapter 5, it is thought that during the fabrication of Hawaiian feathered cloaks the braiding of certain

fibres to the chanting of prayers caught the chant and objectified it as protection for its wearer.

Lono and Kū, in paired opposition, were alternately high and low depending on the time of the year or for what reason they were invoked. To maintain a connection with Lono, an *ipu o Lono* (gourd of Lono), sometimes with a small sculpted image attached, was kept in a sacred area of each household to receive offerings and prayers, which were usually concerned with fertility and protection against sorcery. But the fertility of land, sea, and people was important to the whole society, and the high chiefs with the aid of specialized experts (*kahuna*) used sacred *heiau* precincts to enact rituals on behalf of the whole society in honour of Lono. In other *heiau*, rituals associated with war were enacted in honor of Kū. At some *luakini heiau* (temples of national importance), both Lono and Kū gods were invoked, illustrating the intimate association between two competing social forces manifested metaphorically as gods and symbolizing fundamental cultural principles that were opposed to, but also depended on, each other.

Postcolonial Carving in Hawai'i

The first Western influences in Hawai'i were from Britain, beginning with the voyages of Cook and Vancouver, but American missionaries and whaling voyages brought further influences. The arrival of American Protestant missionaries from New England in 1820, the year following the overthrow of the state gods by Lihohilo, brought a new concept of the divine, one that must have seemed strange to Hawaiians brought up on paired opposites. The Christian concepts of a holy trinity, or a male creator without the help of a female, and of absolute qualities of good and evil, must have been difficult to understand. Christian concepts were assimilated to the overthrown state gods. Kāne, Kū, and Lono were transformed into the Triune God, while Kanaloa took on the evil qualities of Satan. The *'aumākua* and their use in sorcery continued to flourish—not in competition with the Christian god, but as a separate strain, as helpers in times of trouble or need. Instead of building or rebuilding *heiau*, chiefs built churches. Hawaiian ministers began to interpret Christianity in such a way that the *'aumākua* did not need to be discarded.

Specialized carvers probably continued to ply their trade and sold their new creations to visiting ships. By 1824, 'the officers of H.B.M. ship *Blonde*, when here, were anxious to procure some of the ancient idols, to carry home as curios. The demand soon exhausted the stock on hand: to supply the deficiency the Hawaiians made idols, and smoked them, to impart to them an appearance of antiquity, and actually succeeded in the deception.'[24] Figures for sale to tourists continued to be carved and sold, while replicas of sculptures in museum collections

were used in gardens and for interior decoration, as well as for festivals and expositions of identity.

In Hawai'i today, there are many ways of interpreting the remnants of traditional religion and the symbols of the past. Each is a personal view. Many Hawaiians take pride in their past and, in their search for cultural identity, have attempted to make such symbols and concepts relevant in today's world. The members of Hale Nauā III, an association of Hawaiian artists, have used symbols and concepts of the past in creating new works of art in traditional and modern media. In contrast to traditional images of the state gods, which appear to have been representations primarily of Lono and various aspects of Kū, Rocky Ka'iouliokahihikolo'Ehu Jensen, for example, has carved a modern sculpture of Kāne. The only known images associated with Kāne are large stone pillars only slightly altered by man, and the pillar-like carving by Jensen has preserved this abstract feeling.

The carvings of today, however, have taken on an entirely different meaning. They are not meant to be religious images as such, but illustrations of aspects of gods and chiefs of the past. They were not carved to duplicate historic images or concepts, but rather to establish links with the past—links that are important to modern Hawaiian artists. These works are visual metaphors of a changing society that relate not only to the past, but to the present and future. One such grand work is the 1989 *kālepa* of Rocky Jensen entitled *Born the Night of the Gods . . .* [**58**]. This represents the inner circle of sacred images of a Hawaiian *heiau*, interpreted in abstract expressionist style. Following

58

Born the Night of the Gods . . . Akua Kālepa presentation of eight Hawaiian god figures, by Rocky Jensen (1989).

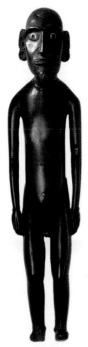

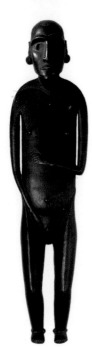

Two wooden figures from Rapa Nui, *moai tangata* and *moai papa* (mid nineteenth century).

the sacred crescent (*hoaka*) temple configuration, eight tall sculptures invite the viewer to examine the foundation of Hawaiian beliefs. Jensen explains,[25]

My *akua kālepa* consists of eight divine elements, four female and four male. As our tradition dictates, the female are on the left and the male on the right. The first to represent the female principle is Haumea, ruling the domains of life and death . . . the ultimate gift of woman to the Race of Man. Then comes Kihawahine, the Hawaiian equivalent of the Kundalini, resplendent in her dragon form. Following is Pele, 'Born in a flame,' representing continuous earthly energy and growth . . . ending with Hina, our paramount female principle. As individuals they represent separate departments. One basic theme, however, underlies these womanly aspects: rebirth and continued life. The masculine side commences with Kāne in the superior position. He is endowed with the responsibility of maintaining the lifeforce of *Kānaka Maoli* [indigenous Hawaiians]. Secondly, is Kanaloa, representing the harmony of body and soul . . . then comes Lono, he who is the guardian of human and heavenly sound. Lastly there is Kū, the awesome symbol of emotions that govern man.

Like Ross Hemera in his modern Māori gateway, Jensen shared with the viewer his distillation of a Hawaiian view of the gods in an aesthetic of the late twentieth century.

Rapa Nui Wooden Figures: A Polynesian Artistic Style

In Rapa Nui, wooden figures were representations of ancestors who were honoured and invoked for continued fertility of the descent group [**59**]. It appears, however, that they did not become important until the rise of the birdman religion and decline of the stone statue carving (see Chapter 6).

Important distinguishing features of Rapa Nui figures are eyes, hands, overhanging brows and high foreheads, bas-relief carvings on the top of the head, bulbous cheeks, vertically elongated noses with flaring nostrils, and horizontal lips, as well as design motifs of chevrons, spirals, concentric circles, and especially, crescents. Many figures, both male and female, have small goatees or vertical lines on the chin. An interesting feature of many of the sculptures is the importance of the back and the top of the head—echoing the genealogical symbolism of the spine and the *tapu* top of the head in many Polynesian areas.[26]

Well-defined hands must have been important in various Rapa Nui contexts. A realistic, elegantly carved hand was collected by the Tahitian Mahine during Cook's visit to Rapa Nui and is now in the British Museum. Petroglyphs at Orongo have dissociated hands, linking the importance of carved hands with birdman rituals. Elegant hands are carved in relief on stone figures, wooden female figures,

60

Carved stone boulder with
Makemake face and two
birdmen, Orongo, Rapa Nui
(*c.*1500).

wooden lizards have elegant hands on their undersides, and bas-relief figures on the heads of wooden male figures include hands.

Eyes are typically inset in Rapa Nui images with round pieces of obsidian encircled with bird bone. Red or black stone pupils embedded in white coral eyes were inlaid in stone figures, and the ritual of opening the eyes was an important last step in setting up the figure. It is thought that these eyes were set in place only when the figures were invoked and were removed at the completion of the rituals. Many early wooden figures have only one eye (the right eye is often missing); removing one (or both) eyes may have rendered them inactive and thus made them available for trade. Barkcloth figures [**69**] also have inset eyes similar to stone faces at Orongo [**60**].

Along with the importance of the eyes were eyebrows. Carved as elongated crescents with a central ridge and elaborated with chevron incising on wooden images and a straight overhanging ridge in stone images, eyebrows form the residual frame into which the eyes could be set when used in rituals. Eyebrows, more than any other feature, could abstractly indicate the face of an ancestor or god and conveyed the idea of human form in dance paddles.

Another diagnostic feature of Rapa Nui figures is the mouth and especially the lips. On stone figures pouting lips are carved horizontally. Janus-headed carved wooden staves and short wooden hand weapons with carved faces have similar horizontal lips without teeth as do faces on breastplates. Faces of many wooden figures and other wooden objects retain this horizontal-lip feature, while, on a few, the lips curve upwards into the cheeks.

Well-carved ears are characteristic of most Rapa Nui human figures. Many stone figures have elongated ears, and staves have elongated side pieces to represent ears. Human wooden figures of all sorts have well-carved ears, which are sometimes decorated with spirals or adorned

with representations of ornaments worn by Rapa Nui people, who artificially elongated their ears and inserted bone earplugs.

Polynesian Aesthetics

The overall Polynesian aesthetic system can be characterized as an aesthetic of inequality, and this concept is the basis for understanding all social and cultural forms. Through woodcarving we can begin to understand the importance of social metaphors and allusions. Inequality was expressed as stratified social rank, and people were connected vertically and horizontally. Vertically, chiefs were connected with the gods and with their people—expressing history and society over time. Horizontally, individuals were connected to each other, and these groups were connected to each other—expressing the operation of society at a specific time. Vertical rank was distilled into one's genealogy, often likened to backbones and their visual representation. Horizontal rank was often conceptualized and visually displayed by the use of space, such as the layout of villages and interior architectural space (see Chapter 6). Carving of wooden figures connected humans with gods. Aesthetic principles based on veiled meaning and skilfulness combined with carving into a philosophy of stratification.

Polynesian languages do not have specific words for either art or aesthetics, but their vocabularies include many concepts that refer either directly, or as extensions, to objects of value and to evaluative ways of thinking. The most important aesthetic principle is the idea that a subject should not be approached directly but should be referred to by going around it. This concept takes different forms in the various Polynesian islands but usually derives its primary meaning from oral literature and particularly poetry. Indigenous terminology for this concept expresses the importance of layers of meaning which one apprehends by going around a subject, never to the point, and approaching it repeatedly in different ways from different points of view in order to convey symbolic hidden meanings. Local terms include *kaona* in Hawaiian, *whakahurihuri* in Māori, *heliaki* in Tongan, *hesingihaki* in Bellonese, and *hakake* in Rapa Nui. According to Kirch and Green, there is a Proto-Polynesian word for design patterns, *kanu*.[27]

Polynesian concepts encompass a complex of core characteristics that express the cultural and aesthetic signature of each island group. A viewer unravels the layers of meaning in a visual or verbal form by using his or her cultural knowledge in a non-passive way. The audience, in effect, participates in the process to understand the final product. Aesthetic experiences can be realized when fundamental cultural principles are made specific in works of art—that is, when the underlying structure is manifested in a cultural form and is comprehended as such by individuals.

61

House mask from Mortlock
Island, Caroline Islands (mid
nineteenth century).

Micronesian Carving: Simplicity of Form

An aesthetic concept based on simplicity of form and design is widespread in Micronesia and reached some of its high points in the dramatic black-and-white masks from the Mortlock Islands and the human sculptures of Nukuoro.

The Mortlock Islands, known indigenously as Nomoi, include three atolls, Lukunor, Etal, and Satoan (Satawan), located south-east of Chuuk and south-west of Pohnpei in the central Caroline Islands. Dramatic black-and-white masks were worn by men and houseposts [**61**]. An early reference notes that 'they seemed to be used by executioners, that they might do their duty faithfully, and remain unknown'[28] but this has never been verified, and the idea of executioners in Micronesia seems singularly out of place. J. S. Kubary, the earliest ethnographer in the Mortlock islands, does not describe the use of the masks, but he did collect at least one, which is now in the Museum für Völkerkunde, Leipzig. A 1910 description by Krämer seems the most appropriate: he notes that the masks were called

tapuanu, a word that means spirit or ghost, which can also be applied to carved wooden images. According to Krämer, the first makers of the masks were Remaura of the Sorr clan and Rautu of the Sauefang clan, from Satoan. Associated with men of the Soutapuanu secret society, the masks were worn in conjunction with the performance of songs and dances to combat the wind. In a mock battle with dancing staves, the men faced east, where the wind god Fangileng lived. It is also said that they were used to assist in the ripening of the breadfruit.[29] The men of Satoan staged a performance for the German Südsee Expedition.

The masks were mounted at the crossbeam inside the large canoehouses.[30] Each village had at least one canoehouse with beams decorated with black-and-white painted designs. Tied to an upright post, usually facing the interior, was a large black-and-white mask. Holes at the side of some masks at about ear level were used to attach a comblike ornament. The early masks, although used as an architectural element, include a carved projection that fitted over the head when worn and horizontal eye slits to enable the wearer to see.

Although the Mortlock masks are unique in Micronesia, they can be related to artistic styles in other areas of Micronesia, as well as Polynesia and Melanesia. The Mortlock area of the Pacific ocean was part of the central crossroads of Pacific cultures. Directly north of the mask-using areas of Melanesia and close to the Polynesian outliers of Nukuoro and Kapingamarangi, the Mortlock carvers seem to have combined the Polynesian outlier-style faces with the Melanesian idea of a mask and the ritual use of weather charms in human form from Yap and the surrounding islands [110]. The resulting *tapuanu* were worn by men as masks and attached to houseposts—combining such concepts as images attached to houseposts as in Luangiua, faces mounted on housegables as in New Guinea, and the painted and decorated housebeams as in Yap and Belau.

Today in the Mortlock Islands, administratively part of Chuuk, they are known as '*tapwpwaanu* . . . mask-like spirit head carved of wood and set up on the gable end of a Mortlockese canoe house or meeting house'. The root word is *anu*, ghost, and they are thought to have been used to ward off typhoons. They are said by contemporary Mortlockese to have existed as male and female pairs, the male mask having a beard and a topknot that represents the traditional male hairdo—long hair twisted and held in place with a *tek*, a multipointed comb about a foot long, made from mangrove wood, which doubled as a weapon.[31]

The earliest known masks are characterized by pouting lips and expressive eyebrows resembling the wings of a bird in flight, while those from the 1870s are characterized by lips in an elongated horizontal diamond shape, slightly arched eyebrows, and a circular appendage mounted at the upper right or left corner.

62

Kawe, female figure from Nukuoro (nineteenth century).

Nukuoro, a Polynesian outlier, is one of a group of islands lying geographically outside the Polynesian triangle, but inhabited by Polynesians. The people of Nukuoro shared concepts of hierarchy and rank with their West Polynesian counterparts, but have incorporated cultural ideas from their geographic neighbours. The art of Nukuoro combines the Micronesian aesthetic concept based on simplicity of form and design with Polynesian artefact types. Nukuoro sculptures are reminiscent of West Polynesian sculptures, with well-developed chest area, straight arms, and slightly bent knees.

Nukuoro figures were the embodiment of certain male and female gods. The large female figure in Auckland Museum, said to be the goddess Kawe, has tattoo designs in the pubic area, echoing the tattoos of Nukuoro women [**62**].[32] The large male figures have tattoo designs on the shoulders and upper arms in the same style as the tattoos of chiefly men. Two male figures collected by Kubary were named Sope and Tehi Tapu.[33] The smaller figures usually do not have painted tattoo designs, but it is possible that the paint has disappeared. The figures were placed in the central temple (*amalau*), and in smaller houses belonging to each clan. Food, clothing, flowers, and ornaments were presented to them during religious rituals and tattooing ceremonies. Little is known of the content of the rituals, but it is likely that they were similar to West Polynesian ceremonies that honoured gods and ancestors with first-fruits at harvest-time with thanks for fertility of the land, sea, and people.

Nukuoro was part of the central crossroads of Pacific cultures. The placement of the god figures at the end of an enclosed sacred house combines the layout of outdoor Polynesian *marae* with an enclosed space more characteristic of Micronesia and Melanesia. In Luangiua (Ontong Java), a Polynesian outlier in the Solomon Islands, a similar type of image was attached to the outside face of a housepost. Polynesian in function, Polynesian/Micronesian in style, and Micronesian/Melanesian in placement, Nukuoro sculptures are a Pacific intercultural dialogue. Outside the Pacific, they have influenced modern art and artists, including Alberto Giacometti, who in 1929 made a drawing of a Nukuoro figure in the Musée de l'Homme[34], which prefigured his famous sculpture *Invisible Object*.

Genealogical Connections
The Texts of Textiles

4

Queen Sālote Tupou III of the Kingdom of Tonga (1900–65) noted that 'the history of our people is written in our mats'. By this, she was referring to special mats known as *kie hingoa*, mats that are named and embed genealogical histories [**63**]. These objects were plaited of pandanus leaves by unknown hands 'in the long ago'. They are heirlooms passed from generation to generation as treasures (*to'onga*), and are worn or presented during weddings, funerals, investitures, and commemorative events by members of the Tongan chiefly lines, who trace their ancestry to the god Tangaloa. *Kie hingoa* are still worn and used on the most important ritual occasions, illustrating that the ancestors, whose essence they contain, are living presences and that their ancestral *mana* makes them *tapu* to ordinary people. What makes them valuable is that they contain the reproductive power of Tongan society. Some of them circulate, but others have the status of crown jewels, and as objects of prestige and power they are involved with the bilateral inheritance of rank. People become attached to them, and thereby intertwine their personal histories with those of their illustrious ances-

63
Standing beside Queen Elizabeth II in 1953, Queen Sālote of Tonga wears a fine mat known as 'Lalanga 'a 'Ulukilupetea' to commemorate the event.

Detail of 72

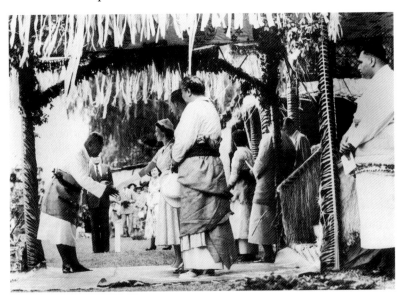

tors and events. Their circulation does not create obligations for direct return, but, rather, an expectation that when they turn up again, they will move along a slightly different route. Their social life as ritual objects validates Tongan societal concepts of rank and prestige.

The following vignette will serve several purposes.[1] It examines textiles as works of art within a cultural context. It conveys an aesthetic concept based on age and genealogical importance by which textiles are made special. It is a living example of how social symbolism is embedded in objects—a concept that was widely held in Polynesia.

Rather than giving priority to the people who possess them or once possessed them, priority is given to the *kie* themselves and how people and lines of descent are attached to them. Many *kie* can no longer be traced to their original owners but are associated with myths, legends, historical events, people, and places, and are mentioned when recounting the circumstances from which their name derives, or during which they were used and by whom.

Mats are rectangular constructions plaited from prepared pandanus leaves. Some are as large as 3 metres long and 1.5 metres wide and are so finely woven—as many as twelve strands to a centimetre—that they look almost like linen. Although mats are ubiquitous in most of Polynesia and Micronesia, Tongan mats seem to have a greater value than their counterparts in other Pacific societies, for in Tonga they are intimately involved in the reproduction of political power and social prestige. Through these mats we can understand how objects are the ritual embodiment of social life and focus our attention on the centrality of genealogy in many Polynesian societies.

The full history (and sometimes even the name) of a *kie hingoa* may be forgotten, just as full genealogies are often forgotten if they are not written down; however, even if the name and specific history are not known, they are still presented and treated in the same manner. *Kie hingoa* are the material, mystical manifestation of past events and genealogies, which can be remembered, forgotten, or adapted to current situations. They activate genealogical relationships and cultural memory.

Named mats form only one of several kinds of Tongan valuables, known collectively as *koloa*. Complementary to *koloa* are *ngāue*, products derived from agricultural work, fishing, and animal husbandry. *Koloa*, products made by women, are, like women, prestigious. In contrast, products associated with men are considered 'work', and like men, are powerful. *Ngāue* regenerates people physically, while *koloa* regenerates people culturally. Both are necessary, and together they regenerate and reproduce society. Thus, *koloa* is the complementary domain to *ngāue*, and is not a complementary or contrasting domain to objects made by *tufunga*, craftsmen. The fabrication of *koloa* is not a craft, but a fine art, which creates valuables, an important distinction in Tongan cultural domains. *Kie hingoa*, however, are no longer made, but are heirlooms

The Tongan social system is based on three principles of rank: (1) in ego's own generation, sisters are considered *'eiki*, high or chiefly, to brothers; (2) in ego's parental generation, paternal kinsmen are *'eiki* to ego, while maternal kinsmen are *tu'a*, low, to ego; and (3) elder siblings of the same sex are *'eiki* to younger siblings of the same sex. It is primarily by the principle that sister outranks brother that prestige rank is acquired; title, with its concomitant of power, is usually inherited patrilineally by males through the principle of primogeniture. The Tongan chiefly houses trace their origin to the first Tu'i Tonga, 'Aho'eitu, whose father, the god Tangaloa 'Eitumatupu'a, climbed down from the sky on a *toa* (casuarina, ironwood) tree and cohabited with an earthly woman who descended from an earlier population derived from a maggot. This elevation of a woman from the lowly original population accounts, at least in part, for the importance of 'sisterliness' and a sister's elevation and prestige. That is, the brothers of this woman would consider themselves inferior to their sister, the mother of the ruler, and to their sister's child—'Aho'eitu, the demigod ruler. 'Aho'eitu was 'above the law' to his mother's brothers and their descendants. In succeeding generations, a systemization of this concept resulted in sisters outranking brothers. It is from this principle that the concept of *fahu* or 'above the law' derives. A *fahu* is a man's sister's child or a father's sister's child—an important element for understanding Tongan society and art.

of the sacred past. In their conceptualization as treasures, *kie hingoa* have the most elevated status of all objects.

Symbols of Sacred Sovereignty

In Tonga, the most important parts of the body are the head—especially the top of the head and the eyes, which are sacred—and the area between the waist and knees, the seat of fertility. The names of *kie* are often associated with these body parts and their coverings. Especially important for chiefs and their descendants, these body parts were protected and decorated on important and dangerous situations, including war, investiture, weddings, funerals, welcoming and entertaining visitors, and commemorative events. The highest-ranking individuals had the most elaborate protective and decorative garments, and the materials from which they were made were difficult to obtain and time-consuming to work. Objects associated with the Tu'i Tonga line were the most elaborate and sacred.

During the time of the visits of Captain James Cook to Tonga (1773–4; 1777), the highest-ranking objects were (1) a feathered headdress (*pala tavake*), worn by the Tu'i Tonga, and (2) a special kind of decorative garment, called *sisi fale*, worn by the Tu'i Tonga, his sister (Tu'i Tonga Fefine), the Tamahā (Tu'i Tonga's sister's daughter), and perhaps other descendants of an incumbent Tu'i Tonga and previous Tu'i Tonga. *Sisi fale* are overskirts made of small pieces of intricately twined *kafa* (coconut fibre) in a basketry technique. These small pieces, in the form of circles, stars, half-moons, or rectangles,

were covered with red feathers, and incorporated shell beads, animal teeth, and carved pieces of ivory (from whale's teeth), and were joined together to create an overall design [64]. These materials, especially coconut fibre, red feathers, and whale-tooth ivory, were considered sacred materials throughout Polynesia, and their fabrication into chiefly articles was considered to be a sacred act known to only a few specialized individuals.[2]

It is significant that shortly after Cook's visits, the manufacture of *sisi fale* ceased, and these ritual garments were replaced by *kie*, just as the power of the Tu'i Tonga was replaced by that of the Tu'i Kanokupolu. Many *kie hingoa* came from Sāmoa, where they are known as *'ie tōga*, the highest-ranking part of a Samoan woman's dowry. They have fertility connotations and were imported as such into Tonga. Ritual defloration was practised in Sāmoa, but not in Tonga, where *kie* became part of Kanokupolu-line ritual paraphernalia, and are still used to wrap the virgin blood for presentation to a bride's mother after a marriage has been consummated. Wearing a fertility mat as an investiture garment gives it a double symbolic role in ensuring an heir and the reproduction of the Kanokupolu political system. *Kie* are associated with the Tu'i Kanokupolu line, just as *sisi fale* were associated with the Tu'i Tonga line.

64
Feathered overskirt (*sisi fale*) of sennit covered with red feathers. Collected during the second voyage of Captain James Cook (mid eighteenth century).

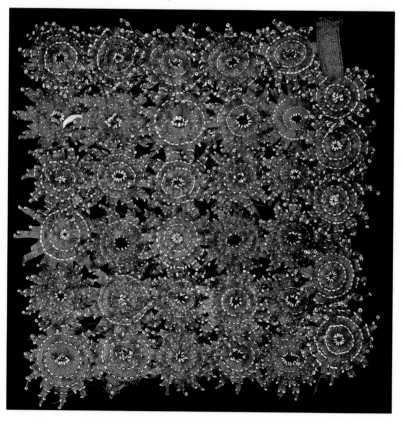

An origin story of Tongan *kie* involves a woman, Fataimoeloa, from Felemea, Ha'apai, who exposed herself to the Sun, became pregnant, and had a son whom she named Sisimatala'a. He was extremely handsome and was chosen to marry the Tu'i Tonga's daughter, Fatafehi. After a series of adventures, he travelled with his mother and they brought two packages (given by the Sun and called *monu* and *mala*) and a *kie* made by his mother, the first in Tonga. Fataimoeloa used the *kie* as the top layer of Sisimatala'a's wedding clothing. Since that time, *kie* have been worn for wedding ceremonies. This mat became known as 'Sisimatala'a' and may be the *kie hingoa* now known simply as 'La'a'.

It is significant that *kie* were not specifically mentioned in the journals from Cook's voyages; however, George Forster on the second voyage observed 'their elegant mats, which for workmanship and variety excelled even those of Taheitee'.[3] David Samwell on Cook's third voyage noted that 'the finest sort they use for Cloathing & to sit upon on extraordinary [*sic*] Occasions'.[4] As *kie* were often old and full of holes, to a European they would not look valuable. None of these treasured fine mats are in Cook-voyage or other early collections. This may be because they were not seen, their importance was not recognized, or they were simply too important to be given away.

Kie hingoa appear only rarely, and when they do, it marks the occasion as one of note and records the importance of the event. The *kie* then contains the essence of the event and the person who wore or used it. They become chronicles of history, imbued with lives of their own. Besides weddings and funerals of individuals of chiefly lines, such events include investitures, openings of Parliament, and greeting and entertaining important visitors. Such an occasion was the visit of Queen Elizabeth II in 1953, when Queen Sālote wore 'Lalanga 'a 'Ulukilupetea' [**63**]. The visit of Queen Elizabeth was a large state celebration (*kātoanga*), and Queen Sālote gave it the dignity it deserved by wearing a *kie hingoa*. She had worn the same *kie* at the official *kava* ceremony during which she had received her title as Tupou III in 1918 and again to commemorate her 60th birthday. King Tupou IV wore it the first time he opened Parliament. According to Queen Sālote, this *kie* was more than 600 years old and 'the Tongan counterpart of the Coronation chair of King Edward I'.[5] It is named after 'Ulukilupetea, the mother of Tupouto'a, father of Tupou I. She was a descendant of Malupō, chief of 'Uiha, a descendant of a brother of the twentieth Tu'i Tonga, *c*.1400.[6]

Weddings and *Kie Hingoa*

The practice of wearing Samoan fine mats during marriages of the chiefs was well established in Tonga by the time of William Mariner (resident in Tonga from 1806 to 1810), but the mats were apparently worn only by women. At the wedding of chief Finau 'Ulukālala's son,

```
TK Maʻafu-ʻo-Tuʻitonga                      Malupó (Chief of ʻUiha)
         |                                           |
   Ngalumoetutulu              =              Siuʻulua (daughter)
                                      |
        TK Tukuʻaho  =  ʻUlukilupetea (daughter)
                          |
                   TK Tupoutoʻa
                          |
  Finau Kaunanga  =  TK Tupou I  =  Kalolaine
            |                  |
  Filiaipulotu = Sālote Pilolevu    Tevita ʻUnga  =  Fifita Vavaʻu
            |                              |
      Fatafehi Toutai         =         ʻElisiva Fusipala
                              |
       Lavinia   =   Tupou II   =   Tupoumoheofo
            |                 |
      Sālote Tupou III      Vilai
            |                 |
        Tupou IV           Vaea
            |                 |
     Lavaka/Ata/ʻUlukālala  =  Nanasipauʻu
```

Notes: TK = Tuʻi Kanokupolu.
ʻUlukilupeteʻa, known as 'the woman with the ivory stomach' because she had so many important children, had at least five partners. The person of importance in this genealogy is Tukuʻaho, a Tuʻi Kanokupolu, progenitor of the Tuʻi Kanokupolu line of Tupou I.

the two Tongan brides were dressed in the finest Samoan mats, but the only element noticed by Mariner for the groom was his donning of a white barkcloth turban ornamented with small red feathers. In the wedding exchange, the groom, who already had a Samoan wife, presented fine mats.[7] On another occasion, at the marriage of the Tuʻi Tonga to Finau's daughter, she wore Samoan mats 'of the finest texture and as soft as silk. So many of these costly mats were wrapped round her, perhaps more than forty yards, that her arms stuck out from her body in a ludicrous manner; and she could not, strictly speaking, sit down.'[8] The bride's five attendants were also dressed in Samoan mats. No mention is made of anything remarkable about the Tuʻi Tonga's wedding clothing, and the presentation he made consisted of large pieces of barkcloth, a wooden pillow, and a basket containing bottles of oil.[9] Apparently Samoan mats were worn only by women at marriage rituals, and women controlled them. Mariner notes that when Finau sent a present to an important woman, his contribution was a bale of barkcloth and strings of beads, while his wife sent three valuable Samoan mats.[10]

Wearing important *kie hingoa* with distinguished histories for weddings has a dual function: (1) a *kie hingoa* is like a distinguished ancestor whose appearance graces the occasion and gives it dignity; and (2) its use as a garment or part of the bedding ensures the fertility

of its wearer/user and hence the continuance of his or her line. *Kie hingoa* have supernatural associations with the continuity of the chiefly lines. The choice of which *kie hingoa* is used on a specific occasion reveals information by *heliaki*, veiled meaning.

For her wedding, Princess Sālote (later Tupou III) wore ten *kie hingoa*: the uppermost one was 'Fangaifāia', and her consort, Tungī Mailefihi, also wore ten. The royal double wedding of their sons included a Christian ceremony in the royal chapel, where marriage vows were exchanged, and the traditional *tu'uvala* ritual, which took place on the open *mala'e* next to the royal palace. During the Christian ceremony, all four principals wore *kie hingoa*. For the *tu'uvala*, the two princes did not wear *kie hingoa* but special ornamental costumes called *fakalala* [**65**], which can be worn only by descendants of the Tu'i Tonga line—the line through their mother. Each bride wore several *kie hingoa* edged with white triangles of pandanus leaf, a decorative element often added to enhance the rather drab appearance of the *kie* for celebratory occasions. The weddings of Tupou IV's daughter and his youngest son were equally elaborate, and the brides and grooms each wore numerous *kie hingoa*. The wedding of the king's granddaughter, in 2003, also included several *kie hingoa*.[11]

Kie Hingoa and Investitures

Throughout Polynesia, ritual investiture was, and in some areas still is, one of the most important events—verbally celebrated in oratory and/or poetry and visually displayed with an investiture garment worn around the loins, proclaiming the right to rule or the right to the title being invested.

The important elements for the investiture of a Tu'i Kanokupolu are that the designated individual leans against a specific *koka* tree or an object (such as a throne) that includes wood from this tree from the ancestral village, while taking part in a *kava* ceremony (see Chapter 2), where the title is called by an appropriate ceremonial attendant. And the title-holder must be the recipient of the *kie* named 'Maneafainga'a'.

65
Double wedding of Prince Tāufa'āhau and Prince Tu'i Pelehake, Tonga, 1947. They wear clothing of specific genealogical significance. The grooms wear *fakalala*, ceremonial clothing associated with the Tu'i Tonga line; the brides wear named mats.

The investiture celebrations for King Tupou IV were held one year and a half after the death of Queen Sālote. They included the traditional *kava* ceremony, two days of dancing and feasting, and a European-style coronation. During all these ceremonies, the king, the queen, and often their children wore *kie hingoa*, as did the king's brother, Prince Tu'i Pelehake, his wife Princess Melenaite, and their children. During each ceremony, *kie hingoa* were worn that related each wearer to genealogically important people who had worn the mats on previous occasions. The most important traditional occasion was on 6 July 1967, the official investiture *kava* ceremony. Tupou IV wore 'Lalanga 'a 'Ulukilupetea' (as his mother had worn it for her investiture). Maneafaiga'a also appeared, but it was too fragile to be worn. Later that day, for his official meeting and talk with other members of his lineage, the king wore 'Falavala 'o Tuku'aho', named after his father's father. Thus, during his official investiture the king wore mats associated with his mother's Tu'i Kanokupolu line, but for other events of the day he wore mats associated with his father's Ha'a Takalaua line, as did his son who would be the next king.

Ritual investiture is a sociopolitical event, combining verbal and visual expressions of authority and consent sanctioned by traditions that have their origin in mythical times binding together the king, chiefs, and people. The ritual acknowledges the rights and duties of various chiefly lines and the people to whom they owe their support. To experience such a ceremony is to be transported back in time to the rituals associated with the propitiation of the descendants of the sky god Tangaloa and the first-fruits rituals that dealt with fertility of land, sea, and people. These events reaffirm the values of the society, the stratified societal structure on which it is based, and the political importance of land.

Kie Hingoa and Funerals

A most elaborate state funeral was that of Queen Sālote in December 1965. The *kie hingoa* used on that occasion reveal important information about Queen Sālote, her government, and about these mats of power, rank, prestige, and history. The official list includes twenty-eight *kie hingoa*.[12] Twenty-three were used under the coffin, and five had specific duties. Maneafaiga'a was placed with the European-style crown of the Tupou dynasty. That this *kie hingoa* was given pride of place indicates that it was the most important presence at the wake. Second only to Maneafaiga'a were the pair of *kie* 'Hau-o-Momo' and 'Laumata-o-Fainga'a', which were placed on elevated tables. They embody the sacred power of the Tu'i Tonga line brought into the Tupou dynasty as part of the inherited treasures of Sālote. The joining of these three important mats on the occasion of Sālote's funeral indicated the present inseparability of the lines of power and prestige and Sālote's attachment to them.

Two other *kie hingoa* were separated out at Sālote's funeral, 'Langa'a'ula'

and 'Kiemanu'a', which covered two tables that held pillows with the royal orders Queen Sālote had acquired during her lifetime from Queen Elizabeth of England. Queen Sālote treasured these marks of recognition from the higher queen; carried on pillows in Sālote's funeral *cortège* by her two eldest grandsons, they are now part of the living history of two *kie hingoa*.

Of special interest is that *kie hingoa* reveal the important Samoan influence in the Tongan Tu'i Kanokupolu line. Although mats were considered treasures elsewhere in Polynesia, often more important were barkcloth and objects braided from coconut fibre. Barkcloth is held to be sacred in various parts of Polynesia. The *sisi fale*, of sennit and red feathers, associated with the Tu'i Tonga line, represent sacred processes of manufacture that were also sacred elsewhere in Polynesia, especially in Tahiti and Hawai'i, where investiture garments for the highest chiefs were made from special fibre and covered with red feathers. These sacred clothes can be related to the sacred lineages of old Polynesia.

In Tonga, high-ranking people of the past and present are attached to *kie hingoa* and are inseparable from them. The chiefly lines claim power and prestige by association with them. But objects cannot act on their own: they need to be activated by people attached to them and who know their histories. Their use objectifies social relationships. The ancestors are metaphorically invoked to bring their essence into these mats of power and prestige. Having touched the bodies of the chiefs of old, they transmit their *mana* and power to the chiefs of today.

In Sāmoa, fine mats have similar but different symbolic qualities. Tauese Sunia, an orator of Manu'a, Sāmoa, explained that the name of a Samoan fine mat is 'rather like a praise name for the chief or orator who has the right to give it'. Besides the named mats that can be given only by certain orators, other mats are used for specific occasions. For example 'Nofova'a' is a mat taken in a boat when a woman elopes; however, even if a couple do not elope, one mat of the bedding is called 'Nofova'a'. 'Fusitā' is a mat made by a women to be worn at a ceremony when her son's tattooing is finished and then given to the tattooer.[13] Although the mats themselves may be materially the same or similar in Tonga and Samoa, their uses are culturally distinct.

Barkcloth: A Basis for Clothing, Sculpture, and Presentation

Another textile widespread in Polynesia is barkcloth. The finest bark-cloth is made of the inner bark of the paper mulberry (*Broussonetia papyrifera*), cultivated specifically for the purpose. Other plants include breadfruit (*Artocarpus*), fig (*Ficus*), and *Pipturus* (called *māmaki* in Hawaiian). Textiles made of inner bark are also found in Japan, Indonesia, South America, and Africa, but their use reached a high

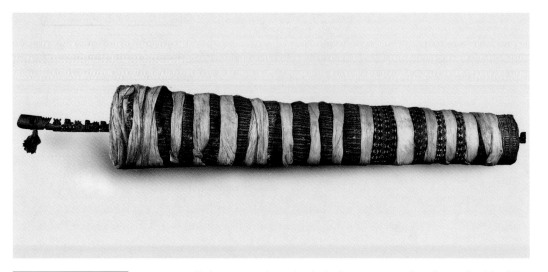

point in Polynesia, where barkcloth was considered a valuable. The fabrication of barkcloth is usually women's work, but the resulting product was often sacred to men, women, and the gods. In the Cook Islands, images of gods and ancestors were wrapped with cloth and fibre attachments, the most remarkable of which is the staff god from Rarotonga now in the British Museum [**66**]. About 4 metres long, the figure was wrapped with a huge bale of barkcloth, and embellished with red feathers and pearlshell pieces. The carved wooden section of the image includes an upright head, a phallus at the opposite end, and a number of horizontal secondary figures near the ends of the long staff. In this barkcloth vignette, I shall focus on barkcloth from Hawai'i, Rapa Nui, Sāmoa, and Niue.

East Polynesian Barkcloth

The most important uses of barkcloth in Polynesia were for bedding and clothing—often specially prepared and decorated for people of rank. Designs and technique can be distinguished between East and West Polynesia, as well as from island to island. In East Polynesia, barkcloth was made by a felting technique, and designs were imprinted into the cloth by a carved beater.

Hawaiian barkcloth (*kapa*) is among the finest in Polynesia in both texture of the cloth and richness of design. As bedding, *kapa moe* were made in several layers sewn together along one edge, with the upper layer beautifully decorated. *Pa'u*, women's wraparound skirts, were also made of sheets sewn together along one edge. *Malo*, men's loincloths, were long narrow garments, often having two separate designs divided along the centre line and folded lengthwise to show both designs when tied. *Kihei*, a shoulder garment, was worn for decoration and warmth.

The technique was a variation of felting achieved by two separate

beatings. After soaking in water, the first beating produced long strips, which could be dried and stored until needed. For the second beating, the dried strips were soaked, lightly beaten, placed in layers between banana leaves, and left for about ten days to mature by 'retting'. The partially rotted and layered strips were felted, by beating, into a finished rectangular piece. To make larger pieces, they were joined by sewing. Most eighteenth-century Hawaiian barkcloth is relatively thick, is often ribbed (on a grooving board), and has bold angular designs [**67**]. Nineteenth-century barkcloth is thinner, has smaller designs organized differently, and has an elaboration of a 'watermark', derived from beating with a mallet with incised designs. This watermark impressed a design into the cloth. In pre-European times, the watermarks were primarily straight lines in different widths,

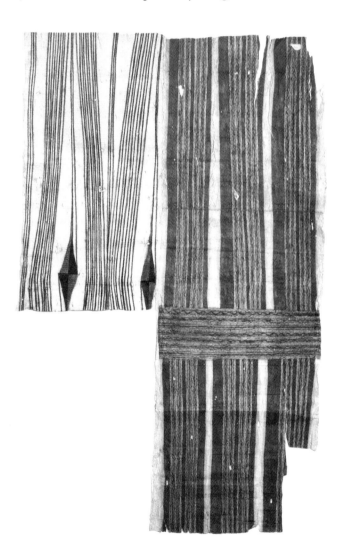

carved side by side on the length of the mallet, sometimes with the addition of lines in another direction. With the influx of metal nails and carving tools from Europe, more elaborate designs were carved into the mallet and impressed into the barkcloth.

A second layer of design was painted or printed on the upper surface of the cloth. In eighteenth-century barkcloth, this upper layer of design was based on creative combinations of linear elements that cross and converge to form squares, triangles, and diagonals, giving a feeling of boldness and directness. Nineteenth-century designs have less emphasis on linear elements; straight lines that occur are more on the order of space dividers and give frames to enclosed arrangements of small motifs. Sometimes these frames are entirely filled in with one design, or the linear elements enclose or define the space for the more consciously placed motifs. Motifs were printed with stamps carved on the inside end section of strips of bamboo 30 to 45 centimetres long. One end was carved with a design 2 to 5 centimetres long, and 0.5 to 2 centimetres wide, and the uncarved section functioned as a handle. This intricate carving was made possible by imported metal tools, which Hawaiians quickly recognized as useful for refinement of traditional techniques and elaboration of their aesthetic traditions. The stamps were skilfully manipulated so that the tiny designs were placed in groups (by printing them end to end, side to side, or at angles) to form a larger design. Large designs, such as triangles, were filled in with small varied motifs. The top layer of design is readily apparent, but as the watermark impressed from the beater is visible only when held to the light, we find the subtle layered indirectness characteristic of classical Hawaiian art [68]. Complicated designs derive from negative space left between stamps. A further elaboration was perforation: an undyed underlayer of cloth had affixed to it an upper layer of coloured cloth in which a design has been cut through.

The introduction of European cloth and ideas stimulated a new art tradition in the form of Hawaiian quilts, which has become ever more popular. Missionary wives introduced the art of making quilts in the

68

Hawaiian 19th-century barkcloth showing watermark and stamped designs.

1820s, and Hawaiian women quickly took up this new sewing technique, probably because they saw in it an almost exact correspondence with barkcloth bed covers. The similarity lies particularly in the two layers of design. Whereas barkcloth has an overall watermark design that permeates the whole sheet and a second design printed on the upper surface [**68**], a quilt has a stitched design sewn through the entire quilt and another design appliquéd on the upper surface. Thus, elements of barkcloth fabrication were carried into the quilt tradition and are still part of the living art of the community.[14] Quilting was also introduced to other parts of Polynesia and became particularly creative in the Cook Islands and Society Islands, where it is known as *tivaevae* and *tifaifai* respectively. Here quilts have replaced barkcloth for ceremonial presentations, weddings, and funerals.

Rapa Nui Barkcloth Sculptures

Barkcloth in Rapa Nui, called *mahute*, was rare and valuable, as plants for its manufacture did not grow well. Rapa Nui chiefs showed their status by wearing barkcloth cloaks and belts formed of oval turtleshell plates enclosed in lengths of barkcloth. Rapa Nui people were especially anxious to obtain barkcloth when Cook's second Pacific voyage called there; Tahitian barkcloth was exchanged for feathered head-dresses and other objects.

69
Two Rapa Nui barkcloth sculptures (early nine-teenth century).

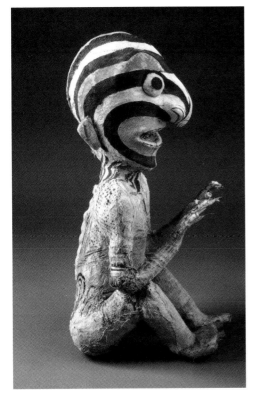

Especially rare were sculptures made of a sedge and covered with barkcloth. Only seven such constructions are known; four of them are in the Peabody Museum, Harvard University. One of the Peabody figures is essentially naturalistic in form [69]; although the face is reminiscent of a bird face in profile (and has similarities with the Māori *manaia*), the body is rounded, and the hands are distinctly human. The back has a well-formed vertebral column with distinct vertebrae, which continue up over the top of the head (similar to some Hawaiian figures). The second body form of barkcloth figures is known from two examples, in the Peabody Museum, Harvard, and in the Ulster Museum, Belfast. In this form, the head is quite naturalistic in its proportions, but the body is flat [69] and resembles the flat bodies of the female wooden *moai papa* [59].

Barkcloth figures appear to be receptacles for the ancestral gods and were high status versions of the lesser-ranked wooden figures.[15] They could be worn by chiefs in the same way that lesser-status individuals wore wooden figures around their necks during feasts and on various ceremonial occasions.

Although we have no information about the use of the two barkcloth headpieces from the Peabody collection [70], such objects would be appropriate to cover the sacred head of a high-status person, and add to his sacred *mana*. The important elements are the emphasized overhanging eyebrows, the inlaid eyes, the bulbous cheeks, and the delineation of the mouth, which are also the important sculpted features of the wooden figures (Chapter 3).

West Polynesian Barkcloth

Barkcloth in West Polynesia is made by a pasting technique, and designs are added by rubbing over a stencil or rubbing board. Each piece of inner bark is beaten separately, and then several pieces are pasted together with a paste made from a plant such as arrowroot.[16] In Sāmoa, barkcloth (*siapo*) was made only of the inner bark of the paper mulberry plant and was produced in relatively small pieces (that is, compared to Tongan and 'Uvean barkcloth). *Siapo* is decorated in two ways: by rubbing dye over the cloth that is placed on a design board (*'upeti*), and highlighting parts of the rubbed design by overpainting (*siapo tasina*), or by freehand painting (*siapo mamanu*).[17] The famous twentieth-century *siapo* maker Mary Pritchard (1905–92), who learned her craft in the 1920s, used these same terms.[18] A third category, called *siapo vala*, is used for a wraparound skirt. These pieces are rubbed on the *'upeti*, and the design is finished by creatively highlighting aspects of the design transfer by overpainting.[19]

In examples from the nineteenth and early twentieth centuries, the designed area is usually divided into squares, filled with geometric motifs often based on floral patterns. This designed area was

70

Barkcloth headpiece from
Rapa Nui (early nineteenth
century).

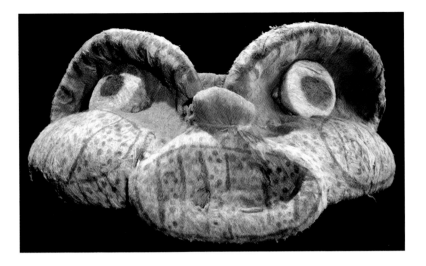

sometimes bordered on two sides by a plain brown strip about the width of the squares. Besides floral designs, motifs include geometric squares and triangles, divided and decorated in various ways with circles or dots, and crescents. Some of these motifs are given names, such as pinwheel (*pe'ape'a*), flying fox (*pe'a*), jellyfish (*'alu'alu*), and star *(fetū)*.[20] Although motifs have been given names, we do not know whether originally these names were invariable, if they varied from barkcloth maker to barkcloth maker, or if they derived from the beholder.

Some *siapo* have the remains of a yellow dye that appears to be turmeric, which in some parts of West Polynesia has a religious ritual significance. In Sāmoa, turmeric (*lega*) retains an aura of sacredness and is found in place names such as Sālega (sacred turmeric). Pratt's definition of *potu* as 'the *siapo* screen from behind which an *aitu* [spirit] spoke' opens the possibility that some *siapo* pieces had a similar ritual function to their counterparts in Fiji, where a piece of barkcloth hung from the rafters of the godhouse (*bure kalou*), and served as a pathway for the god to descend to the priest.[21]

Some *siapo* motifs are similar to the form of the 'star mounds' used for the ritual sport of pigeon-catching and perhaps other rituals (Chapter 6). Seen from above, the mounds have a number of rays or arms, with actual and metaphorical shapes of animals such as octopus, starfish, turtle, and eel or snake, which can be associated with animals in the Samoan pantheon of gods, and associated with pigeon-snaring and the acquisition of wives. With the coming of Christianity, designs may have served as remembrance of things past, such as the old gods and their association with ritual mounds and specific chiefs. By the end of the nineteenth century, wearing *siapo* with such designs may have been an effort to imbue the present with a sense of significance of the past—of carrying the past into the present.

Now, in the twenty-first century, *siapo* designs have been recycled by Fatu Feu'u, a Samoan artist living in New Zealand. Using Samoan barkcloth motifs and their overall design layout in adjoining squares, along with Lapita pottery motifs and other Polynesian motifs, he has made his mark on modern art with large-scale prints and paintings [**71**, **138**].

Little is known about early Niuean barkcloth, *hiapo*; the earliest extant pieces are from the second half of the nineteenth century and were collected by missionaries. Most researchers attribute the introduction of barkcloth as known to Niue in historical time to Samoan missionaries, who taught Niueans the Samoan method of making barkcloth and introduced the poncho (*tiputa*), which had previously been introduced to Sāmoa from Tahiti.[22] However, it is equally likely that the Niueans traditionally used barkcloth; designs from the earliest known pieces are similar to those on Tongan barkcloth.

Characteristic of Niuean *hiapo* design is a spiral motif that radiates in four or eight crescentic lines from the centre of a square—essentially curving the four or eight straight lines characteristic of Samoan and Tongan motifs formed from crossing a square diagonally, and/or vertically, and horizontally. Other motifs are concentric circles, concentric squares, and squares divided into eight triangles, some or all of which are filled with crescents that diminish in size. Niueans introduced writing along the edges and into the designs, and, most importantly, Niueans introduced naturalistic motifs and were the first Polynesians to introduce depictions of human figures into their barkcloth [**72**]. The human figures usually appear as a series of foci as

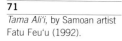

71

Tama Ali'i, by Samoan artist Fatu Feu'u (1992).

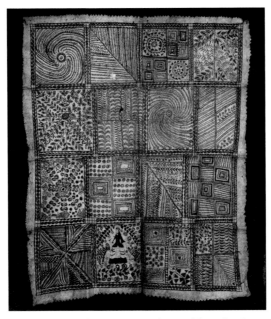

one or more of the squares formed by a horizontal and vertical grid that divide the whole piece into a series of smaller areas, which are often done in a different 'style' from the surrounding more geometric and plant-related designs. One of the most compelling of these foci squares is a set of five people, perhaps a family, which occupies one corner of a poncho in the Bishop Museum [**73**]. These people, of different ages and sexes, wear feather headdresses and hold their arms in two dance positions—three have their arms held to the sides with lower arms bent upwards, and two (along with another individual placed higher up in the poncho) have their arms lowered and their upper arms close to the body. Perhaps these foci allude to the enactment of an event: metaphors and allusions for which we no longer have the text.

A piece of *hiapo* with a human figure in the British Museum is dated 1887 by a printed date on the cloth—a very early date for the incorporation of naturalistic designs in West Polynesia. It appears that although Niuean designs may have been imported from or influenced by Tonga and Sāmoa, these design concepts were transformed by Niueans and in turn influenced the design systems of Tonga and Sāmoa.

On a more contemporary note, John Pule (b. 1962), a Niuean artist in the New Zealand diaspora, is a creative force in Polynesian art today; his work can be found in galleries and private collections of many parts of the world. Inspired by the *hiapo* designs of Niue, he has creatively taken human figures and other naturalistic motifs and recycled them into his contemporary artistic works. An echo of the overall design of Niuean barkcloth in horizontal and vertical squares can be seen in his prints and paintings [**74**]. The vertical lines sometimes disappear, and then all lines disappear. The squared design foci, however, are still

73
Barkcloth poncho from Niue and detail (late nineteenth century).

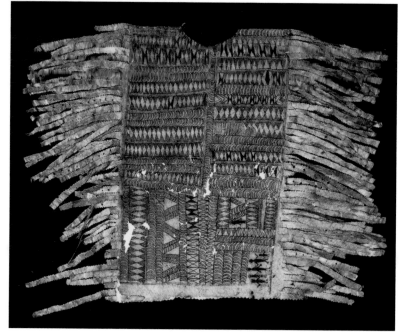

there. Buildings, chairs, fish and other animals, and especially people are transformed from *hiapo* to pencil, pen, prints, and oil on canvas.

Pule was particularly influenced by the 'family' from the corner of the poncho in the Bishop Museum, and similar groups of people inhabit Pule's work.[23] Like the foci in the *hiapo* pieces that are done in a different style from the surrounding more traditional designs, in Pule's work the fine-lined people and other representations contrast with the rest of the more abstract work. Unlike the barkcloth designs, in which the motifs cannot easily be read today and seem to have no connection with one another in meaning, Pule's canvases and prints have an overall meaning and are often part of a series with an overarching theme. Indeed, although Pule may have been inspired by an artistic dialogue with his ancestors, his works take this dialogue into the diaspora of New Zealand and the world. He has shifted the aesthetic concepts from metaphor and allusion to depiction, which can more readily be understood. In the mid-nineteenth century, Niueans dialogued with Tongans, Samoans, and missionaries, resulting in a Niue *hiapo* aesthetic system, which in turn influenced barkcloth design in Tonga and Sāmoa. John Pule, in turn, transformed this aesthetic system into his own diaspora of New Zealand and beyond.

Tongan barkcloth (*ngatu*) is still made in great quantity [**18**]. The geometric motifs from the eighteenth and nineteenth centuries have been entirely transformed by the addition of representational designs. The traditional designs based on metaphors, such as the *manulua* motif (also important for baskets, Chapter 2), have been incorporated

74
Part of *Pulenoa Triptych* (1997). Lithograph by Niue artist John Pule.

4/8

into contemporary *ngatu* as decorations of representational designs that incorporate place, genealogy, and event. The designs record new introductions, such as gramophones, bicycles, and electricity; they preserve the memory of historic sites that no longer exist; they objectify and celebrate the monarchy. During the Second World War, aeroplanes were introduced into *ngatu* design, to commemorate the purchase of Spitfire aeroplanes for the British airforce.[24]

Presentation of Textiles in Polynesia

Barkcloth is intimately associated with the aesthetics of presentation. Mangarevan wood sculptures [124] were holders for barkcloth streamers and other offerings. Barkcloth was often introduced attached to a person of rank and then presented in a dramatic flourish. In Fiji, a chief presents himself to a higher chief clothed in hundreds of feet of narrow barkcloth [7] and disrobes, either by spinning to unravel wrapped barkcloth or by dropping a huge looped barkcloth dress as an aesthetic gesture in honour of the receiving chief. In 1840, 'The chiefs of Kandavu appeared, each encircled with many folds of tapa and mats . . . [each of-whom] after disburdening himself of the tapa in which he was enveloped, gave place to another, and so on to the last . . . and the king took especial care to place the new acquisitions among his valuables.'[25]

In 1877, Theodore Kleinschmidt described and illustrated a similar ceremony in which the chief of Nadrau wore 180 metres of barkcloth for presentation [75]. Barkcloth (*masi*) was considered a sacred textile and was often a marker of transition and transformation and a principal valuable in ceremonial exchanges. In 1985, Marshall Sahlins described the installation of the Tui Nayau as paramount chief of Lau, Fiji. The new title-holder is considered to be a 'stranger-king', who repeats the legend of the ancestral holder of the title who came to power as a stranger from the sea. At various points, he is led along a path of barkcloth by local chiefs of the land.

At the kava ceremony constituting the main ritual of investiture, a native chieftain will bind a piece of white Fijian tapa about the paramount's arm. The sequence of barkcloths, together with the sequence of movements to the central ceremonial ground, recapitulate the correlated legendary passages of the Tui Nayau from foreign to domestic, sea to land, and periphery to center. The Fijian barkcloth that in the end captures the chief represents his capture of the land: upon installation, he is said to hold the 'barkcloth of the land' (*masi ni vanua*).[26]

Sahlins goes on to explain that the 'chief's accession is mediated by the object that saliently signifies women' and that his acquisition of the 'barkcloth of the land' signifies that 'he has appropriated the island's reproductive powers'.[27]

75

Tui Nadrau dressed for a
ceremonial presentation
of barkcloth, Fiji. Drawing
by Theodore Kleinschmidt
(1877).

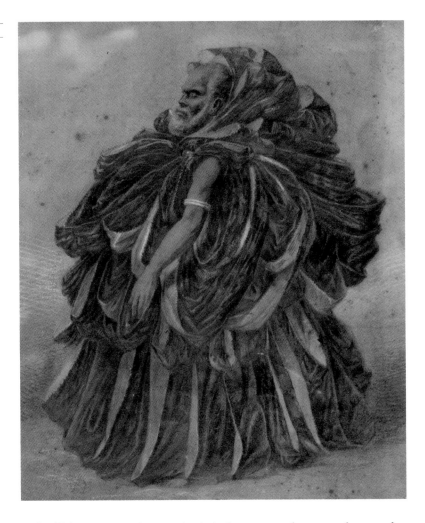

In Tahiti, not only was barkcloth presented wrapped around a
high-ranking individual, but it was accepted in the same manner,
unwound from the giver and rewound onto the receiver. No Tahitian
gift presentation was complete without a large piece of barkcloth.

In Sāmoa, John Williams recorded a presentation to missionaries:
'As soon as we had taken our seats, Malietoa made his appearance,
bringing in his hands two beautiful mats, and a large piece of native
cloth, one end of which was wrapped round him, and the other formed
a train, which an elderly female bore lightly from the ground.'[28]

Māori Cloaks: A Warm Alternative to Barkcloth

In the harsher environment of New Zealand, the more widespread
Polynesian tropical plants did not flourish, and the Māori elabo-
rated their technology to deal with indigenous plants, such as flax
(*Phormium tenax*). Cloaks were made using weft-twining techniques,
which varied for the body of the cloak, shaped to drape on the body

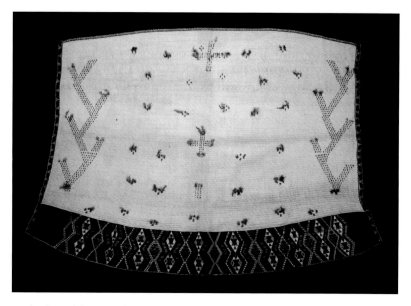

with the addition of extra rows that did not extend the full width of the cloak, and of *taniko* borders, which incorporated designs by adding different-coloured elements or changing the direction of the twining [76]. Like Tongan fine mats, Māori cloaks absorbed the sacred qualities and *mana* of their owners and were used to cover the dead during mourning rituals.

Textile Texts in Micronesia

It is for loom-weaving that Micronesian textiles are best known. Simple forms of back-strap looms were used in Kosrae and Pohnpei. They were strung with a continuous spiral warp that encircled a warp-beam attached to a frame and a second unattached warp-beam (or breast-beam); these were separated from each other by a distance of half the desired finished length of the fabric. The breast-beam was tied to a strap that encircled the waist of the weaver, whose body tension held the warp taut. The weaving proceeded by passing the weft yarn through an open shed with fixed heddles that separated threads of the upper plane of the circular warp and moving the circular fabric around the warp-beams. In other areas, such as the Marshall Islands, the continuous spiral warp was wrapped around a series of wooden pegs set into a benchlike loom.

The resulting cloth was varied in design, colour, and decoration. Fibres used were primarily those from banana stalks and the inner bark of the hibiscus tree. Traditional colours were black, red, and yellow, but European dyes in blue, purple, green, and a brighter red were introduced early. Decoration consisted of shell and glass beads and European yarn or thread unravelled from European cloth.

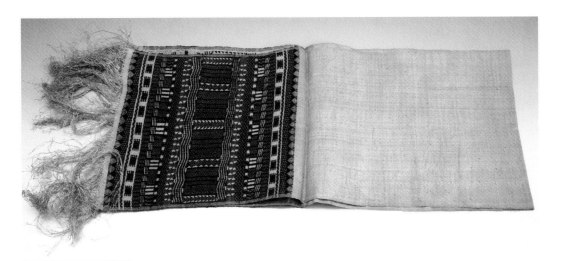

77
Ceremonial cloth from
Fais Island in the Western
Carolines (nineteenth
century).

A nine-strand band pattern on women's skirts in Fais, an island in the Carolines, derives odd-number symmetry by successive bifurcation from centre to edge. This design organization is replicated in traditional tattoo patterns, architecture, canoes, and village plans based on dual opposition and the separation of villages into chiefly and commoner sides. These designs are also found in the elaborate decorated borders of Fais Island shrouds [**77**]. Woven of banana and hibiscus fibre in the style of women's wraparound skirts, rather than being worn, they were presented to the chief, who imbued them with sanctity by placing them on his spirit-shelf for four days as an offering to his ancestral spirits. The shrouds were then used for investiture, initiation, and burial of men of rank.[29]

Pohnpei and Kosrae were the homes of fine loom-woven textiles, especially narrow belts with woven patterns with shell and glass bead decoration. These banana-fibre belts were about 15 centimetres wide with warp so fine that they sometimes numbered thirty warps per centimetre. In Kosrae, the design was strung into the warp by tying in different-coloured threads, while the weft primarily bound the warps together into a fabric. In Pohnpei, extra wefts added designs with a brocading technique.

In the Marshall Islands, famous for their canoes and navigation stick charts (Chapter 6), the women excelled in two-dimensional designs of plaited dress mats. About a metre square, designs were worked in with darker-coloured hibiscus fibre forming bands around a central undecorated section. These pandanus-leaf dress mats (*ir*) were worn in pairs by women; one mat hung like an apron in front, and the second mat overlapped it back to front. Both were held in place by a cord belt [**78**]. The outer decorative band of the mat often consists of a series of vertically stacked horizontal bars aligned to a section of 'fire adze' motifs. The design elements vary, but the arrangement follows a

Woman wearing dress mats,
Marshall Islands (early twen-
tieth century).

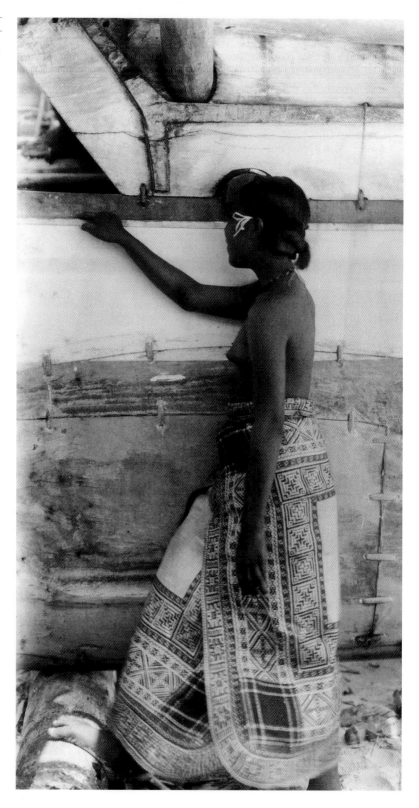

definite pattern of several parallel bands of decoration in red and black. The design motifs of diagonal lines, diamonds, chevrons, zigzags, triangles, squares, and crosses are interpreted quite differently by different individuals. Thus, similar designs might be interpreted as an eye, a fish, or a turtle, but the regularity of design organization within an established pattern illustrates creativity within the recognized aesthetic system.

The traditional importance of women in Micronesia is clearly seen in the role that woven and plaited materials played in wealth, tribute, and exchange. Many Micronesian societies were matrilineal, and individuals traced their ancestry, titles, access to knowledge, and wealth through the mother's line. A type of cloth woven by women on Pohnpei was so valuable that it could be exchanged for a canoe.[30] Women's woven valuables were integral to political and religious presentations to the chiefs, and the food, floral garlands, and coconut oil made by women and used at feasts were the goods that integrated the society.

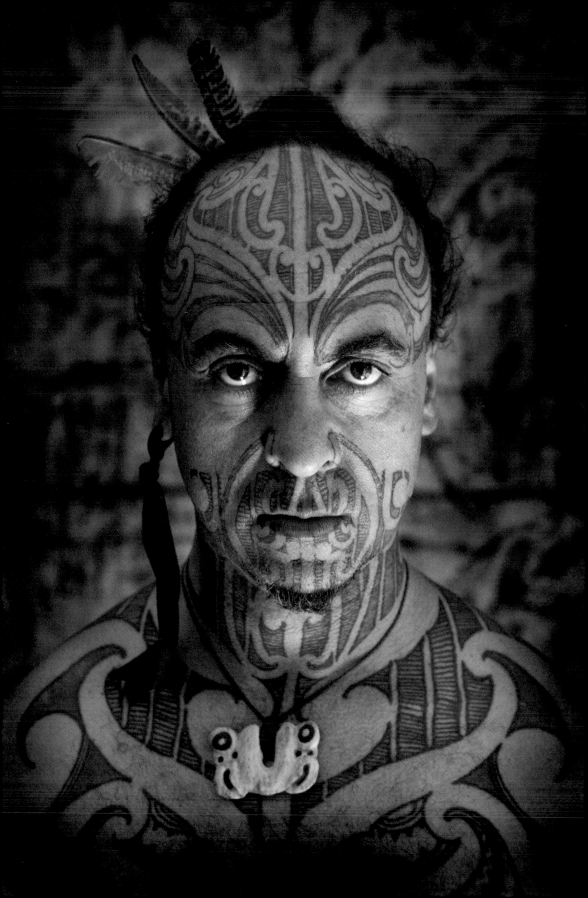

Adorning the Adorned

Tattoo, Ornaments, Clothing, Fashion

5

> The drummers do not beat the drums
> So the artists do not soil their fingers with paint.
> They shall not hear, not hear the drumming
> While they design the lines, the lines, the lines.
> Design well the lines, you tattooers.
>> (From a Marshallese tattooing chant)

Presenting and adorning the body is an important aspect of Polynesian and Micronesian art. The body itself is adorned with tattooing [**79**], and clothing and jewellery is a secondary adornment. New fashions displaced old ornaments and pieces of clothing and these became heirlooms, or items for trade and sale. Each culture had its own styles and fashions, and in each the meaning and symbolism was different.

Tattoo and Jewellery in Micronesia

The body as aesthetic object is an important Micronesian concept [**19**]. In the Marshall Islands, tattooing was done with aesthetic intent: 'Tattoo did not change or disfigure forms; it harmonized with the form in decorative designs and brought out beauty.'[1] The Marshallese believed that the gods of tattoo gave this art to the Marshall Islanders to make them beautiful, and gave them the following message:

You should be tattooed so that you become beautiful and so your skin does not shrink with age. The fishes in the water are striped and have lines; therefore, also human beings should have stripes and lines. Everything disappears after death, only the tattoo continues to exist; it will surpass you. The human being leaves everything behind on earth, all his possessions, only the tattooing he takes with him into the grave.[2]

The gods were called upon the night before, and if an audible sound in agreement was not heard, the operation was not undertaken; if the gods were not heeded, the ocean would flood the island and the land would disappear.

Besides being a decorative device urged and sanctioned by the gods,

(a) Tattooed chief from
the Marshall Islands.
*Larik chef du groupe des
îles Romminoff.* Coloured
lithograph after a drawing
by Louis Choris. Plate I in
*Voyage pittoresque autour
du monde* (Paris, 1820–2).
(b) Tattooed woman from the
Marshall Islands. *Femme
du groupe des îles Saltikoff.*
Coloured lithograph after
a drawing by Louis Choris.
Plate V in *Voyage pittoresque
autour du monde* (Paris,
1820–2).

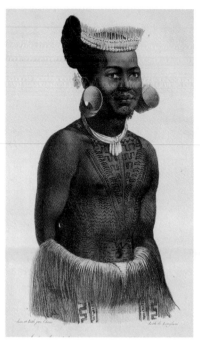
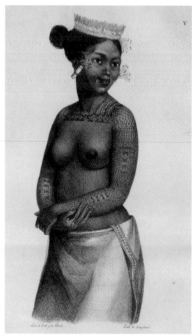

tattooing was embedded in social and economic life. Marking a boy's elevation to manhood, the beauty of his tattoo attracted women to his manliness and demonstrated his ability to endure pain. Parts of the tattoo are usually covered by clothing and can be seen only at intimate times. The great chiefs had the finest ornamentation, and facial tattooing to cover the wrinkles of age was a prerogative of the chiefs. Chiefs' wives had the fingers and back of the hand tattooed. The extent and beauty of the designs was dependent on offerings to the gods and the necessary payments to the tattooer in food, mats, and a feast.

A tattooer's inspiration was regarded as a gift from the gods, and he required complete silence while he drew the preliminary design. Tattooing began with a great chief and then moved on to the commoners. The tailfeather of a tropicbird or the midrib of a coconut leaflet served as an implement for the preliminary drawing. The tattooing chisels, made of fish or bird bones, were dipped in dye made of burned coconut sheaths mixed with water, placed on the skin, and struck with a mallet made from the mid-stem of a coconut leaf or other piece of wood. The blackness of the sea swallow (noddy tern) was emulated for colour, and the lines of a butterfly fish were the model for the design. The Marshallese word for tattoo (*ao*) means to draw lines; and straight and zigzag lines were the basic elements [**80**]. A breast and back tattoo took about one month and was very painful. The flesh swelled, and the tattoo was rubbed with coconut-juice medicine and covered with healing leaves. When the preliminary drawing of the design was finished, songs accompanied

81

Micronesian jewellery (late nineteenth and early twentieth centuries).
(a) Shell belt from Pulusuk, Caroline Islands; ear ornament of coconut shell and seashell, Chuuk.
(b) Coral necklace with turtleshell pendant, Arno, Marshall Islands; shell necklace, Arno, Marshall Islands; coral necklace with teeth, Yap; necklace of red beads and teeth, Kiribati; coral and shell necklace, Chuuk.

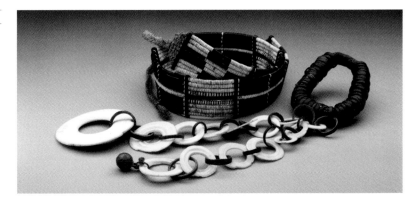

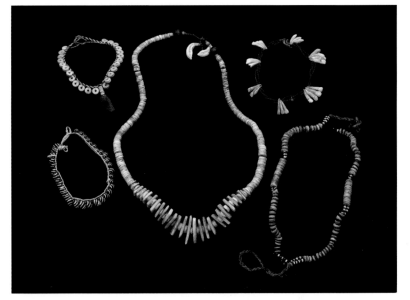

by drumming and handclapping were performed to overcome pain, and the face of a tattooed man was covered with a special mat. Male tattooing adorned chest, back, arms, shoulders, neck, face, thighs, and genitals, depending on preference, rank, and wealth, while women were tattooed on shoulders, arms, and hands.

Permanent ornamentation indexes one's place in society and enhances the body as an object to be admired and evaluated apart from its temporary ornaments and clothing. In the Marshalls, the clothes that adorned the tattooed bodies of men and women were covered between the waist and knees with finely woven wraparound skirts and belts made from pandanus, banana, and hibiscus fibre. They carried plaited fans, and wore decorated combs carved from wood and fresh leaves and flowers. Coconut oil provided shine and scent to the skin. Coconuts also provided jewellery from coconut shell and fabric for ritual clothing. The sea furnished shell ornaments, some of which were a form of currency, and included belts, necklaces, bracelets, and

ADORNING THE ADORNED II3

earrings featuring orange *Spondylus*, white *Conus*, white *Trochus*, and other shells, along with coloured coral and turtle shell [**81**].

Elegantly tattooed and elaborately dressed, groups of singers and dancers perform for the gods or an audience assembled for entertainment in the contexts of feasts and competitions [**80, 14**].

Polynesian Tattoo

Tattoo was widespread in Polynesia and reached high points in the Marquesas, among the New Zealand Māori, in Sāmoa, Tahiti, Hawai'i, and Rapa Nui. The Polynesian term *tatau* (or some variation of this term) is the origin of the English word *tattoo*. Many Polynesian tattoo designs descend from designs found on Lapita pottery,[3] and its antiquity in Polynesia is unquestioned. In the past several years there has been a tattoo renaissance in Polynesian tattoo [**79**], including an international festival of Polynesian tattooing in Ra'iatea, Society Islands, in 2000; a series of postage stamps was issued to commemorate the event [**82**].

The most extensive tattooing in Polynesia was in the Marquesas, where almost the entire body was tattooed; this was associated with gender, wealth, and status, but not necessarily chiefly rank. Marquesan tattoo marked social identity and the ability to pay and endure pain, and marked one's association with a particular group of warriors, graded associations, chiefs' banqueting societies, and groups of entertainers called *ka'ioi*.[4] Tattoos honoured special events, such as chiefly rites of passage, victories in battle, or participation in feasts, and commemorations of these events [**83**].

82
Stamps from French Polynesia commemorating the International Festival of Tattoo.

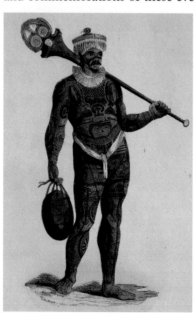

83
Tattooed man from the Marquesas Islands, from *Voyage autour du monde sur la Nadjedja et la Neva* (1813).

84
Wooden arm with tattoo designs from the Marquesas (mid nineteenth century). Collected by Robert Louis Stevenson.

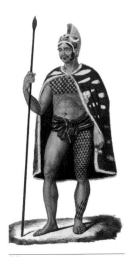

Tattooed Hawaiian chief in
feathered cloak and helmet.
Lithograph after a drawing
by Jacques Arago (1819).

In organizing the designs, the body was divided into zones that were subdivided into smaller sections. Patterns, often named, were fitted into the spaces. An overall symmetry characterized the zones on each side of the body, but within the zones the designs were often asymmetrical. These designs are also found on carved wooden legs and an elegant arm [84]. The legs may have been part of corpse stands or bed legs. The wooden arm was probably used as an offering stand and is similar to Mangarevan offering stands with human hands [124].

In Hawai'i, in contrast to most other Polynesian areas, tattooing was asymmetrical; sometimes one side of the face was tattooed, or one shoulder, or one leg [85]. The term for the technique was *kakau i ka uhi*, literally, 'to strike on the black'. Some designs had names: a tattoo colouring the right side of the body solid black was *pahupahu*. The Maui chief Kahekili, descendant of the thunder god Kānehekili, had this tattoo, as did his warrior chiefs and household companions. Kahekili's head was shaved on both sides of the central hair crest and tattooed with crescents (*hoaka*). Overarching and underarching crescents are tattooed asymmetrically on the left shoulder of a Hawaiian man depicted by Webber on Cook's third voyage. Tattoos were applied to one arm or one leg. Women were tattooed on the back of the hands, sometimes on an arm or leg, and occasionally the chest. Tattooing the tenderest parts of the body, such as the tongue, was practised to commemorate the death of an important chief. Hawaiian tattooing appears to have been a protective device, applied in conjunction with chanted prayers, capturing the prayer in the tattoo and offering permanent protection. The right arm especially needed sacred protection and help, as it was this arm—raised in a crescent—that threw the spear. Likewise, tattooing a row of dots around an ankle was a charm against sharks. In post-European times, some tattoos became decorative and symmetrical and included exotic motifs—hunting horns, goats, and lettering.[5]

Māori facial tattoo (*moko*) has fascinated outsiders since the time of Cook's voyages, when several tattooed individuals were depicted by Cook's artists [86]. The facial designs carved into the skin can be related to Māori woodcarving, both in design and technique, while the technique used for female tattoo and men's body tattoo was similar to tattoo techniques elsewhere in Polynesia. Women's tattooing was limited to the lips and the chin, while men's body tattooing was between the waist and the knees. Facial tattooing was sacred for high-born men of chiefly rank, who were *tapu* during the operation. They could not feed themselves, but were fed with carved feeding funnels. Māori designs, especially for the face, were individualized and were drawn as signatures to sign documents during the nineteenth century. Spaces to be covered were divided into zones and these further divided, giving an overall symmetry, which has been seen as the pairing of life/death and *tapu/noa*, elements of Māori culture that expressed

86

Portrait of a New Zealand man (1769). Pen and wash by Sydney Parkinson on Cook's first voyage.

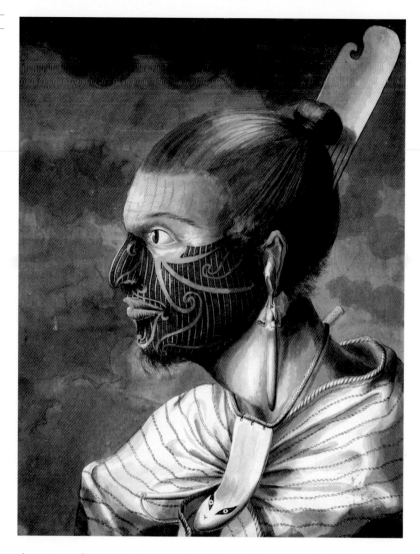

the unity of nature/culture and a fully social personality.[6] The design elements and their organization within the zones, however, was often asymmetrical, giving it an autographic quality. Tattooing varied from tribe to tribe and region to region, as well as over time. Although the classical curvilinear style of tattoo predominated during the nineteenth century, both vertical and horizontal parallel lines were also used, sometimes overlaid with curvilinear designs. Tattooing is found on the carved figures and houseposts of meetinghouses. The buttocks of ancestral figures have tattoo designs similar to the tattooed buttocks of important men. Today Māori tattoo has new life, with elaborate facial and body tattoo. George Nuku [**79**] was tattooed in 2003 by Haki Williams of Ngati Tuwharetoa descent, and, as a carver himself, uses tattoo designs in his artworks [**87**]. There is a feeling that tattoo makes people Polynesian: Māori artists have depicted Captain Cook

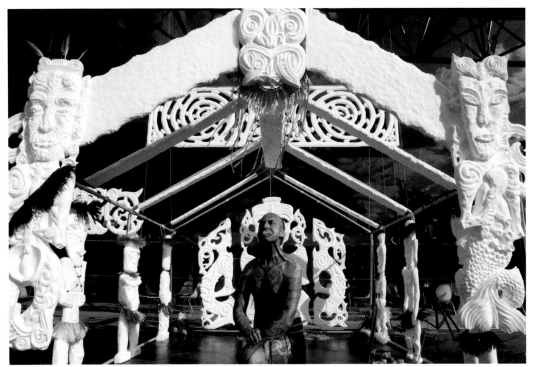

George Nuku in a traditional
Māori challenge gesture of
sticking out of the tongue.
He was tattooed in 2003 by
Haki Williams and kneels
in front of the polystyrene
house that he carved at the
Sainsbury Centre for the
Visual Arts, University of
East Anglia (2006).

with tattoo, and in 1999 a Samoan photographer, Greg Semu, depicted
Jesus Christ with Samoan tattoos in his *Crucifixion of Christ with tatau,
a Classical Study.*[7]

In the Society Islands, tattooing was associated with puberty for
both boys and girls. Applied to the buttocks of both men and women,
tattoo sometimes blackened the buttocks completely, emphasizing the
underarching crescent shape of the lower buttocks and the crescent
designs that were placed above the blackened areas.

Adornment and Clothing in Sāmoa

Men's tattoo designs in Sāmoa, traditionally associated with puberty,
extend above the waist and cover the thighs. Men of certain status
required tattooing; fine mats were given in payment. Today, tattoo is
found on any young man who can afford the pain and money. A man's
tattoo is exhibited when he accompanies a female dancer. Shedding
his shirt and tucking up his wraparound skirt reveal much of his
tattoo.

Samoan tattoo specialists were called upon to tattoo high-ranking
Tongans, especially the Tu'i Tonga, whose body was considered too
sacred and dangerous for Tongans to touch. One Tu'i Tonga, Fatafehi,
wished to be tattooed, and as no Tongan could do the work, he made
two trips to Sāmoa for this purpose. His first trip was to Manono
Island, where the first part of his tattoo was done; and his second trip
was to Manu'a, where the rest was completed. Fatafehi's nickname

was Fakauakimanuka (two times to Manuʻa), to commemorate his trips. On both occasions, the tattooers' bodies are said to have swollen up, and they ultimately died from having 'wounded' the Tuʻi Tonga's sacred body.[8] Two Samoan *ʻie toga* (fine mats) were acquired by Fatafehi during his tattooing in Sāmoa. It is a Samoan custom for a fine mat to be given to the tattooer; here it appears that Samoans gave fine mats to the Tuʻi Tonga, perhaps to commemorate the event.

Samoans highly value propriety and self-presentation. Their body aesthetic is especially important for individuals of high rank. At a marriage ceremony in Sāmoa in the early 1830s, the bride's

dress was a fine mat, fastened round the waist, reaching nearly to her ankles; a wreath of leaves and flowers, ingeniously and tastefully entwined, decorated her brow. The upper part of her person was anointed with sweet-scented cocoa-nut oil, and tinged partially with a rouge prepared from the turmeric root, and round her neck were two rows of large blue beads. Her whole deportment was pleasingly modest.[9]

Since the mid-nineteenth century, a headdress (*tuiga*) has been worn by the *tāupou* or *mānaia* for *kava* mixing and dancing [**88**]. It classically consists of a barkcloth cap surmounted by human hair, feathers, a headband of nautilus shells, decorated sticks, and other elements. Orators perform wearing barkcloth skirts, holding a staff (*toʻotoʻo*), and displaying a flywhisk (*fue*) over one shoulder.

Ornaments include necklaces of carved ivory pieces shaped to curved points and strung. Fans of pandanus leaves and coconut fibre were decorated with human hair. Decorative combs were made from coconut midribs bound together with fine sennit and enhanced with beads or carved of wood in delicate openwork.

Samoan Society

Sāmoa today consists of two nations, an independent Sāmoa (formerly a colony of Germany and later administered by New Zealand) and American Sāmoa, a territory of the United States. The 210,000 people (some 170,000 of Western Sāmoa and 40,000 of American Sāmoa) inhabit about 300,000 hectares divided among ten major islands or groups of islands. Traditionally a system of *tui* titles provided the conceptual framework for rank and status, but the political system was basically decentralized. Each village had its own council of chiefs, and each family had its own family chief (*matai*) who organized agriculture, fishing, cooking, and house-building. Each level included talking chiefs (*tulāfale*), who specialized in speech-making, ceremonial duties, and protocol. Each village included a *tāupou*, a young chiefly woman, whose duties included the mixing of *kava*, and a *mānaia*, a young chiefly man, leader of the young men of the village. Today, the two Samoas have separate political systems based on different combinations of Samoan custom and Western democratic traditions.

Samoan young men dressed
as *mānaia*, wearing *tuiga*
headdresses (*c*.1900).

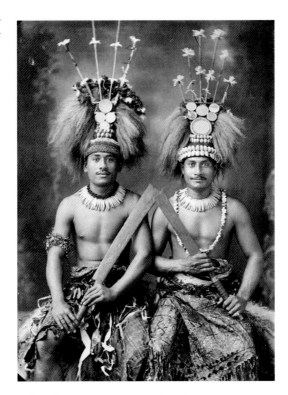

Adorning the Adorned in Hawai'i

In Hawai'i, the arts were visual indications of rank and helped to sustain social differences. Although the fabrication of sculpture virtually ceased with the overthrow of the state religious system in 1819, tattoo continued into the mid-nineteenth century, and the fabrication of status-elevating clothing continued in various forms throughout the nineteenth century. The twentieth century saw a renaissance and re-creation of many traditional forms of art which have become associated with Hawaiian identity.[10]

The most distinctive and visually spectacular Hawaiian works of art were feathered cloaks and helmets, feathered god figures, a feathered sash which carried with it the right to rule, a unique feathered 'temple', and feathered standards called *kāhili*, which heralded the presence of individuals of rank. Feathered cloaks, capes, and helmets were visual objectifications of social inequality. They were worn by male chiefs in dangerous or sacred situations and carried the social metaphor that one's genealogy is one's sacred protection [**89, 6**]. The feathers were primarily red from a honeycreeper, the *'i'iwi* bird. Designs were incorporated as the feathers were tied to the backing of knotted fibre by adding yellow feathers, or occasionally black or green feathers from other honeycreepers or honeyeaters. Yellow feathers came from birds that were primarily black—the yellow tufts were removed and the bird released—making yellow feathers rare and valuable.

89

Hawaiian feathered cloak
and helmet (early nineteenth
century).

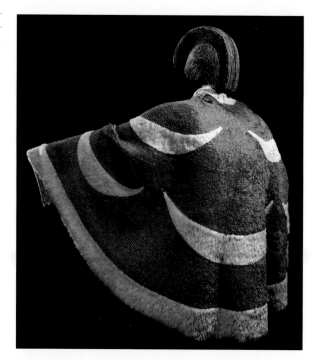

Feathered helmets, *mahiole*, were sometimes worn with the cloaks [85]. Made of a basketry foundation, they were of two main styles—one with a wide low crest, the whole of the helmet being covered with long, round, stiffened fibre strips, to which feathers were attached; the second with a high narrow crest that was covered with a netting to which feathers attached. Feathers were red, black, green, and yellow. Feathered head and neck ornaments (*lei*) in a variety of colours and designs were made and worn by women.

Hawaiian featherwork was part of a system of sacred symbols and ritual objectifications. The term *symbol* is generally regarded as something that stands for or represents something else. The term here refers to the visible manifestation of invisible concepts or knowledge, and specifically to concepts about embodiment of the divine. In Hawai'i, the divine was transmitted genealogically from the gods to chiefs, whose bodies were vessels of divine sacredness (*mana*). The most sacred parts of a chief's body were the head (especially the top of the head) and the back (especially the backbone). It was necessary to protect these body parts during dangerous or sacred situations, and feathered helmets, cloaks, and capes protected and drew attention to them. Important elements were colour, design, length, shape, and backing.

The process of making feathered pieces was related to making an even more sacred object that embodied the divine, an *'aha* cord. The Hawaiian concept of *'aha* refers not only to cordage made of plant fibres (especially coconut fibre), human hair, or animal intestines, but

also to a prayer or service whose efficacy depended on recitation under *kapu* (*tapu*) without interruption.[11] *'Aha* cords were described in the *Ku'oko'a* newspaper 19 July 1884:

The cords were made by chiefs and kahunas [priests] with the worship of certain gods. They were of sennit braided tight into a rope, some with a depression down the center, some like fish nets, others like the koko carrying net for wooden calabashes and still others with fringes. There were many kinds made by chiefs and priests who placed their faith in the gods they worshipped. The chiefs took the sennit cord as a sign of their high rank, of a lineage from the gods and also to observe the kapu of the priesthood.

In making an *'aha* cord, one or more priests chanted a prayer while braiding the cord. 'All of the chief's priests concentrated their prayers on it as it was being made under *kapu*. The priests forbade all those outside to enter, nor could those on the inside go out while the *'aha* was being put in place, for the penalty was death.'[12] The braiding captured the prayer and objectified it and became a 'tool' of the *kahuna*.[13] It would be especially useful for chiefs to carry or wear such a prayer during sacred or dangerous situations.

The base of the feathered cloak was *nae*, a net structure of *olonā* fibre (*Touchardia latifolia*). This backing was often in small pieces, made by several people of varying skill. If the *nae* was fabricated while chanting prayers, it could entangle or capture (*ho'oheihei*) them to serve as perpetual prayers to protect its wearer. The addition of red feathers gave the *nae* even more sanctity. Red was the sacred colour in Hawai'i, as elsewhere in Polynesia, and red feathers were considered among the most sacred natural products.[14]

Although the term for feather cloaks and capes is *'ahu'ula*, 'red shoulder garments', most feathered pieces are a combination of red and yellow.[15] Sacred red feathers attached to a perpetual-prayer backing constituted protection for the sacred backbone of a chief. Red feathers activated that to which they were attached, including images of the great gods Kūka'ilimoku and Lono [**90**]. A temple ceremony, *kauila huluhulu*, focused on readorning the images with feathers.[16]

An important *tapu* called *kua'ā*, 'flaming back', prohibited approaching a chief from the back; breaking this *tapu* was punishable by death.[17] A feathered cloak might suspend this *tapu* in warfare, or in a procession when it was appropriate for individuals of lesser status to walk behind a chief. Feathered helmets offered protection for the sacred top of the head. The base of a helmet was intertwined *'ie'ie* (*Freycinetia arborea*) vine, activated by the addition of red feathers. Some helmets were entirely covered with feather-covered cords similar to *'aha* cords, and feather-covered cords were sometimes attached to the edges of the helmets.

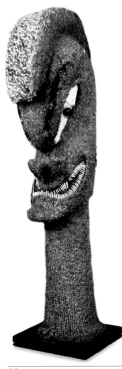

90
Hawaiian feathered god figure (late eighteenth century), collected during Cook's third voyage.

When examining designs on cloaks and capes, it is difficult to determine which is figure and which is ground, what are the designs and what are the spaces between them. Important design motifs were circles, crescents, and triangles. The designs and colours appear to be related to specific chiefly lines, and the foregrounding and backgrounding of the motifs changed over time. Information about design elements and their combinations was not recorded, nor do we know the 'grammar' of the underlying design system. We know who some of the cloaks belonged to and can therefore associate some relationships between designs and people. Circles (*pō'ai*) seem to be related to certain chiefs, especially Kahikili of Maui and Ka'eo of Kaua'i. Triangles seem to be associated with the chiefs Kalani'ōpu'u and Kamehameha from the island of Hawai'i. Many capes incorporate crescent designs [**89**].

Hoaka, crescent, is a powerful word. Besides a design used in the openwork carving on *pahu* drums [**55**] and a motif used in tattoo, it means to cast a shadow, to drive away, ward off, frighten, spirit, apparition, and ghost, as well as brightness, shining, glittering, and splendid. It is the term used for helmet crests, and has the figurative meaning of 'glory'.[18] During rituals, the arms of the human participants were raised skyward, forming crescents like those carved on *pahu*. Crescent designs could give additional sacred qualities to sacred red-feather-covered prayer-enhanced backings.

Feathered cloaks and helmets were made for specific individuals. The cloaks often began as short capes, probably for wear on a specific occasion, and could be ritually renewed by lengthening or adding important feathers as an overlay [**91**]. This is comparable to the ritual renewal of temples (*heiau*), which were rebuilt or refurbished for important occasions. The cloaks and helmets had touched the sacred

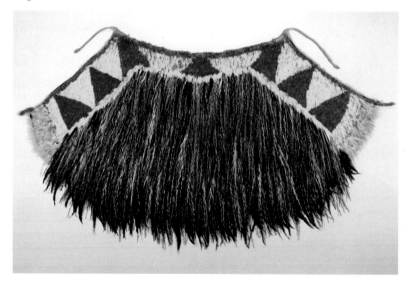

91

Hawaiian feathered cape (late eighteenth century), collected during Cook's third voyage.

bodies of the chiefs and carried their sacred power (*mana*). They were dangerous for others to wear or even touch.

Feathered cloaks could be acquired by appropriation or inheritance. If a chief was killed in battle, his cloak would be taken as a battle prize. After a chief's natural death, his cloak would be kept by his son, as a symbol of his legitimate acquisition of power. Liholiho (Kamehameha II) had three cloaks—one he inherited with the sacred *mana* of his father, Kamehameha the Great; one embedded the power of Kamehameha's paternal line in that it had been the cloak of Kekuaokalani (son of Kamehameha's full brother), taken as a battle prize by Liholiho, thereby consolidating his power; and one embedded the sacredness of Liholiho's mother's line, having belonged to Kiwala'ō (Liholiho's mother's father), taken as a battle prize by Kamehameha I.

It is unlikely that Liholiho (or any other Hawaiian) ever wore these cloaks because of the important *tapu* against wearing clothing that had touched the body of someone else, especially the body of a high chief. Clothing embodied personal *mana*, and individuals who did not respect prohibitions associated with clothing were vulnerable to sorcery.[19] An important clothing *tapu* was that a son could not wear the clothing of his father; nor could a daughter wear the clothing of her mother. A father could wear the clothing of his son, but apparently only if the child were not of higher rank through the female line. It was best not to wear clothing that had belonged to someone else if one did not want to make one's body vulnerable.

These ritual objects, dangerous to others and incompatible with Christianity, were transformed along with Hawaiian society during the late eighteenth and early nineteenth centuries. Material culture not only changed by importing and adapting Western objects, but traditional Hawaiian material culture evolved as part of changing relationships and changing categories to meet the needs of a changed society. Objects were part of the transformation of social relationships among people, the gods, and the universe. In pre-European times, authority in its ideal Hawaiian form derived from the power of the most genealogically prestigious chiefs, especially before the charismatic chief Kamehameha (*c.*1758–1819) acquired guns and powerful followers. Kamehameha operated by what was expedient, rather than by what was genealogically correct. He downplayed highest genealogical descent and its concomitant *tapu*, and promulgated the change from the notion that genealogical prestige gives power and therefore authority to the notion that power gives authority and therefore prestige. His son Liholiho (of higher rank than Kamehameha through his mother) introduced his own changes, such as the overthrow of the state gods and their restrictive *tapu*, including the *tapu* prohibiting men and women from eating together. The scepticism about traditional beliefs and practices that followed the influx of foreign ideas and the

unpunished lapses of *tapu*, induced at least some priests to support and encourage Liholiho. Within a few years, during which Christian missionaries arrived, the concept of 'power gives authority and therefore prestige' evolved further to 'chiefly status equals authority'. Status, rather vaguely defined and without the sanctity of the gods, became the norm.[20] Values and traditions that continue today derive from this concept. The bilaterally extended kin group (*'ohana*) grew in importance, as did the tradition of feasting without gender or rank proscription.

The primarily peaceful reigns of Kamehameha's successors, and the influx of foreign ideas, expanded values to emphasize the *'ohana*, based on kinship and the extended family. Along with social changes, objects of sanctity, protection, utility, ritual, and power took on expanded value as works of art in the Western sense. Prestige, power, authority, and status became more interchangeable and traditional Hawaiian objects became objects of value for the enhancement of status.

In pre-Christian times, shared cultural knowledge was necessary to understand what meanings were attached to designs or motifs, how they could be combined into patterned sets as a visual grammar, and how to decode the messages embodied in them. If chiefs were going to continue to wear feathered cloaks, it could be on the basis of tradition and aesthetics, rather than as objectified prayers—a concept incompatible with Christianity. Feathered objects retained their importance as status objects suitable for ceremonial occasions.

With the demise of the Kamehameha line of chiefs in 1872, the wearing of featherwork almost ceased, except for harmless replicas used by Hawaiian Royal Societies, such as Hale Nauā, for funerals and other ceremonial occasions. Featherwork pieces were acquired by Hawaiian monarchs to become what might be called the 'state cloaks and capes'. Queen Lili'uokalani posed for an 1892 photograph seated on her throne with a cloak over the back of it, but the primary use of featherwork pieces during the late nineteenth and early twentieth centuries was for funerals. The techniques of fabrication were all but forgotten. In recent years, the making of feather clothing has been revived; these pieces are considered art objects and are used primarily for display.

Nineteenth-century Hawaiians, like most people, wanted to be up to date. In 1818, Kamehameha wanted to be painted in his red vest, while the French artist Louis Choris wanted to depict him in his traditional clothing. Liholiho and his entourage wore European-style clothing during their visit to London in 1823, but the English artist John Hayter represented chief Boki wearing a feather cloak and helmet—and the cloak and helmet were left in England. Hawaiian self-presentation enlarged nineteenth-century traditions. The extended family, and values associated with it—especially feasts (*lū'au*)— became more

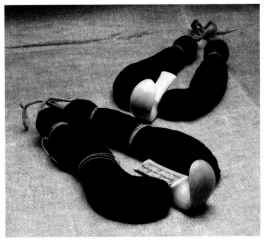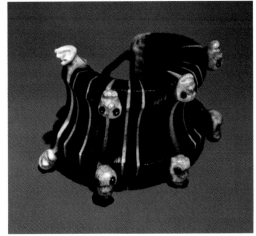

Two Hawaiian necklaces, *lei niho palaoa*, of ivory and human hair (early nineteenth century). Hawaiian bracelet of turtleshell and bone (late eighteenth century).

prominent than the eighteenth-century values associated with warring chiefs. During the eighteenth century, feathered cloaks were protective devices worn during sacred and dangerous situations; during the nineteenth century, Hawaiian chiefs wore feathered cloaks as visual expressions of status and prestige on ceremonial occasions.

With the coming of Christian missionaries in 1820, the life of objects became less sacred and more social and political. Since the mid-nineteenth century, these objects have become art in the Western sense of the term, and featherwork now plays a significant role in Hawaiian concepts of the past. Identification with these objects reveals how individuals and groups perceive themselves and want to be perceived by others. Today, mutual support, environmental conservation, and sharing are values associated with the extended family, while feather-cloaked 'chiefs' appear in replica during Aloha Week events and ceremonial occasions.

Ornaments, another social distancing Hawaiian form, are often strung on carefully made twisted or braided fibres of coconut or human hair [**92**]. Such ornaments may have carried metaphorical social and sacred power, derived from the materials from which they were made, as well as the process of making them. One *lei niho palaoa*, ivory hook ornament strung on braided human hair, was worn by Kamehameha's younger brother, Keli'imaika'i, when he dedicated the rebuilt temple to Kūkā'ilimoku, the war god. For this ritual, he surely needed protection and it may have been incorporated into his necklace. Bracelets were made of carved ivory pieces in the shape of turtles strung on human hair, or a series of carved pig tusks shaped and strung side by side, or pieces of turtleshell strung on fine fibre. An exceptional bracelet, thought to have descended in the Kamehameha line, is made of numerous pieces of turtleshell, interspersed with pieces of bone, some of which have been carved with faces [**92**]. There were also necklaces of a variety of shells and seeds and anklets of shells, seeds, or dog teeth.

93

Dress worn by the 'chief mourner' at the funeral of a high chief in the Society Islands (late eighteenth century).

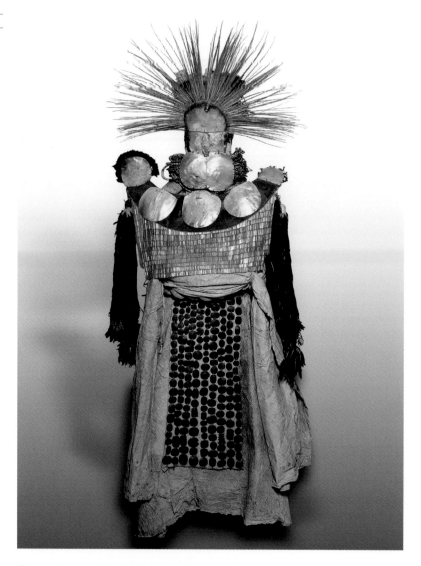

Funerals and Self-Presentation

Funerals were (and still are) important occasions throughout Polynesia. Self-mutilation by mourners, such as cutting off finger joints in Tonga, or cutting oneself with a shark-tooth implement and tattooing of the tongue in Hawai'i, were common. In Tonga and Sāmoa, hair is cut and ragged mats are worn. The September 2006 funeral of King Tāufa'āhau Tupou IV of Tonga revealed the still important rituals of pre-Christian sancity when the king's casket was turned over to the royal undertakers (*ha'atufunga*) for the final burial rites.

In the Society Islands, an elaborate ritualized performance of the chief mourner was a spectacular display of grief at the death of a chief or other important person. A priest or close relative of the high-ranking deceased brandished a shark-tooth-edged stave, wore an

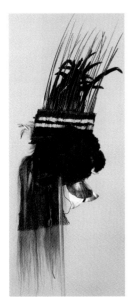

94
Headdress with tailfeathers of the tropicbird and other birds from Rurutu, Austral Islands (early nineteenth century).

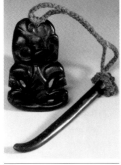

95
Māori pendants, greenstone on a flax cord (late eighteenth century).

elaborately constructed costume [**93**], and accompanied himself with a pair of pearlshell clappers. Two complementary crescents formed a spectacular visual centrepiece. A large wooden chest crescent was mounted with several large pearlshells. Attached to the bottom of the crescent was a sparkling chest apron, made of rows of thousands of tiny slips of pearlshell sewn together with fine coconut-fibre sennit. The mourner's face was covered with a mask of large pearlshells and/or pieces of turtleshell, with only a small peephole through which to see. The top pearlshell of this group was the base for the upper crescent, consisting of tropicbird tailfeathers. A barkcloth head covering held the mask in place. A long barkcloth apron covered with pieces of carved coconut shell was held in place by other pieces of barkcloth, which formed a skirt and ties. The dress was completed with a barkcloth cape and sometimes a feathered cape and tassels.

Ornaments and Objects of Authority

Clothing and ornaments demonstrated the sanctity, rank, and wealth of the people who wore them and the skill and patience of the specialists who made them. Materials used in Polynesian ornaments meant to endure were those of high value, either because of their sacred qualities—such as red feathers or hair—or because of their rarity—such as greenstone, whale ivory, turtleshell, pearls, and pearlshell. In addition, ephemeral ornaments were made of flowers (often sewn in elaborate, painstaking constructions), seeds, and other parts of plants.

Human hair had a sacred quality because it came from the *tapu* part of the body, either from ancestors or defeated enemies, thus capturing their *mana*. Human hair was used in wigs and headdresses, necklaces, fans, and belts. Feathers, especially tailfeathers of tropicbirds and red feathers of various kinds, were used in headdresses [**85, 94**], flywhisks, waist girdles, and rings. Human and animal teeth (including shark, dog, and pig) were used in necklaces, bracelets, head ornaments, and gorgets [**101**]. Coconut fibre was used in flywhisks, combs, and belts.

Rare materials, such as Māori greenstone, were used as earrings, pendants [**95**], weapons, and ceremonial adze blades. Whale-tooth ivory was used in necklaces [**96**], earrings, flywhisk handles, and presentation pieces. Whalebone was used for combs, weapons [**103**], and bowls. Turtleshell was used on headdresses [**97**], bracelets, and handles of feathered standards. In Tahiti, pearls were used as earrings, and pearlshells were used in necklaces, and on mourning dresses. Some of these materials were imported into Tahiti from the Tuamotus and Cook Islands, where they were considered valuables. In Manihiki, pearlshell was used for inlay. Rare shells were used as pendants, on headdresses, and to decorate dance costumes.

Dog hair was another status material in Polynesia. Māori cloaks were

96

Necklace of carved ivory pieces on coconut-fibre sennit, Austral Islands (early nineteenth century).

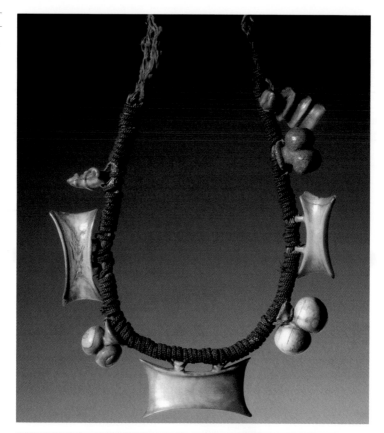

97

Headdress of feathers, pearlshell, and turtle-shell, Marquesas Islands (late eighteenth century). Collected during Cook's second Pacific voyage.

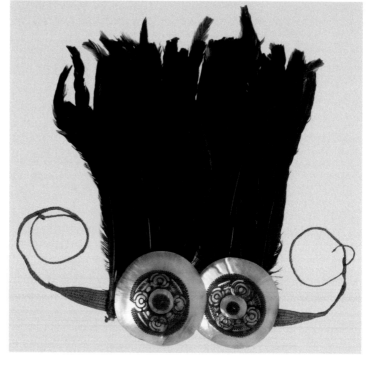

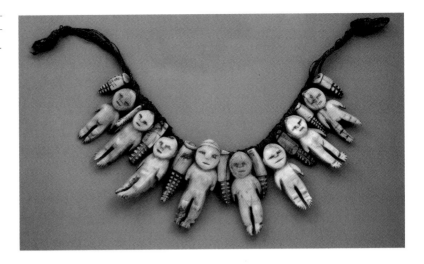

Necklace with carved ivory figures on coconut-fibre sennit from Fiji (late eighteenth or early nineteenth century).

in some cases completely covered with dogskin with the hair attached, or by pieces of skin or hair attached in small pieces to the corners of cloaks or throughout the cloak as tags or tassels. The body of the cloak was made by women, and the dogskin strips were added by men. Tahitian gorgets were outlined with a fringe of dog-tail hair [101].

Some of the most treasured objects in Fiji and Tonga were made of ivory, considered a most valuable substance. In Fiji, prepared whale teeth (*tabua*) were the most important ceremonial objects. Presented to a chief or other important person as a token of goodwill, loyalty, and reverence, they were a necessary part of ceremonial presentations concerned with birth, marriage, death, and for the departure or return from a long journey. In Tonga, ivory was carved into female figures and tiny objects that were worn as decorations by women of rank or carved as hooks that were used to hang important objects [2]. Some of these figures were exported from Tonga to Fiji or made by Tongan craftsmen resident in Fiji.

Perhaps the most remarkable ivory human figures from Fiji are a series of eight ivory pendants which form a unique necklace [98]. The figures are closely related in style to hook figures and the small ivory pendant figures from Tonga. Ivory-and-shell breast ornaments combine Fijian-style whalebone breastplates and Tongan shell necklaces into a form distinctively Fijian. The basic part of the ornament is a large pearlshell of Tongan style. This is extended around its edges with carved pieces of ivory and decorated on its surface with Tongan-style ivory pieces in the form of stars, abstract birds, or other simple shapes. These breastplates appear in Fiji about the 1830s and are products of Tongan craftsmen; the technique of tying the pieces together with coconut fibre derives from a Tongan and Samoan boatbuilding technique.

Beautifully made objects were displayed as status objects. Flywhisks [8], fans, and feathered standards were carried by men and women.

Serrated club from Mangaia, Cook Islands (late eighteenth century).

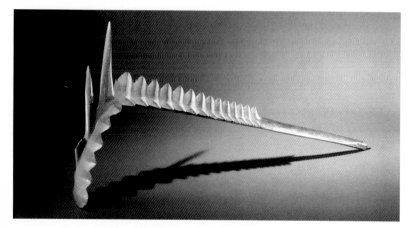

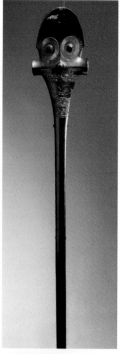

100

'U'u club from the Marquesas Islands (late eighteenth or early nineteenth century). The second set of eyes, below the crossbar, is formed of two turtles.

Staves of authority, beautifully carved and finished, were carried, usually by men; these staves often doubled as weapons, and weapons too were carried as staves of authority [83]. Weapons reached their high points in the Cook Islands, where they were carved as a series of crescents [99]; the Marquesas, where the carving was a series of human heads organized so that they formed other human heads or faces [100]; and in Tonga and Fiji, where weapons were completely incised and inlaid with ivory. After European contact, the stocks of guns obtained by Fijians were carved in the same manner as their clubs, and sometimes inlaid with ivory.

Self-Presentation in the Art of War

In Polynesia, warfare helped maintain chiefly power and prestige and extend political influence. Wars were fought for revenge and as an expression of ceremonial rivalry between villages. The Samoan word *talitā* was formerly used to refer to the use of a club manipulated to parry or shield from thrown spears.[21] Samoans carried out their battles at predetermined times and preceded them with ritual speeches and agreed-upon protocol. This ritual element of warfare can also be found in Māori ritual challenges, which are performed by warriors wielding staffs (*taiaha*).

The presentation of the self in warfare illustrated rank and wealth. In Tahiti, the highest chiefs wore a huge war bonnet, fronted with a feathered construction that formed an overarching forward crescent above the wearer's head. Complementing this crescent were two crescent-shaped chest and back protectors (*taumi*), which protected the vital parts from slingstones and other missiles. A base of sennit and wicker was covered with feathers, an outer fringe of dog-tail hair repeated a series of inner crescents of shark teeth, and pieces of pearlshell and feather rosettes were added [101].

In Fiji, specially fortified villages were encircled by banks and ditches. Huge war canoes were used in sea battles. Weapons included clubs, spears, slings, and bows and arrows. Muskets and cannon were added

Tahitian gorget of feathers, coconut fibre, shark teeth, dog hair, and shell on a sennit and wicker base (late eighteenth century).

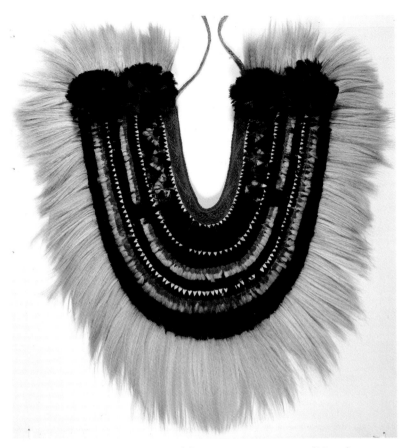

early in the nineteenth century. The most important traditional weapons were heavy two-handed clubs, used in close combat. Only when a man killed an enemy with such a club was he accorded warrior status, and with each slaying he received a commemorative name. Warriors wore barkcloth loin coverings and painted themselves with coconut oil and turmeric; chiefs added a wig of human hair or a barkcloth turban. A warrior who had slain ten people was entitled to wear a black and white cone shell on his arm. A club that had slain a human victim acquired a kind of sanctity, was given a commemorative name, and was greatly feared.

Warriors travelled back and forth between Fiji and Tonga, bringing their weapons—clubs, spears, bows and arrows—and ideas. Tongan warriors used their own Tongan clubs during battles with Fijians, but when taken in battle or traded, Tongan clubs became treasures of the Fijians and vice versa. The usual function of a club is to be used in warfare; however, Tongan clubs should also be considered metaphors and allusions to the great chiefs as warriors and sacred individuals. Many Tongan clubs are works of art; they were also dangerous weapons and given personal names, especially after they had killed an enemy. They were embedded with the *mana* of their owners, their carvers,

and perhaps the gods. An outstanding example is carved with intricate triangles along each of its four vertical edges and is finely incised throughout in geometric designs and a variety of incised figures, including men and animals. The club contains a visual story about the Tuʻi Tonga, depicted in his *pala tavake* headdress, and his activities are visually detailed. He stands either by himself or with people to fan him. Other men are depicted with bow and arrow in the chiefly sport of shooting rats, with one impaled on the end of an arrow [**102**].

In Hawaiʻi, warriors used their javelins (*ihe*) to parry spears thrown at them, but preferred to catch the spears with their hands in order to hurl them back. *Ihe*, about 2 to 2.5 metres long, and *pololū*, about 2.5 to 5.5 metres long, were used to charge the enemy: holding one of these weapons firmly against his right side, the warrior charged on foot and thrust the weapon into his opponent or used it to trip him. Hawaiians also used throwing clubs as tripping weapons; a weight of stone or wood was attached to a cord some 5 to 12 metres in length. The warrior whirled the weight to wrap the cord around the legs of an opponent and jerked the rope to throw him to the ground. To shield oneself against this thrown weapon, a warrior would place his spear (or a carrying pole, if surprised outside a battle) on the ground a few feet in front of him so that the rope would form a big-enough loop to enable him to step out of it; the spear itself was a shield.

Māori weapons included long, thin *taiaha*, used in combat, for ceremonial confrontation, and as symbols of rank and authority. The favorite Māori weapon was a hand club, used in close combat. Made of basalt, greenstone, wood, or whalebone, *patu* were symbols of status and are important as heirlooms and historical records [**103**].

In Micronesia, warfare was usually the result of political rivalry, revenge for murder, and disputes over land and women. The most fearsome warriors, from Kiribati and Nauru, wielded shark-tooth-edged spears and hand weapons of various styles and lengths. To shield themselves, warriors wore helmets made of the skin of porcupine fish

102
Incised Tongan club collected during Cook's voyages (late eighteenth century).

103
Three Māori hand clubs, *patu*, of whalebone (*patu paraoa*), basalt (*patu onewa*), and wood (*wahaika*) (late eighteenth or early nineteenth century).

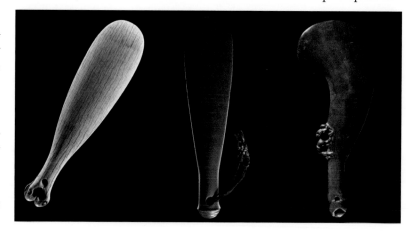

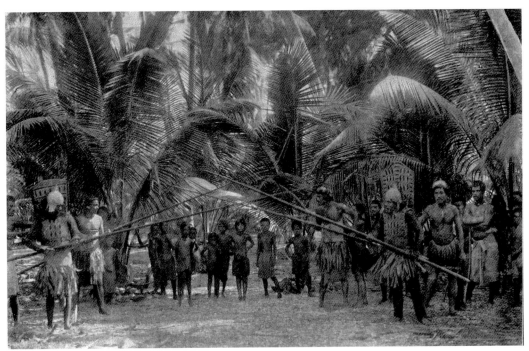

104
Warriors from Kiribati (*c.* early twentieth century).

with quill-like spines, knotted coconut-fibre leggings/pants, and body armour that covered the torso and had an additional head-and-neck protective shield that rose from the back of the armour [**104**]. The body armour was finely woven of coconut fibre and decorated with human hair in designs often based on diamonds. The backshield was especially important for protection from flying stones.

Fashion, Yesterday and Today

Clothing and how fashions change over time are especially dynamic aspects of art. Fashions change from within and as intercultural dialogues with neighbours and colonizers and can add a time frame to the art of clothing. For example, we can follow changes in the necklines of Hawaiian feather cloaks—from straight necklines in the eighteenth century to fitted-rounded necklines in the early nineteenth century. A straight neckline was particularly useful during warfare, as it could extend upward to protect the neck from slingstones and other missiles [**91**]. After the introduction of European weapons, cloaks and capes lost their protective function but retained their visual marking of a social category and genealogical prestige [**89**]. Straight-necklined cloaks and capes fell out of fashion and were given away to ship captains and foreign kings. Necklines became narrower, shaped, and rounded—repeating the bottom of the garments—probably evolving from first-hand acquaintance with European clothing that fits both neck and shoulders [**6**]. These new-fashioned cloaks and capes became clothing for ceremonial occasions.

Clothing in Polynesia and Micronesia changed dramatically with the importation of European ideas and cloth. The introduction of the so-called 'mother Hubbard' dresses became fashionable *mu'umu'u* and *holokū* in Hawai'i and elsewhere. Female chiefs wore long-sleeved silk dresses, and male chiefs took pride in military uniforms. As noted in Chapter 4, with the aid of missionaries, ponchos made of barkcloth moved from Tahiti to Sāmoa and Niue, and probably elsewhere. The wraparound skirts of men, though still worn on national and ceremonial occasions, have been almost universally replaced with trousers. Since the last decades of the twentieth century, even women have worn trousers, although in many islands they are still considered not 'quite right'. On public occasions Māori women wearing trousers will wrap a piece of cloth, or even a jacket, over their trousers if they rise to perform or speak.[22]

Today, high fashion takes us back to traditional materials combined with globalized style. Elaborate wedding dresses are made of white barkcloth, and clothing is cut to reveal small or large tattoos. Polynesian and Micronesian designers of clothing and jewellery are featured in shops in Auckland, Honolulu, Pagopago, Guam, and elsewhere. Polynesian models parade on fashion catwalks and on stages at the Pacific Festivals of Art [105], at local and regional 'Miss'

105
Pacific Sisters Fashion Show at the 1996 Pacific Festival of Arts in Apia, Sāmoa.

'Wild Victoria', a gown made from New Zealand flax strips by Linda Lepou, won the award for the Pasifika bridal section of the 2005 Westfield Style Pasifika New Zealand Fashion Awards.

contests, and at transvestite extravaganzas such as the annual 'Miss Galaxy' contest in Tonga. A leader in Pacific fashion is Rosanna Raymond, a designer of mixed Polynesian and European descent, who grew up in New Zealand. In the 1990s, her work with The Pacific Sisters resulted in fashion shows and photographs that challenged and reworked the 'exotic dusky maiden' of the nineteenth century, but 'with attitude'.[23] She now lives in London, and her jewellery, clothing, and performances are internationally sought after. An annual event in Auckland that attracts designers and performers from Polynesia is the 'Westfield Style Pasifika'. Now in its second decade, this indigenous cultural event has become a fashion extravaganza. Here Pacific-inspired fashions are presented in a slick professional show, which has become *the* venue for presentation of new fashions of the Polynesian avant-garde [**106**]. Indeed, fashion has created a time frame for a timeless Pacific story.

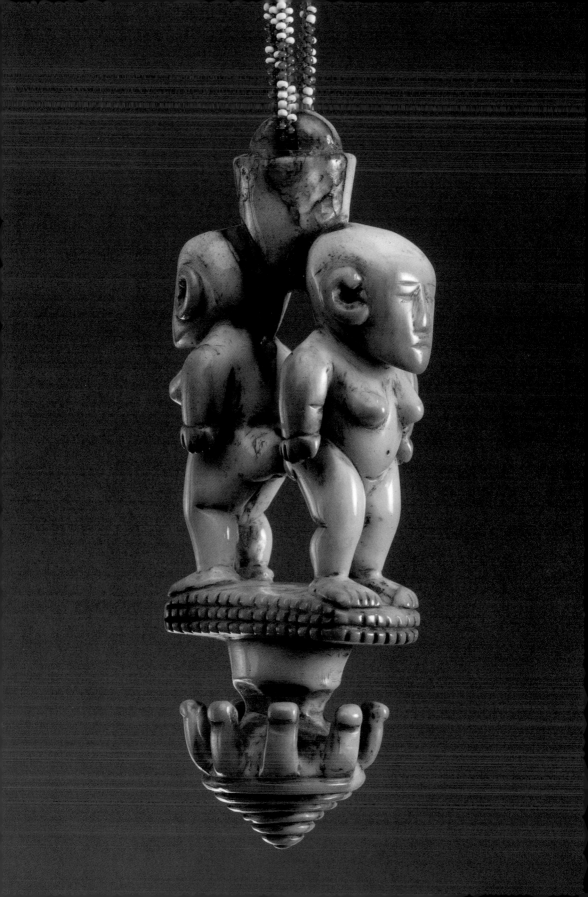

Ritual Spaces, Cultural Landscapes
Space and the Aesthetic Environment

6

Faustina Rehuher, Belauan academic and director/curator of the Belau National Museum, has noted that three terms are used in discussions of local aesthetics: *besiich* denotes aesthetic impact or describes how an object is artistically rendered; *kldachelbai* denotes artistic creation with reference to the body and the creator's mind; and *cheldecheduch* denotes the content of an artistic work. These terms are used in discussing body adornment, buildings, and canoes—all important elements in the arts of Micronesia.

Space in the Natural and Built Environment

Artistic, mythological, and religious concepts shape the cultural landscapes and universes of Polynesians and Micronesians. Their art reflects their concepts of the layout of horizontal and vertical space, how objects are placed in it, how one moves in it, what one wears and carries while moving, and how all these elements change according to contexts and activities. The organization of space constitutes a system of knowledge, which is culturally constructed and changes over time. Polynesian philosophical systems were often based on paired opposites that were complementary and necessary aspects of each other. Polynesians conceived of their vertical universe as a vast coconut-shell container with several layers—underworld, ocean, land, sky. In the Cook Islands, the ten-layered heaven was the dwelling place of Vātea, the sky-father. From Vātea and Papa, the earth-mother, were born the three great gods, Tangaroa, Rongo, and Tāne, along with two specialized gods Tonga-iti and Tangiia.[1]

Horizontally, the sea was filled with hundreds of islands. Tupaia, the Ra'iatea navigator-priest who joined Cook's first voyage, recorded the names and locations of seventy four islands, which were localized by the 'direction from which favourable winds would blow to allow a voyage', rather than their position in regard to other islands.[2]

See 2

Polynesians and Micronesians used oral and visual maps that ordered space, assisted in getting from place to place, explained natural phenomena, and gave social meaning to physical surroundings. In some islands, such as the Tuamotus, space was conceptualized visually,[3] while in others, such as Tonga, oral maps explain the skies:

The first and second skies
Are the skies of Maui Motu'a [who brought light to the land by pushing
 the sky away from the land].
The third and fourth skies
Are the living place of 'Ūfia and Latā, the covered and enclouded;
These are separate skies—a sky that rains and covers the cloudless sky;
There is hidden the star Tupukitea [Venus, the morning star],
And it can't appear outside.
The fifth and sixth skies
Are the living place of the blood-red sunset;
There, resembling a loosely made flower girdle or necklace
Are the stars that stand in rows [the Milky Way].
The seventh and eighth skies
Are the skies of Tamutamu, the reddish cloudy sky
Like anger that is silent before the burst.
The ninth and tenth skies
Are the skies of thunder, the noise that ends in little or nothing.
But what about the last
And the sky of clouds of fleece like feathers of birds?[4]

The organization of space is based on prior knowledge of what will take place in the conceptualized spaces—sailing, presentations, feasts, worship, dancing. Most important to Micronesians was how the sea, land, and sky articulated. If one asks Micronesians about the organization or layout of the world, many begin with a discussion of navigation and canoes and how the organization of society and the views of the universe are influenced by relationships with the sea. Traditionally Micronesian lives were concerned with sea spirits, canoes, and fishing. Micronesians made some of the finest ocean-going vessels in the world—canoes that could sail with either end forward, usually formed of a single asymmetric hull, planked by sewing together pieces of wood with coconut-fibre twine, an outrigger, and triangular sails. Navigating by the apparent motion of the sun and stars, wind direction, ocean currents, wave patterns on the surface of the sea, and the flight of birds, navigators closely guarded family secrets, and knowledge was passed from an expert sailing master to a chosen apprentice. Canoes were built and sailed by men; women usually plaited the mat sails.

Caroline Islands navigators recognized thirty two directions based on the position of specific stars, how the islands were situated in the ocean, and wind directions at various times of the year. Each area has its own origin tales, which relate to space or the layout of the islands.

The origin of Belau is traced to an insatiably hungry boy who was tied up and set on fire; in his struggle, his body fragmented into the more than 300 pieces that form the islands of Belau.

Famous for their canoes and navigational ability, Marshallese navigators had secret knowledge, some of which could be visualized in stick charts [107]. By acute observation of the sea, the Marshallese accumulated a rich fund of accurate knowledge about the action of ocean swells, what happens to them as they approach and pass by land, and the characteristics of two or more swell patterns' interaction with each other in the presence of an island. Also studied were reflection, refraction, shadow phenomena, and other ancillary wave actions. From this information, the Marshallese developed a system of piloting and navigation, which was encoded in stick charts as science models and as piloting instructions.

Knowledge that stick charts encode is indicated by the arrangement of the sticks relative to one another and by the forms given to them

107

Meddo stick chart, Marshall Islands (mid nineteenth century). Collected by Robert Louis Stevenson.

by bending and crossing. Curved strips indicate the altered direction taken by ocean swells when deflected by the presence of an island; their intersections are nodes where these meet and tend to produce a confused sea, which is regarded as a most valuable indication of the voyager's whereabouts. Currents in the neighbourhood of islands are sometimes shown by short straight strips, whereas long strips may indicate the direction in which certain islands are to be found.

Science models (*mattang*) illustrate the abstract general concepts of swell movements and interactions in the vicinity of one or more small islands. Piloting instructions (*meddo*) illustrate the layout of the islands of the Marshall group and their distinguishing wave characteristics. Neither were taken on board a canoe, for the information existed primarily as memory in the navigator's head. In *meddo*, shells or coral pieces are tied to sticks to represent islands and possible navigation courses between them. Their position relative to one another is indicated with considerable accuracy, but the distances from island to island are only approximately suggested. Not made to scale, *meddo* are essentially mnemonic devices made for the use of their owner and usually unintelligible to others. The *meddo* collected by Robert Louis Stevenson covers most of the Marshall group [**107**]. The straight sticks represent systems of swells rolling into the Marshall Islands, and shells tied to the framework represent islands of the group.

Mattang are used for instructional purposes. These usually represent a simple problem, such as that of a single island at the centre of a chart, with curved swell fronts arranged in four quadrants. The construction is generally symmetrical in order to present a simple set of conditions.

In the Caroline Islands, canoe-building was a high-status occupation, and how the canoe looked was considered important. Often painted red and black with bifurcated prow and stern pieces, canoes were noted for their purity of line. According to people from Puluwat, canoes 'are intended not only to be used but also to be admired and are judged by utilitarian and aesthetic criteria'.[5] In Chuuk, both ends of the canoes were mounted with removable figureheads carved as two birds with their beaks meeting and tails outstretched [**108**]. Approaching land or

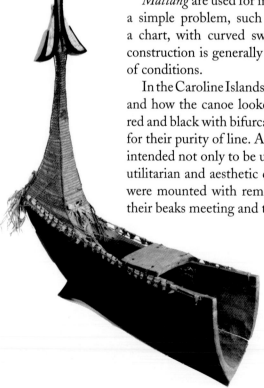

108
Mounted Chuuk canoe prow depicting two frigate birds with meeting beaks (nineteenth century).

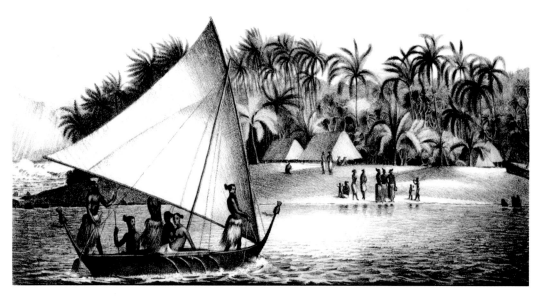

109
Marshall Islands canoes.
Vue d'une île dans le groupe Krusenstern [Marshall Islands]. Coloured lithograph after drawing by Louis Choris. Plate XIV in *Voyage pittoresque autour du monde* (Paris, 1820–2).

another canoe, the placement of the figureheads signified the occupants' intentions—peace if lowered, war if raised. Marshall Islands canoes were mounted with removable crescent-shaped ornaments at both ends and had platforms and thatched houses. They were beautifully illustrated by Louis Choris during von Kotzebue's voyage [**109**]. Red paint was often important as a sacred application to canoes, and stories about the origin of red paint abound.

Weather charms, formed of a carved wooden body and legs of stingray spines, were used to calm bad weather and ward off storms [**110**]. The efficacy of the charm derived from the navigator's chanting the power of his patron spirit into it near the coconut tree where he had learned the arts of navigation.[6]

The canoe-builder also used his skill and artistry for work in stone, shell, and wooden objects, including bowls, tackle boxes, small human figures, and coral food pounders. Canoe-houses served as meeting places for the men of a village, as well as the place for housing the canoes and the sacred objects and their fabrication.

Ritual Spaces in Micronesia

The most dramatic site in the Pacific is situated on the south-east side of Pohnpei. This is the ceremonial complex of Nan Madol, situated in a shallow lagoon and made up of ninety-two natural and artificial islets related to specialized activities. The islets are separated by waterways navigable by canoe. Most of the walls are made of huge basalt boulders and prismatic basalt columns that were quarried miles inland and ferried by sea to the site. At its zenith, about 1500 CE, Nan Madol housed as many as 1,000 people. The basalt columns were laid horizontally in stacks to form the outside retaining walls; shorter columns were

110
Weather charm, Yap (late nineteenth or early twentieth century).

111
Entrance to the Nan Dauwas
tomb enclosure, Nan Madol,
Pohnpei.

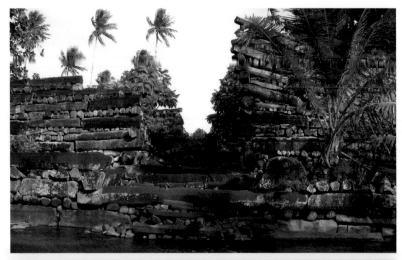

112
Computer-generated model
of the ruins of Nan Madol.
The Nan Dauwas Complex
was the site of the tombs
for the paramount chiefs
of Pohnpei. Pahnwi is a
massive artificial islet that
anchored the south-eastern
corner of Nan Madol. Pahn
Kadira was the residence
area of the Sau Deleur
chiefs, who represented the
ruling line of Pohnpei, while
nearby Dorong Islet has an
artificial tidal pond in the
centre that was used for
aquaculture. Usendau was
a ritual centre in the priestly
area of Nan Madol. Karian
served as a priestly burial
complex. Nan Mwoluhsei
represents a massive sea-
wall and entryway into Nan
Madol from the lagoon and
open ocean lying to the east.

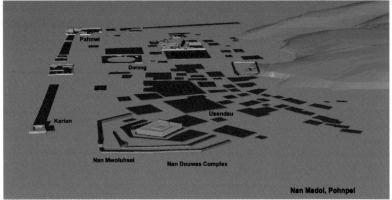

laid perpendicularly between them—a type of construction known as headers and stretchers. Inside the walls are stone pavings, platforms, and house foundations.[7] Associated with the ruins are large rocks for pounding *sakau* for ceremonial drinking (Chapter 2).

Nan Madol was the seat of the Sau Deleur dynasty, the ruling line of Pohnpei, and formed an 80-hectare political and religious centre. It was composed of two main areas intersected by a waterway: a religious centre, where religious leaders lived and the major tombs were located, and an administrative centre, where royal dwellings and ceremonial areas were located. A large seawall protected the entire area from the sea. The most impressive islet is Nan Dauwas, the site of a royal tomb with a large crypt and platforms, which had retaining walls 7.5 metres high upswept at the corners and entryways [111]. Protected by a seawall 4.5 metres high and 10.5 metres thick, Nan Dauwas was oriented on an east–west axis, which was used by navigators to indicate points of the rising and setting of the sun [112].

The islet of Pahn Kadira was the residence of the Sau Deleur, his immediate family, and houses for his visitors. The islet was outlined

with stacked prismatic basalt walls 5 metres high with an entryway 4 metres wide. The Sau Deleur's own house had a courtyard of interior walls 2.5 metres thick. Idehd islet was the main religious centre, where agricultural rituals were held. A great saltwater eel, the medium between the people and the Sau Deleur's god, lived on this islet. At the end of certain rituals, a sacrificial turtle was given to it, which if accepted, indicated that all was well on Pohnpei. Peinering islet was the centre for making and storing coconut oil used for ceremonial anointing of the living and dead and for lighting. A priest responsible for the production of this oil lived on the islet. Archaeological investigations have found Pohnpei-made pottery, shell adzes, other tools, and shell ornaments.[8]

A similar ceremonial complex, Lelu, dated c.1250 to 1850 CE, is found 550 kilometres to the east, on Kosrae. Constructed of stacked prismatic basalt columns, from the opposite side of the island, the foundation was built by filling in the shallow lagoon of a small island to the east side of the main island known as Oualan. Lelu, an island city of more than one hundred walled enclosures, was the administrative and ceremonial centre for a hierarchical society similar to that of Pohnpei. Waterways were used for the canoes that transported food and other goods along a 900-metre canal. Inside the outer walls were dwelling compounds enclosed by 6-metre-high walls, and inside these walls were huge houses with thatched roofs that curved gracefully upward in an arc or crescent to form front and back gables rising 12 metres above the ground and 12 metres long. Some of these were feasthouses used for rituals and funerals and enclosed spaces as large as 450 square metres; dancing, wrestling, and games took place in the courtyard [113]. A reconstructed interior shows the elaborate A-frame structure and structural bindings [114]. Within the walled city were sixteen sacred compounds that held spirithouses and five royal tombs. The tombs have crypts lined with walls of stacked prismatic basalt that served to prepare the royal dead. After elaborate funeral rituals, the body was placed in the crypt with mats and ornaments until the flesh decayed. The bones were then exhumed and placed in an opening in the reef near Yensar Islet. Historic Kosrae houses were similar to historic architecture of Yap, Kiribati, and Belau. All have high gabled roofs with large interior spaces. In Yap, the gable fronts of the houses face the beach, and important houses are enhanced by large discs of stone valuables (quarried on Belau) leaning on their front and sides [115]. The interior of a large Yap house is divided into longitudinal sections lashed to the numerous houseposts that support the ridgepole and purlins with diamond and square designs. Crossbeams are painted with fish, heavenly bodies, and money in black, white, red, and yellow, and three-dimensional birds are suspended from them. Large meetinghouses in Kiribati are more open, with only a few

113

Feasthouses and courtyard, Lelu, Kosrae, from Frédéric Lütke, *Voyage autour du monde* (1835).

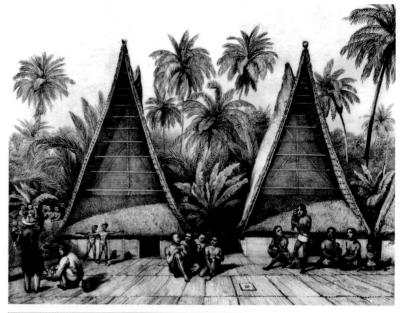

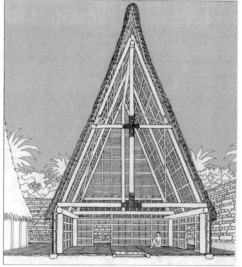

large houseposts to hold the enormous roof structure [**116**]. These vast buildings without walls (*maneaba*) are formed of a huge domed thatched roof that nearly reaches the ground supported by rows of graduated coconut-wood houseposts as high as 15 metres at the centre. Some *maneaba* are decorated with white shells on the rafters, or with red and brown geometrical designs on posts and horizontal beams. The building houses a formalized seating arrangement (*boti*) based on patrilineal social divisions along its four sides, leaving the centre area open for presentations, speeches, and competitive dancing.

In Belau, elaborate large houses known as *bai* are used for ceremonies for village title-holders, as chiefly clubhouses, and for meetings of men's

groups. The four cornerposts are the sitting places of the four principal title-holders of the village. The title-holders are men, but they have been elected to their positions by the women of their clans. A title-holder can be removed by these women if he does not act in ways deemed to be in the best interest of the group. The *bai* is the basis for metaphors that incorporate concepts significant to the people. From the metaphors concerned with the conceptual ordering of space and time, Parmentier has isolated four dimensions that Belauans use to integrate their natural and social universe.[9] 'Paths' establish a linear linkage associated with natural features of the landscape linking human relationships among persons, groups, and political units connected historically by a precedent-setting action and continue to influence social action for exchanges and present-day social cooperation. 'Sides' establish a principle of opposition that divides space and people into symmetrical partners. 'Cornerposts' combine features of paths and sides to express relationships between coordinated elements that support a total structure. 'Larger/smaller' is the basis for social rank, through which everyone and everything is graded. While paths and sides are natural, cornerposts are cultural, and larger/smaller is social. Together, these concepts integrate the Belauan world. This aesthetic of everyday life is visually and socially manifested in *bai*. The buildings are divided symmetrically in halves, and their four cornerposts are ranked. The title-holders associated with the cornerposts carry exchange responsibilities.

Bai in traditional architectural style are now rare; in 2006, only four existed: at Airai village [**117**], Melekeok village [**10**], Aimellik village, and at the Belau National Museum. A-shaped and gabled, the housefronts display carved and painted designs that depict circular motifs (often placed horizontally at the bottom), faces, and birds. A face with long earrings with a circle and cross design symbolizes money. The houses were concerned primarily with finance: circles represent valuables, faces depict heads that were ransomed for valuables, birds are

115 *(below left)*
Meetinghouse from Yap with stone valuables (1884).

116 *(below right)*
Kiribati meetinghouse (*maneaba*) (1897).

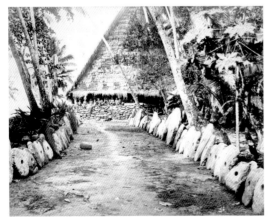

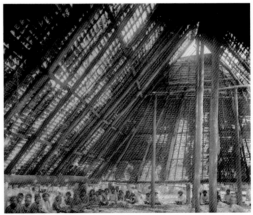

Belau meetinghouse, *bai*.
Airai, Belau (refurbished in
the mid twentieth century).

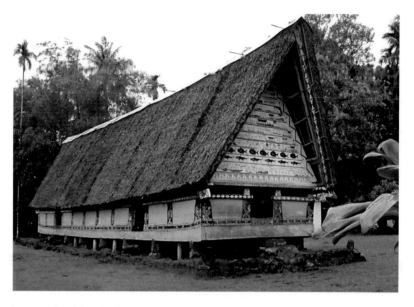

'money birds', which generate valuables, and roosters, a male symbol.[10]
In times past, some houses were adorned with the sculptured female
image of Dilukai [118], indicating the presence of a woman whose
affections brought money to the village title-holders.

Modern *bai* have the elaborated 'storyboard' gable fronts that have
been popular for at least a century. These storyboards evolved from the
interior housebeams that were carved in relief and painted with stories
depicting important historic and moral events [11]. Since 1929, owing
to the influence of Hijikata Hisakatsu, these painted-relief stories have
been transferred to portable boards for sale to tourists. In the 1960s,
prisoners began carving storyboards and developed a distinctive style.
Storyboards are now sold to tourists in shops in Belau and beyond.

The *bai* at Airai [117] is a refurbished version of the last remaining
house of three ranked houses that were described as located next to each
other.[11] It is 20 metres long and 6 metres wide, with a decorated gable
at each end of a roof structure that rises more than 11 metres high and
is 26 metres long (the roof structure projects 2.5 metres on each end).
The whole structure is raised four feet above the pavement on sixteen
foundation stones, and the house has six entryways—one on each end
and two on each side. The underside of each door lintel is carved and
painted with a bat with outstretched wings, symbolic of how a bat who
stole sweets was destroyed by the clever ruse of the men of Angaur
Island. Large and visually impressive *bai*, sometimes associated with
upright stones with sculptured faces, as well as the dramatic landscape
of Belau's sculptured hills, are among the most impressive sights in
Micronesia.

In the Marianas Islands, architectural sites (some date from 1000
CE) consisting of double rows of megalithic columns called *latte* with

Sculpture of Dilukai from a *bai* housefront in Belau (nineteenth century). Collected by Augustin Krämer, 1908–10.

upturned hemispherical capstones were the bases for large wooden structures. Remains of the House of Taga on Tinian were depicted during George Anson's visit in 1742 [**119**]. Its twelve 5-metre stone columns were part of a site that ran parallel to the coast and included megalith house platforms. At the time of Anson's visit, the site was no longer in use, but it is thought that large wooden houses similar to Belauan *bai* with high gables were built on top of columns [**120**] and housed high-ranking chiefs and their families. Marianas Plainware pottery is found in conjunction with the sites.

Spatial Orientation in Polynesia

In Polynesia, settlement patterns, spatial orientation, shape of ceremonial sites, height, and the alignment of houses and their internal divisions reveal relationships between gods and people, between chiefs and commoners, and between men and women. Fijian villages are divided between seaward areas (considered chiefly), and landward areas (considered common). Houses repeat this spatial orientation. In the analysis of houses in Moala, Fiji, Marshall Sahlins notes that the village 'is divided down the long axis into a "chiefly side", traditionally set parallel to the sea, and a "common side" toward the inland'.[12] Each end is associated with a side, so that the chief of the house is associated with one end and one side, which Sahlins argues is a modelling system for dual organization, tripartite organization, and the four-class system of the Moalan social order. Godhouses (*bure kalou*) had striking pointed roofs. Images of the gods and pieces of barkcloth, through which the gods descended, were placed inside.

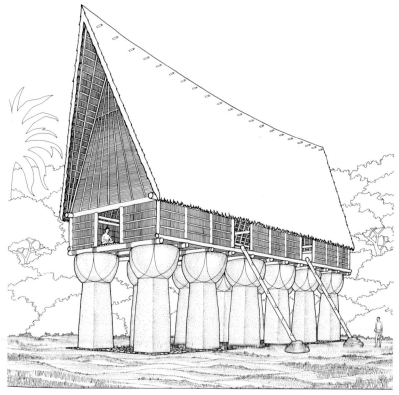

Drawing of the interior layout
of a Tikopia house.

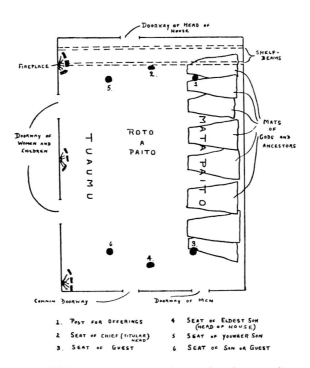

1. POST FOR OFFERINGS 4 SEAT OF ELDEST SON (HEAD OF HOUSE)

2. SEAT OF CHIEF (TITULAR HEAD) 5 SEAT OF YOUNGER SON

3. SEAT OF GUEST 6 SEAT OF SON OR GUEST

In Tikopia, space is also ordered according to seaward and inland orientations. Circularity is thought to be given by nature and rectangularity provided by culture; thus, the Tikopia house, being a cultural feature, is rectangular, and space within it is divided rectangularly [121]. The seaward side of the house is higher in rank and sacred—being associated with canoes, fish, ancestors, men, and chiefs—while the inland side of the house is associated with ovens, vegetable food, social activity, daily life, women, and those of lesser rank. Movement and social action within the Tikopia house are governed by these spatial regularities as well as by proximity, precedence, and orientation, both in direction and elevation.[13]

In Tonga, huge elevated rectangular stone constructions marked the historic gravesites of the highest-ranking lineage. The great oval houses of the chiefs were distinguished by complex rafter formations and rafter lashings that incorporated designs formed from coconut-fibre sennit of two colours [20]. The highest chiefs of the Kauhalauta lineage groups lived inland, while the lesser chiefs of the Kauhalalalo lineage-groups lived close to the sea. Special mounds used by chiefs for resting (esi) and pigeon-snaring (sia heu lupe) were elevated in height.

In Sāmoa, houses were, and still are, laid out with a specific order in relation to the village pathways, the concepts of centre and periphery, and the orientation of the malae (village green), with the chief's house and guest houses, round or oval in shape, in the most important positions, raised on earth and stone platforms. The most formal kava ceremonies take place on the malae, with each person

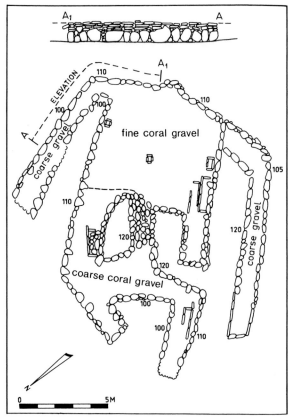

accorded a specific place depending on his personal rank and the rank
of his title.

Mounds believed to have been for pigeon-snaring in the interior of
the islands were elaborated into star shapes [**122**] or ray shapes, which
were related to concepts about the shapes of animals and natural
phenomena personified by the gods. In addition, pigeon-snaring was
metaphorically associated with wife acquisition. A common form of
these mounds had eight rays and is related to the god Tagaloa, who

had eight livers outside of his body, as well as the octopus god, 'O Le Fe'e. The shapes of other mounds with different numbers of rays are associated with gods and traditional lore dealing with the sun, turtles, and eels.[14] One of the mounds looks centipede-like from above [122].[15] Organized competitive pigeon-snaring has not taken place on these mounds for some time, but fishing could have acquired a similar metaphorical association with the catching of wives—both are carried out with a net, and both pigeon-snaring and fishing are men's work. In addition, Samoan gods are often associated with fish and fishing.

In East Polynesia, open stone temples with stone or wooden images and chiefs' living sites marked the religious and societal centres of social action. An elaborately shaped ceremonial site is Te Papa-o-Sokoau in Omoka, on the island of Tongareva in the Cook Islands.[16] In the form of a human figure, this site was a *marae* of refuge for wrongdoers [123]. It was named after Sokoau, a daughter of Tangaroa who was killed by her husband for infidelity. Tongareva does not have a tradition of sculptural woodcarving in human form, but priests represented the gods visually with objects made of coconut leaves in human shape that were placed on upright pillars during ceremonies on the *marae*. Feathers were attached to a wooden stick, and pieces of wood were given human-hair attachments. In other islands, offering stands were sculpted human arms [124].

In islands such as Hawai'i and the Societies, chiefs lived with their people in settlements laid out according to mythological or social rules that divided the island into wedge-shaped pieces from mountain to sea and included fishing areas, agricultural areas, and the mountains that were the home of wild plants and birds.

Religious sites in Hawai'i varied from simple fishing shrines to elaborate high-walled enclosures (*heiau*) used for rituals of state importance [125]. Rectangular in shape, *heiau* were often built at the top of a hill or slope of a mountain range, parallel or at right angles to the shoreline, as part of the cultural landscape. A pavement of pebbles lay at the end where the images would be placed, and it was here the rituals were carried out. A series of large images were arranged in a crescent, with the most important image, called *mō'ī*, usually a smaller one, placed at the centre. Important structures included the *lele*, on which offerings were placed; the *anu'u*, 'oracle tower', in which religious specialists plied their trade; a small *waiea* house, where a prayer-entwined cord was placed; a *hale pahu*, where drums were played facing the *lele*; a *mana* house, in which the most important image and other ritual objects were kept; and a *mua* house, a shedlike structure used for baking pigs and preparing offerings. *Heiau* plans varied according to use, land form, and importance.

Rituals for *heiau* building and use were described by Hawaiian historian Samuel Manaiakalani Kamakau:

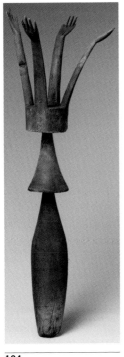

124
Offering stand from Mangareva (eighteenth century).

The images outside the north (or right) *paehumu* [*heiau* enclosure] were male, and those outside the south (or left) wall were female. The carved images formed wooden *paehumu* outside of the heiau. The lines of images (*na lalani ki'i*) inside were called Kukalepa. They were better carved than those outside the *paehumu* and had hair, eyes of mother-of-pearl, and real teeth. Some were girded (*ka'ei*) with *'oloa* tapa, some with *moelua*, and some with *'olena*, which ever was suitable to the character of the male or female image.[17]

A large and important site is the ceremonial centre of Hōnaunau in Kona, Hawai'i, which includes a refuge area (*pu'uhonua*) and the Hale-o-Keawe mausoleum, which contained the bones of the paramount chief Keawe and his chiefly descendants, including Kalani'ōpu'u, the high chief of Hawai'i who met Captain Cook and exchanged food, tools, and ritual gifts.

Hawaiian *heiau* fell into disuse in 1819, when Hawaiians overthrew their state religious system. What remain are mute walls and platforms, while the surviving images of the gods now reside in museums. Related ceremonial sites in other areas of East Polynesia are similar, but often have huge stone uprights that served as backrests for the gods. Some *marae* have unusual features, such as the archery platforms of the Society Islands that were used in sacred rituals.

Māori religious precincts (*marae*) are still in use, and are built and rebuilt in traditional form. Like Hawaiian *heiau*, they have open spaces with a forecourt where ritual activity takes place. Important buildings are a carved meetinghouse and *pātaka* storehouses (described in Chapter 3), a kitchen and dining hall, and sometimes extra sleeping houses. *Marae* are the centre of community life, and outsiders do not enter until invited by women chanting *karakia*; elaborate protocol is prescribed.

Canoes and Metaphors in Polynesia

Canoes were (and still are) some of the most important treasures in Polynesia. Navigation was one of the artforms which was almost lost, but has been reconstructed with the help of Mau Pialog, a Micronesian navigator from Satawal, and the revival of ocean-going vessels, starting with the Hawaiian Hōkūleʻa in 1976. Huge double canoes were used for inter-island travel and exploring and populating the great unknown. Sailing hundreds of miles out of the sight of other islands, the canoes were navigated by specialists who used their knowledge of stars, prevailing winds, ocean swells, changes in wind direction, the colour of sky and water, and the flight patterns of birds. Canoes were also used in warfare and were decorated with carved prow and stern pieces [126]. The warriors carried a variety of weapons and wore specialized ceremonial clothing.

Among the Māori, canoe parts are interpreted as metaphors for ancestors and the cosmos [127, 128]. Carvings may represent the sky-father Rangi in the upper section, and the earth-mother Papatuanuku in a horizontal figure on the baseboard. In the middle, a figure of Tāne pushes them apart, and the carved spirals represent the coming of light. Figures below Papa represent some of their progeny, for example, Rūamoko, god of earthquakes, and Whiro, god of death. A figure at the prow may represent Tūmāteuenga, god of war. Carved spirals and beaked *manaia* figures on the sternpost are like the 'backbone' that rises from the head of a carved housepost, and the paddles—often painted with patterns similar to rafter patterns—his ribs.[18]

In Tahiti, under the watchful eye of the god Tāne, master canoe-builders directed the cutting of trees, the building of canoes, the fabrication of sennit fibre used to hold parts of the canoe together, the plaiting of sails, the manufacture of tools, and the production of

126

Drawing of a New Zealand war canoe showing mounted prow and stern pieces, by Sydney Parkinson (1770), from Cook's first voyage to the Pacific, in the *Endeavour*.

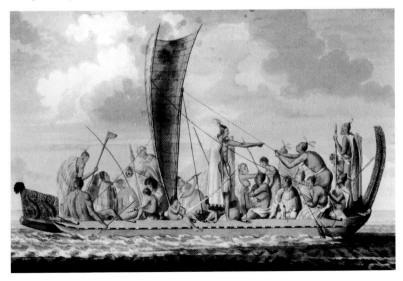

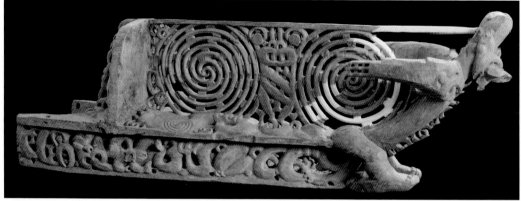

127
Canoe prow, Māori (eighteenth century).

food for the workers. Sacred canoes had carved human figures on their raised endpieces [**129**], and some carried shrines that contained *to'o* representations of the god 'Oro (see Chapter 2). During warfare, the highest chief wore a huge headdress with feather decorations (*fau*), and the warriors wore protective breast and shoulder pieces (*taumi*) [**101**]. Mastering canoes and navigation required alliances with the gods, the winds, and the sea.

Sacred Spaces in Rapa Nui

Rapa Nui is the home to some of the best-known sacred sites (*ahu*), with their huge stone sculptures which face inland.[19] In this small island of 14,000 hectares, the usual Polynesian distinction between power and prestige was observed. The *ariki mau* had highest prestige and supernatural influence through the creator god Makemake, but secular power came to be held by the chief or head of a tribe, the war leaders, and later those associated with the birdman rituals. Each tribe had its own traditional lands and sacred places, including an *ahu*, or religious platform, which served as a burial site as well as a place to erect stone images [**130**]. Rapa Nui people used a variety of sacred places. The large stone structures were the local variation of the *ahu* sections of the late period forms of East Polynesian *marae*. These sacred places were used for burials and religious ceremonies. *Ahu* were surmounted by large stone figures, *moai*, carved of soft volcanic tuff; a few figures were carved of red scoria, basalt, and trachite. Some were topped with hatlike *pukao*, and had inset white coral and red scoria eyes when in use. It is thought that the *moai* commemorated illustrious ancestors, or ancestor-gods who brought benefit to their living descendants.

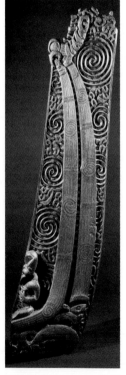

128
War canoe sternpost. Carved for the Ngati Raukawa canoe *Te Whangawhanga*, at Kupulaiva (1831). Said to represent the two ribs of existence being attacked by a *manaia* of the spirit world.

When the first people arrived in Rapa Nui, they carried with them knowledge of their ancestral traditions of stone and wood sculpture. They found a quantity of easy-to-carve stone, but good-to-carve wood was not abundant. Palm trees and *toromiro* trees were available on the island when people first arrived; however, wood from palm trees

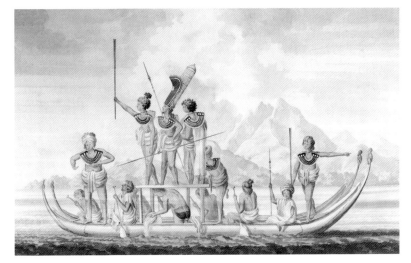

Drawing of a war canoe from
Ra'iatea, Society Islands,
showing human figures
mounted on the prow and
stern, by Sydney Parkinson
(1769), from Cook's first
voyage to the Pacific, in the
Endeavour.

was not traditionally used for sculpture in Polynesia, and *toromiro* trees were small compared with the trees used for carving in their ancestral homeland. The abundant stone was quickly exploited, and stone carving became the major, and more highly valued, sculptural tradition.

After centuries of emphasis on the *ahu moai* tradition, the emphasis changed to religious activities based on birdman rituals.[20] This evolved form of first-fruits ceremonies centred on the first person who acquired an egg of the sooty tern (*manu tara*, *Sterna fuscata*) from the tiny islets off the coast of the Orongo area. This person, or someone representing him, had to swim with the egg to the coast and climb the cliff to become the ritually important 'birdman' for that year, a period

130

Ahu Naunau ceremonial
site at Anakena, Rapa Nui,
1200–1600 CE.

during which he developed an association with the god Makemake. Specialized objects became associated with the birdman/first-fruits rituals, including the recarving of some of the stone *moai*, When Europeans arrived, the birdman religion was waxing, while the *ahu moai* tradition was waning.

The cultural importance of social status, especially of the Miru clan and chief, *ariki mau*, was interwoven with the importance of fertility. In many Polynesian societies there is a stratified social system in which the highest group is descended from a founding ancestor. With the evolving importance of the birdman religion and the concept of transformation, the symbolic system of Rapa Nui, and its visual dimension in artistic forms, were enlarged from the stone *moai* tradition. Human figures transformed into birds, lizards transformed into humans, and fish were transformed with the acquisition of a pouch similar to the gular pouch of the frigate bird—all visually represented in woodcarving; stone sculptures were secondarily carved with birdman/Makemake imagery; petroglyph imagery was elaborated and carved into *rongorongo* tablets and transferred to the heads of human figures; stone figures and wood sculptures had cuplike holes carved into them, and were sometimes refilled. Nevertheless, high status and fertility remained with the Miru and the *ariki mau*. Rapa Nui art not only reflected society, but helped construct it, and was a visual reminder of status and prestige.

Rock Art

Polynesia is the home of extensive rock art, especially the incised petroglyphs of Rapa Nui and Hawai'i. In Rapa Nui, the placement and form of rock art is associated with *ahu* and other sacred sites [131]. The famous birdman carvings associated with male chiefs at Orongo on Rapa Nui are carved in relief and have a three-dimensional quality [60]. The female essence is also found in the ubiquitous vulva incisings on the boulders at Orongo, at *ahu* sites such as Ahu-'O-Pepe and Tongariki,[21] and on portable puberty-ritual rocks.

Rapa Nui Society

Rapa Nui chiefs (*ariki*) were distinguished from commoners (*huru-manu*). The highest chief, *ariki mau*, descended from the legendary founder, Hotu Matu'a. Ten tribes descended from his sons and grandsons, but those who descend from his son Miru have the most elevated status. Individuals were born into a social class and into a specific descent group, usually traced through the father's line. Kinship connections, however, were traced through both mother and father. Chiefs formed a kind of aristocracy and were given status and prestige in accordance with their social rank. Chiefs, and especially the *ariki mau*, had personal privileges and sacred tapus. Hotu Matu'a was considered to be descended from the gods Tangaroa and Rongo, which gave his direct descendants supernatural power, *mana*. Experts and craftspeople, called *maori*, were highly esteemed. Their specialized knowledge and techniques were transmitted from father to son.

Petroglyphs in Hawai'i were extensive and constitute a major artistic tradition [132]. The meanings of this prehistoric artform are not thoroughly understood, but it is thought that they marked sacred sites used for the deposit of umbilical cords and other events. An extraordinary boulder from Hawai'i has two humans in ritual postures carved in high relief, and the stone figures from Necker island, Hawai'i, are much like petroglyphs carved in the round. A Tahitian rock carving [133] makes visual the birth process in a dynamic two-dimensional form. These rock-art sites, and a myriad of others, are usually in out-of-the-way places—apparently sites important for gods and their descendants.

131

Fish petroglyph from ceremonial site 14–563 at Tongariki, Rapa Nui.

132

Hawaiian petroglyph field. Part of site E 3-1 of Kaeo Trail, Puako, Hawai'i.

133
Petroglyph boulder,
Tipaerui, Tahiti.

Household Furnishings

Household furnishings were few but aesthetically conceived. Floors were covered with plaited mats; pillows or neckrests were made of bamboo or carved of wood and inlaid with ivory [134]; houseposts and rafters were tied together and decorated with complex designs derived from lashing with twisted coconut fibre in two colours. From the rafters hung relief-carved wooden containers in New Zealand [31], and hooks that incorporated human sculptures in wood or ivory in Fiji and Tonga [2]. Human figures were sometimes incorporated into the houses, as in Māori houseposts [50] and Fijian architectural parts. Beautifully finished wooden bowls were carved with human figures in Hawai'i [56], birds in Fiji [22], multiple legs in Sāmoa, and intricate incised designs in the Austral Islands [135]; while

134
Tongan neckrest, *kaliloa*, in the form of a club with legs and inset with ivory stars and crescent moons (late eighteenth century).

shaped and decorated gourd containers were used in Hawai'i and New Zealand. Tools used in food preparation, such as stone pounders and coconut graters, were decorated with human images or have aesthetically abstract forms that were elaborations beyond function [136, 137]. Tools and fishhooks were varied and beautiful in materials, shapes, and lashings. Piles of plaited sleeping mats were left out or rolled and placed in the rafters. Stools were used to raise the elevation of high-status chiefs. Some were small, such as those from the Society Islands [3]; others were large, such as the chief's seat in front of the mat-wrapped gods as illustrated in Tokelau [137], while others had intricate carving. Aesthetically conceived and elaborated beyond function, these furnishings and tools were made by artisans who learned their crafts from the gods. They too have become heirlooms and embodiments of history passed on to succeeding generations for use, pleasure, and identity.

Globalization of Polynesian and Micronesian Art

Since the time of the voyages of Captain Cook and Commodore George Anson, Polynesian and Micronesian art pieces have found important places in English drawing rooms and curio cabinets, and individual pieces have become icons of Pacific art. In the early nineteenth century, illustrations of objects and dancers became part of French dining-room wallpapers, such as Dufour's 1805 'Les Sauvages de la Mer Pacifique', designed by J. B. Charvet. In 1785, a cotton textile, copperplate printed at Bromley Hall factory, England, reproduced the

135
Incised bowl with linked human figures. *Tamanu* wood (*Callophyllum*). Ra'ivavae, Austral Islands (early nineteenth century).

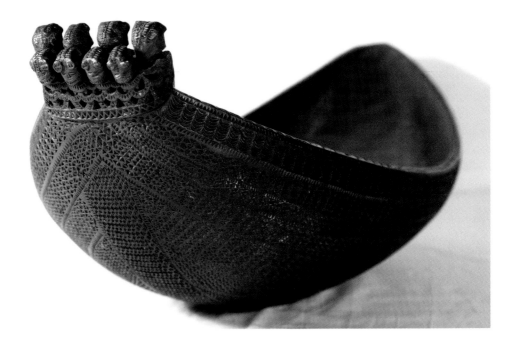

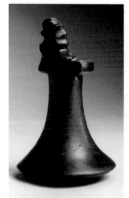

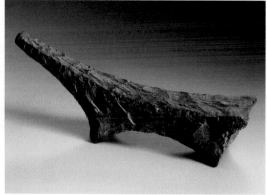

House of Taga in Tinian, after an engraving in Anson's *Voyage around the World in the Years 1740–1744* [**119**], as a fabric for curtains and other interior decoration.[22] Theatre pieces were created, such as John O'Keeffe's *Omai, Or a Trip round the World,* based on Cook's voyages, produced at the Theatre Royal in Covent Garden in 1785, and a pantomime by M. Arnould, based on the death of Cook, produced in Paris in 1788. During the twentieth century, films such as versions of *Mutiny on the Bounty,* with all their historical and geographical inaccuracies, have given millions of cinemagoers the feeling of having 'been there'. The influential British Victorian decorative arts designer Christopher Dresser (1834–1904) copied a Fijian priest's *yaqona* dish [**25**] as a cigar tray in pottery and silver. Henri Matisse's (1869–1954) visit to Tahiti in

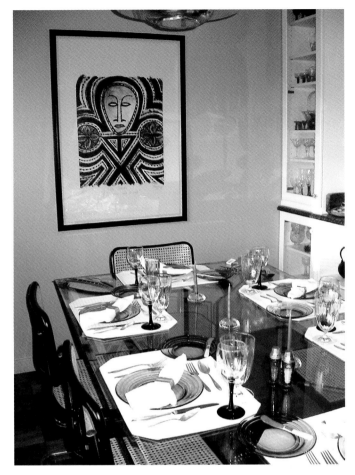

Ole Tausala. "E le iloa ala o vae" (1999), a print by Samoan artist Fatu Feu'u, graces a dining room in Washington, DC.

1930 resulted in some of his well-known artistic works, such as *Océanie, le ciel* (1946) and *Fleurs et fruits* (1952–3). His cut-out gouaches take their inspiration from the *tifaifai* quilts made by Tahitian women, the techniques of which were introduced to the Pacific by the wives of missionaries in the nineteenth century.[23] Fascination with Polynesian and Micronesian art has continued unabated and reached a kitsch highpoint in the 1940s with the so-called 'tiki bars and restaurants', such as Trader Vic's, which still has restaurants in various parts of the world. Although the architectural surroundings of these dining extravaganzas purported to be Polynesian, the A-frame houses had Micronesian and New Guinea antecedents. Today, modern prints by John Pule and Fatu Feu'u grace living spaces throughout the world [**138**].

Notes

Chapter 1 Introduction to Polynesian and Micronesian Art

1. See Further Reading later in this book.
2. Many of them are descendants of immigrants to Oceania within the past 150 years.
3. See for example, the *marae* at Te Papa Tongarewa, National Museum of New Zealand, and carved gateways at museums in Dunedin, New Zealand, and Berlin, Germany.
4. J. Stephen Athens, David Tuggle, Jerome V. Ward, and David J. Welch. 'Avifaunal Extinctions, Vegetation Change, and Polynesian Impacts in Prehistoric Hawai'i', *Archaeology in Oceania*, 37 (2002), 57–78, 57n. 1.
5. Adrienne L. Kaeppler, 'Art and Aesthetics', in Alan Howard and Robert Borofsky (eds.), *Developments in Polynesian Ethnology* (Honolulu, 1989), 211–40, 237–8.
6. *Ibid.*, 213.
7. Terminology here is important. Weaving is done on a loom, and looms were not used in Polynesia. Mats were plaited (not woven); cordage was braided or twisted (not plaited).
8. For a history of research on Micronesian art, see Karen L. Nero, 'Missed Opportunities: American Anthropological Studies of Micronesian Arts', in *American Anthropology in Micronesia* (Honolulu, 1999).
9. Robert Louis Stevenson, *In the South Seas* (Honolulu, 1971 [1900]), 254.

Chapter 2 Artistic Visions, Rituals, and-Sacred Containers

1. Vilsoni Hereniko, *Woven Gods: Female Clowns and Power in Rotuma* (Honolulu, 1995). See also Vilsoni Hereniko, 'Dressing and Undressing the Bride and Groom at a Rotuman Wedding', in *The Art of Clothing: A Pacific Experience* (London, 2005), 103–9.
2. Sean Mallon and Pandora Fulimalo Pereira, *Speaking in Colour: Conversations with Artists of Pacific Island Heritage* (Wellington, 1997), 139.
3. See George Keate, *An Account of the Pelew Islands* (London, 1788), plate following p. 105 entitled 'View of Part of the Town of Pelew, and the place of Council'.
4. In 2005, the Tongan *lakalaka* was declared a 'Masterpiece of the Oral and Intangible Heritage of Humanity' by UNESCO.
5. See also Ellen Dissanayake, *Homo Aestheticus: Where Art Comes From and Why* (New York, 1992), especially chapter 3, 'The Core of Art: Making Special'.
6. See, for example, Maurice Bloch, 'Symbols, Song, Dance and Features of Articulation: Is Religion an Extreme Form of Traditional Authority?', *European Journal of Sociology*, 15 (1974), 55–81.
7. For a full discussion see Adrienne L. Kaeppler, 'Tongan Kava Bowls as Centerpieces for Performance', in *Gestern und Heute: Traditionen in der Südsee* (Berlin, 1997).
8. Roy A. Rappaport, 'The Obvious Aspects of Ritual', in *Ecology, Meaning, and Religion* (Richmond, Calif., 1979), 173–221, 175.
9. Hereniko, 'Dressing and Undressing', 103.
10. Christine Toren, 'Leonardo's "Last Supper" in Fiji', in Susan Hiller (introd. and comp.), *The Myth of Primitivism: Perspectives on Art* (London, 1991), 261–79, 273.
11. Fergus Clunie, *Yalo I Viti* (Suva, 1986), 172–3.
12. Glen Peterson, 'Kava in Pohnpei' and 'Pohnpei', *Garland Encyclopedia of World Music, ix: Australia and the Pacific Islands* (New York, 1998), 175, 740.
13. Saul H. Riesenberg, *The Native Polity of Ponape*, Smithsonian Contributions to Anthropology 10 (Washington, DC, 1968), 105–6.

14. Barbara B. Smith, *Garland Encyclopedia of World Music, ix.* 1035, and an excerpt on the associated CD.

15. Keate, *An Account of the Pelew Islands.*

16. *Ibid.*, 111–2.

17. *Ibid.*, 313.

18. Elsdon Best, *The Maori* (Wellington, 1924).

19. Margaret Orbell, *The Natural World of the Maori* (Auckland, 1985), 116.

20. Janet D. Keller, 'Woven World: Neotraditional Symbols of Unity in Vanuatu', *Mankind* 18/1 (1988), 1–13.

21. However, a few of the carved bone boxes are male. See, for example, the box in Sidney Mead (ed.), *Te Maori* (New York: Harry N. Abrams, Inc., 1984), No. 61, p. 194.

22. A. L. Kaeppler, C. Kaufmann, and D. Newton, *Oceanic Art* (New York, 1997), p. 46; Stephen Hooper, *Polynesian Art and Divinity* (London, 2006), 194.

23. Teuira Henry, *Ancient Tahiti* (Honolulu, 1928), 136.

24. Ibid. 157–77; Alain Babadzan, 'Les Dépouilles des dieux', *RES* 1 (1981), 13–18.

25. For more information and a CD with examples see 'Musical Instruments' in *Garland Encyclopedia of World Music*, ix. 371–403.

26. Adrienne L. Kaeppler, *Pahu and Puniu* (Honolulu, 1993).

27. See Hooper, *Polynesian Art and Divinity*, 199–201 for other examples of Austral drums.

Chapter 3 Aesthetics, Carving, Metaphor, and Allusion

1. Quoted in *Taonga Maori*, ed. Fiona Doig (Sydney, 1989), 45.

2. Kaeppler, 'Art and Aesthetics', 211. The first section of this chapter is based on my unpublished series of lectures 'Aesthetics: Evaluative Ways of Thinking', given at the University of California Berkeley, in 1986, when I was Una Lecturer in the Humanities.

3. Sidney M. Mead, 'Introduction', in *Exploring the Visual Art of Oceania* (Honolulu, 1979), 4.

4. Ralph R. Linton, *The Study of Man* (New York, 1936), 427.

5. *Ibid.*, 87.

6. *Ibid.*, 90.

7. Adrienne L. Kaeppler, 'Aesthetics of Tongan Dance', *Ethnomusicology*, 15/2 (1971), 175–85.

8. 'Te Māori', held in the United States and several venues in New Zealand, 1984; 'Taonga Māori', held in Sydney and Wellington, 1989; and 'Māori Art and Culture', held at the British Museum, London, 1998.

9. This section is based on concepts and examples found in Roger Neich, *Painted Histories: Early Figurative Painting* (Auckland, 1994) and *Carved Histories: Rotorua Ngati Tarawhai Woodcarving* (Auckland, 2001), and Anne Salmond, 'Te-Ao Tawhito: A Semantic Approach to the Traditional Maori Cosmos', *Journal of the Polynesian Society*, 87/1 (1978), 5–28.

10. Neich, *Painted Histories*, 92.

11. This information, explained in a label in the Auckland Museum, was given by members of the Te Aitanga-a-Hauiti *hapu* of the Ngati Porou tribe.

12. In his splendid book *Painted Histories*, Roger Neich explores the art history of Māori meetinghouses and the various artistic strands that led to their conception and evolution. Much of the next few pages is based on his insights as presented in his book. See pp. 146–7.

13. See, for example, F. Allan Hanson 'From Symmetry to Anthropophagy: The Cultural Context of Maori Art', *Empirical Studies of the Arts*, 3/1 (1985), 47–62; Neich, *Painted Histories*, 48–9.

14. Neich, *Painted Histories*, 183.

15. *Ibid.*, chapter 6.

16. *Ibid.* At least 85 meetinghouses were painted in a variety of styles between the 1870s and the 1920s.

17. *Ibid.*, 240–1.

18. Information about this entranceway is taken from the extended object label, through the kindness of Arapata Hakiwai, Director Māori of Te Papa Tongarewa.

19. See Adrienne L. Kaeppler, 'Genealogy and Disrespect', *RES* 3 (Spring 1982), 82–107.

20. David Malo, *Hawaiian Antiquities* (Honolulu, 1951 [1898]), 143.

21. Carol S. Ivory, 'Art and Aesthetics in the Marquesas Islands', in Eric Kjellgren and Carol S. Ivory (eds.), *Adorning the World: Art of the Marquesas Islands* (New York, 2006), 33.

22. Adrienne L. Kaeppler, *Hula Pahu: Hawaiian Drum Dances* (Honolulu, 1993).

23. Kenneth P. Emory, personal communication. When Emory was carrying out research in the Tuamotus in the 1930s, his Tuamotuan friends would fashion a bracelet for him in conjunction with a

prayer to protect him on his way home each evening.

24. W. S. W. Ruschenberger, *A Voyage Round the World Including an Embassy to Muscat and Siam in 1835, 1836, and 1837* (Philadelphia, 1838), 455.

25. From an explanatory handout at the exhibition.

26. See Adrienne L. Kaeppler, 'Sculptures of Barkcloth and Wood from Rapa Nui', *RES* 44 (Autumn 2003), 10–69.

27. Patrick Vinton Kirch and Roger C. Green, *Hawaiki, Ancestral Polynesia: An Essay in Historical Anthropology* (Cambridge, 2001), 185.

28. E. T. Doane, 'The Caroline Islands', *Geographical Magazine*, 1 (1874), 204.

29. A. F. Krämer, *Inseln um Truk.* (Hamburg, 1935), 118.

30. That is, they were mounted on the inside of the houses and not on the outside gable as some writers have suggested, for example, Ralph Linton and Paul S. Wingert, *Arts of the South Seas* (New York, 1946), 74.

31. Mac Marshall, personal communication, 1995.

32. Janet M. Davidson, 'A Wooden Image from Nukuoro in the Auckland Museum', *Journal of the Polynesian Society*, 77/1 (1968), 77–9, 78.

33. J. D. E. Schmeltz and R. Krause, *Die ethnographisch-anthropologische Abteilung des Museum Godeffroy in Hamburg* (Hamburg, 1881), quoted in Bernard de Grunne, 'Beauty in Abstraction: The Barbier-Mueller Nukuoro Statue', *Bulletin des Amis du Musée Barbier-Mueller* (1994), n. 21. They also name a male figure in Hamburg as 'Ko Kawe', but this is unlikely, as Kawe was a female god.

34. Rosalind Krauss, 'Giacometti', in *Primitivism in 20th Century Art* (New York, 1984), 521.

Chapter 4 Genealogical Connections: The Texts of Textiles

1. This section is based on Kaeppler, 'Kie Hingoa: Mats of Power, Rank, Prestige and History', *Journal of the Polynesian Society*, 108/2 (1999), 168–232.

2. The name *sisi fale* may derive from the fabrication of this intricate overskirt under a veil of secrecy, that is, in a house, thus *sisi*–decorated girdle–and *fale*–house.

3. Georg Forster, *A Voyage round the World* (Berlin, 1986), 255.

4. J. C. Beaglehole, *The Journals of Captain James Cook on his Voyages of Discovery: The Voyage of the Resolution and Discovery 1776–1780* (Cambridge, 1967), 1037.

5. Kenneth Bain, *The Friendly Islanders* (London, 1967), 78.

6. *Ibid.*, 38.

7. John Martin and William Mariner, *An Account of the Natives of the Tonga Islands in the South Pacific Ocean* (Edinburgh, 1827), 110–13.

8. *Ibid.*, 97.

9. *Ibid.*

10. *Ibid.*, 267.

11. See video, '*Wedding in Nuku'alofa,*' Juniper films (Sydney, 2003).

12. In the Palace archives, file POA/6/2B.

13. Tauese Sunia, personal communication, 1994.

14. Adrienne L. Kaeppler, 'A Survey of Polynesian Art', in *Exploring the Visual Art of Oceania* (Honolulu, 1979), 189–90.

15. Kaeppler, 'Sculptures of Barkcloth and Wood from Rapa Nui'.

16. For this section, see Simon Kooijman, *Tapa in Polynesia* (Honolulu, 1972); Kaeppler, 'Animal Designs in West Polynesian Barkcloth', *Journal of the Polynesian Society* (2005).

17. Roger Neich and Mick Pendergrast, *Pacific Tapa* (Auckland, 1997), 14, 16.

18. Mary J. Pritchard, *Siapo: Bark Cloth Art of Samoa* (American Sāmoa, 1984).

19. Revd George Pratt, *A Grammar and Dictionary of the Samoan Language* (London, 1911), gives different terms.

20. Augustin Krämer, *The Samoa Islands . . .* (Honolulu, 1995 [1902–3]), ii. 357, 359.

21. Kooijman, *Tapa in Polynesia*, 414.

22. Peter H. Buck, *Samoan Material Culture* (Honolulu, 1930), 313; Kooijman, *Tapa in Polynesia*, 289, Neich and Pendergrast, *Pacific Tapa*, 69; and Nicholas Thomas, 'The Case of the Misplaced Ponchos', *Journal of Material Culture*, 4/1 (1999), 5–20.

23. John Pule, personal communication.

24. Kaeppler, 'Airplanes and Saxophones: Post-War Images in the Visual and Performing Arts', *Echoes of Pacific War* (Canberra, 1998), 38–63.

25. Charles Wilkes, *Narrative of the United States Exploring Expedition* (Washington, DC, 1845), iii. 121.

26. Marshall Sahlins, *Islands of History* (Chicago, 1985), 85.

27. *Ibid.*, 87.

28. John Williams, *A Narrative of Missionary Enterprises in the South Sea*

Islands (London, 1837), 319.

29. Donald H. Rubinstein, 'The Social Fabric: Micronesian Textile Patterns as an Embodiment of Social Order', in *Mirror and Metaphor: Material and Social Constructions of Reality* (Lanham, Md., 1986), 61.

30. Glenn Petersen, 'Ponapean Matriliny: Reproduction, Exchange, and the Ties that Bind', *American Ethnologist*, 9/1 (1982), 129–44.

Chapter 5 Adorning the Adorned: Tattoo, Ornaments, Clothing, Fashion

1. Augustin Krämer, 'The Ornamentation of Dress Mats and Tattooing in the Marshall Islands', *Archiv für Anthropologie*, 30 (1904), 1–18. Translated by Ilse Grimm.

2. *Ibid.*

3. Roger C. Green, 'Early Lapita Art from Polynesia and Island Melanesia: Continuities in Ceramic, Barkcloth, and Tattoo Decorations', in *Exploring the Visual Art of Oceania* (Honolulu, 1979), 13–31.

4. Carol S. Ivory, 'Marquesan Art in the Early Contact Period, 1774–1821', Ph.D. dissertation (University of Washington, Seattle, 1990); 'Marquesan Art and Aesthetics', in *Adorning the World* (New York, 2005).

5. Adrienne Kaeppler, 'Hawaiian Tattoo: A Conjunction of Genealogy and Aesthetics', in *Marks of Civilization* (Los Angeles, 1988), 157–70.

6. Michael Jackson, 'Aspects of Symbolism and Composition in Maori Art', *Bijdragen tot de Taal, Land en Volkenkunde*, 128 (1972), 33–80, 70; Peter Gathercole, 'Contexts of Maori Moko', in *Marks of Civilization*, 171–7, 175.

7. Sean Mallon, *Samoan Art & Artists* (Nelson, 2002), 152.

8. Palace Office Archives, Nuku'alofa, file POA/11/2B.

9. Williams, *Narrative*, 324–5.

10. This section is based on Adrienne L. Kaeppler, 'Hawaiian Art: From Sacred Symbol to Tourist Icon to Ethnic Identity Marker', in *Anthropology, History, and American Indians: Essays in Honor of William Curtis Sturtevant* (Washington, DC, 2002), 147–60.

11. Mary Kawena Pukui and Samuel H Elbert, *Hawaiian Dictionary* (Honolulu, 1971), 5.

12. Samuel Manaiakalani Kamakau, *Tales and Traditions of the People of Old*

(Honolulu, 1991), 162–3.

13. Kamakau, *The Works of the People of Old* (Honolulu, 1976), 143.

14. Similar concepts of sacred processes for making sacred fibrous products by prayer and entanglement were found in Tahiti, as was the importance of the addition of red feathers (see the Orsmond Manuscript in Bishop Museum Archives for twenty pages of *ahu* entries).

15. Yellow feathers were rarer and more difficult to procure; they came from birds that were primarily black. In the 19th century, yellow feathers acquired a political significance in that only powerful chiefs could obtain them.

16. Pukui and Elbert, *Hawaiian Dictionary*, 5.

17. *Ibid.*, 155.

18. *Ibid.*, 68.

19. E. S. Craighill Handy and Mary Kawena Pukui, *The Polynesian Family System in Ka-'ū, Hawai'i* (Wellington, 1958), 181–2.

20. Adrienne L. Kaeppler, 'Hawaiian Art and Society: Traditions and Transformations', in *Transformations of Polynesian Culture* (Auckland, 1985), 105–31.

21. George Pratt, *Dictionary of the Samoan Language* (Malua, 1911), 317.

22. Elizabeth Cory-Pearce, 'Surface Attraction: Clothing and the Mediation of Maori/European Relationships', *The Art of Clothing: A Pacific Experience* (London, 2005), 73–87.

23. Rosanna Raymond, 'Getting Specific: Fashion Activism in Auckland during the 1990s: A Visual Essay', in *Clothing the Pacific* (Oxford, 2003), 193–208.

Chapter 6 Ritual Spaces, Cultural Landscapes: Space, and the Aesthetic Environment

1. William Wyatt Gill, *Myths and Songs from the South Pacific* (London, 1876).

2. Stephen Hooper, *Pacific Encounters: Art & Divinity in Polynesia 1760–1860* (London, 2006), 73.

3. Teuira Henry, *Ancient Tahiti* (Honolulu, 1928), 348.

4. Personal communication from Sister Tu'ifua, a Tongan Catholic nun, and a descendant of the highest chiefs of Tonga.

5. R. W. Brougan, 'Where Does Art Begin in Puluwat', in *Exploring the Visual Arts of Oceania* (Honolulu, 1979), 347.

6. William H. Alkire, *Lamotrek Atoll and Inter-Island Socioeconomic Ties* (Urbana, Ill.,

1965), 118.

7. See William N. Morgan, *Prehistoric Architecture in Micronesia* (Austin, Tex., 1988); and William S. Ayres, 'Pohnpei's Position in Eastern Micronesian Prehistory', *Micronesica*, 2 (1990), 187–211.

8. Ayres, 'Pohnpei's Position'.

9. R. J. Parmentier, 'Diagrammatic Icons and Historical Processes in Belau', *American Anthropologist*, 87/4 (1985), 840–52.

10. Parmentier, review of *The Art of Micronesia, Pacific Studies*, 14/4 (1991), 178–82.

11. Augustin Krämer, 'Palau', in *Ergebnisse der Südsee Expedition, 1908–1910* (Hamburg, 1919).

12. Marshal Sahlins, *Moala* (Ann Arbor, ?1976), 32.

13. See Raymond Firth, *We, the Tikopia* (New York, 1936), 75–81; and Patrick V. Kirch, 'Tikopia Social Space Revisited', *Oceanic Culture History, New Zealand Journal of Archaeology* Special Publication (Otago, 1996), 257–74.

14. David J. Herdrich, 'Towards an Understanding of Samoan Star Mounds', *Journal of the Polynesian Society*, 100/4 (1991), 381–435, 381, 415.

15. *Ibid.*, 404.

16. Peter Bellwood, *Archaeological Research in the Cook Islands* (Honolulu, 1978).

17. Kamakau, *The Works of the People of Old*, 136. See Chapter 3 for a modern version of a Kukalepa.

18. Peter Gathercole, 'Maori Painted Paddles', in *Art as a Means of Communication in Pre-Literate Societies* (Jerusalem, 1990).

19. For further information on this section see Jo Anne Van Tilburg, *Easter Island: Archaeology, Ecology, and Culture* (Washington, DC, 1994); and 'Changing Faces: Rapa Nui Statues in the Social Landscape', in Eric Kjellgren, *Splendid Islolation: Art of Easter Island* (New York, 2001).

20. Accounts of Rapa Nui birdman rituals can be found in K. S. Routledge, *The Mystery of Easter Island* (London, 1919), 254 ff.; Alfred Métraux, *Ethnology of Easter Island* (Honolulu, 1940), 331 ff.; and Van Tilburg, *Easter Island*, 58 ff.

21. J. Anne Van Tilburg, *HMS Topaze on Easter Island: Hoa Hakananai'a and Five Other Museum Sculptures in Archaeological Context* (London, 1992), 194–95.

22. Ruth Y. Cox, *Copperplate Textiles in the Williamsburg Collection* (Williamsburg, Va., 1964), 11–14.

23. John Klein, 'Un artiste français en Océanie: Henri Matisse et Tahiti', in *Océanie: La Découverte du paradis: Curieux, navigateurs et savants* (Paris, 1997), 132–6.

Further Reading

General Works on Oceanic Art, including Polynesia and Micronesia

Bellwood, Peter, *Man's Conquest of the Pacific*. New York: Oxford University Press, 1979.

Brake, Brian, with McNeish, James, and Simmons, David, *Art of the Pacific*. New York: Harry N. Abrams, Inc., 1979.

Buehler, Alfred, Barrow, Terry, and Mountford, Charles P., *The Art of the South Sea Islands, Including Australia and New Zealand*. New York: Crown Publishers, 1962.

D'Alleva, Anne, *Arts of the Pacific Islands*. New York: Harry N. Abrams, Inc., 1998.

Dark, Philip (ed.), *Developments in the Arts of the Pacific*, Occasional Papers of the Pacific Arts Association No. 1. Wellington, 1984.

Duff, Roger, and Park, Stuart, *The Art of Oceania*. Paris: UNESCO, 1975.

Edge-Partington, James, *An Album of the Weapons, Tools, Ornaments, Articles of Dress, etc. of the Natives of the Pacific Islands, Drawn and Described from Examples in Public and Private Collections in England*. Manchester, 1890–8.

Edmundson, Anna, and Boylan, Chris, *Adorned: Traditional Jewellery and Body Decoration from Australia and the Pacific*. Sydney: Macleay Museum, University of Sydney, 1999.

Force, Roland W., and Force, Maryanne, *The Fuller Collection of Pacific Artifacts*. New York: Praeger Publications, 1971.

Gathercole, Peter, Kaeppler, Adrienne L., and Newton, Douglas, *The Art of the Pacific Islands*. Washington: National Gallery of Art, 1979.

Guhr, Gunter, and Neumann, Peter (eds.), *Ethnographisches Mosaik*. Dresden: Museums für Völkerkunde, 1982.

Guiart, Jean, *Oceanie*. Paris: Gallimard, 1963.

Hanson, Allan, and Hanson, Louise (eds.), *Art and Identity in Oceania*. Honolulu: University of Hawai'i Press, 1990.

Hanson, Louise, and Hanson, F. Allan, *The Art of Oceania: A Bibliography*. Boston: G. K. Hall, 1984.

Hornell, James, *The Canoes of Polynesia, Fiji, and Micronesia*. Honolulu: Bishop Museum Press, 1936.

Joppien, Rüdiger, and Smith, Bernard, *The Art of Captain Cook's Voyages, i: The Voyage of the Endeavour 1768–1771*. New Haven: Yale University Press, 1985; ii: *The Voyage of the Resolution and Adventure 1772–1775*. New Haven: Yale University Press, 1985; iii: *The Voyage of the Resolution and Discovery 1776–1780*. Melbourne: Oxford University Press, 1987.

Kaeppler, Adrienne L., Kaufmann, Christian, and Newton, Douglas, *L'Art océanien*. Paris: Citadelles & Mazenod, 1993.

—— *Oceanic Art*. New York: Abrams, 1997.

Kirch, Patrick Vinton, *The Evolution of the Polynesian Chiefdoms*. Cambridge: Cambridge University Press, 1984.

Linton, Robert, and Wingert, Paul S., *Arts of the South Seas*. New York: Museum of Modern Art, 1946.

Mead, Sidney M. (ed.), *Exploring the Visual Art of Oceania*. Honolulu: University Press of Hawai'i, 1979.

—— and Kernot, Bernie (eds.), *Art and Artists of Oceania*. Auckland: Dunmore Press, 1983.

Musée de L'Homme, *La Découverte de la Polynésie*. Paris: Musée de l'Homme, 1972.

Neich, Roger, and Pereira, Fuli, *Pacific Jewelry and Adornment*. Honolulu: University of Hawai'i Press, 2004.

Notter, Annick (ed.), *La Découverte du paradis Océanie: Curieux, navigateurs et savants*. Paris: Somogy Éditions d'Art, 1997.

Peltier, Philippe, 'From Oceania', in *'Primitivism' in 20th Century Art* New York: The Museum of Modern Art, 1984: 99–122.

Phelps, Steven, *Art and Artefacts of the Pacific, Africa, and the Americas: The James Hooper Collection*. London: Hutchinson, 1975.
Polynesian Society, *Future Directions in the Study of the Arts of Oceania*, special issue of *Journal of the Polynesian Society*, 90/2 (1981).
Thomas, Nicholas, *Oceanic Art*. London: Thames and Hudson Ltd., 1995.
—— Cole, Anna, and Douglas, Bronwen (eds.), *Tattoo: Bodies, Art and Exchange in the Pacific and the West*. London: Reaktion Books Ltd., 2005.
Tischner, H., and Hewicker, F., *Oceanic Art*. London: Pantheon, 1954.

Further Reading for Polynesia

Aitken, R. T., *Ethnology of Tubuai*. Honolulu: Bishop Museum Press, 1930.
Archey, Gilbert, *The Art Forms of Polynesia*. Auckland: Auckland Museum, 1933.
Babadzan, Alain 'Les Dépouilles des dieux', *RES* 1 (1981), 8–39.
—— 'Les Idoles des iconoclastes', *RES* 4 (1982), 62–84.
—— 'From Oral to Written: The *Puta Tupuna* of Rurutu', in Antony Hooper and Judith Huntsman. (eds.), *Transformations of Polynesian Culture*. Auckland: The Polynesian Society, 1985.
Barrow, T., 'Maori Decorative Art: An Outline', *Journal of the Polynesian Society*, 65/4 (1956), 305–31.
—— *Maori Wood Sculpture of New Zealand*. Rutland, Vt.: Charles E. Tuttle Company, 1969.
—— *Art and Life in Polynesia*. London: Pall Mall Press, 1971.
Bellwood, Peter, S., *Archaeological Research in the Cook Islands*. Honolulu: Bishop Museum, 1978,
Blackman, Margery, 'Two Early Maori Cloaks', *New Zealand Crafts*, 13 (1985), 12–15.
Brigham, William T., *Hawaiian Feather Work*. Honolulu: Bishop Museum Press, 1899.
—— *Additional Notes on Hawaiian Feather Work*. Honolulu: Bishop Museum Press, 1903.
—— *Mat and Basket Weaving of the Ancient Hawaiians*. Honolulu: Bishop Museum Press, 1906.
—— *Ka Hana Kapa: The Making of Bark Cloth in Hawaii*. Honolulu: Bishop Museum Press, 1911.
—— *Supplementary Notes to an Essay on Ancient Hawaiian Feather Work*. Honolulu. Bishop Museum Press, 1918.

Buck, Peter H. (T. Rangi Hiroa), *Samoan Material Culture*. Honolulu: Bishop Museum Press, 1930.
—— *Mangaian Society*. Honolulu: Bishop Museum Press, 1934.
—— 'Material Representatives of Tongan and Samoan Gods', *Journal of the Polynesian Society*, 44 (1935), 48–53, 85–96, 153–62.
—— 'Additional Wooden Images from Tonga', *Journal of the Polynesian Society*, 46 (1937), 74–82.
—— *Ethnology of Mangareva*. Honolulu: Bishop Museum Press, 1938.
—— *Arts and Crafts of the Cook Islands*. Honolulu: Bishop Museum Press, 1944.
—— *Arts and Crafts of Hawaii*. Honolulu: Bishop Museum Press, 1957.
Burrows, Edwin G., *Ethnology of Futuna*. Honolulu: Bishop Museum Press, 1936.
—— *Ethnology of Uvea (Wallis Island)*. Honolulu: Bishop Museum Press, 1937.
Churchill, William, *Club Types of Nuclear Polynesia*. Washington, DC: The Carnegie Institution, publication 255, 1917.
Clunie, Fergus, *Yalo i Viti, Shades of Viti: A Fiji Museum Catalogue*. Suva: Fiji Museum, 1986.
Cox, J. Halley, with Davenport, William H., *Hawaiian Sculpture*. Honolulu: University of Hawai'i, 1988.
—— with Stasack, Edward, *Hawaiian Petroglyphs*. Honolulu: Bishop Museum Press, 1970.
Davidson, Janet M., 'A Wooden Image from Nukuoro in the Auckland Museum', *Journal of the Polynesian Society*, 77/1 (1968), 77–9.
—— 'The Wooden Image from Samoa in the British Museum: A Note on its Context', *Journal of the Polynesian Society*, 84 (1975), 352–5.
Dodd, Edward, *Polynesian Art*. New York: Dodd, Mead & Company, 1967.
Donnay, J. D. H., and Donnay, Gabrielle, 'Symmetry and Antisymmetry in Maori Rafter Designs', *Empirical Studies of the Arts*, 3/1 (1985), 23–45.
Duff, Roger, *No Sort of Iron: Culture of Cook's Polynesians*. Christchurch: Caxton Press, 1969.
Ellis, William, *Polynesian Researches*. London, 1829.
Emerson, J. S., 'The Lesser Hawaiian Gods', *Hawaiian Historical Society Papers*, 2 (1892), 1–24.
Emory, Kenneth P., *Stone Remains in the Society Islands*. Honolulu: Bishop Museum Press, 1933.

—— *Material Culture of the Tuamotu Archipelago*. Honolulu: Bishop Museum Department of Anthropology, 1975.

Fiji Museum, *Domodomo*, (Fiji Museum Quarterly), Suva, 1983–7.

Firth, Raymond, *We, the Tikopia*. London: George Allen and Unwin, 1936.

—— 'Tikopia Art and Society'. in Anthony Forge (ed.), *Primitive Art and Society* Oxford: Oxford University Press, 1973.

Fox, Aileen, *Carved Maori Burial Chests*. Auckland: Auckland Institute and Museum Bulletin No. 13, 1983.

Gathercole, Peter, 'Obstacles to the Study of Maori Carving: The Collector, the Connoisseur, and the Faker', in *Art in Society: Studies in Style, Culture and Aesthetics*. London: Duckworth, 1978: 275–88.

—— 'Maori Godsticks and their Stylistic Affinities', in Atholl Anderson (ed.), *Birds of a Feather*. Oxford: BAR International Series, 1979: 285–95.

—— 'The Contexts of Maori Moko', in Arnold Rubin, (ed.), *Marks of Civilization*. Los Angeles: Museum of Cultural History, 1988: 171–7.

—— 'Maori Painted Paddles', in Dan Eban (ed.), *Art as a Means of Communication in Pre-literate Societies*, Jerusalem: The Israel Museum, 1990.

Gell, Alfred, *Wrapping in Images: Tattooing in Polynesia*. Oxford: Clarendon Press, 1993.

Gifford, Edward Winslow, *Tongan Society*. Honolulu: Bishop Museum Press, 1929.

Green, Roger C., 'Early Lapita Art from Polynesia and Island Melanesia: Continuities in Ceramic, Barkcloth, and Tattoo Decorations', in Sidney M. Mead (ed.), *Exploring the Visual Art of Oceania*, Honolulu: University Press of Hawai'i, 1979.

Greiner, Ruth, *Polynesian Decorative Designs*. Honolulu: Bishop Museum Press, 1923.

Hamilton, Augustus, *Maori Art*. Dunedin: Fergusson and Mitchell, 1901.

Handy, E. S. C., *The Native Culture in the Marquesas*. Honolulu: Bishop Museum, 1923.

Handy, Willowdean, *Tattooing in the Marquesas*. Honolulu: Bishop Museum, 1922.

Hanson, F. Allan, 'From Symmetry to Anthropophagy: The Cultural Context of Maori Art', *Empirical Studies of the Arts*, 3/1 (1985), 47–62.

Henry, Teuira, *Ancient Tahiti*. Honolulu: Bishop Museum Press, 1928.

Heyerdahl, Thor, *The Art of Easter Island*.

London: George Allen and Unwin Ltd., 1976.

Hooper, Steven, *Pacific Encounters: Art & Divinity in Polynesia 1760–1860*. London: British Museum Press, 2006.

—— 'A Study of Valuables in the Chiefdom of Lau, Fiji', Ph.D. thesis, Cambridge University, 1982.

Howard, Alan, 'Symbols of Power and the Politics of Impotence: The Molmahao Rebellion on Rotuma', *Pacific Studies*, 15 (1992), 83–116.

Idiens, Dale, *Cook Islands Art*. Princes Risborough: Shire Publications, 1990.

Ivory, Carol Susan, 'Marquesan Art in the Early Contact Period 1774–1821', Ph.D. dissertation, University of Washington, Seattle, 1990.

Jackson, Michael, 'Aspects of Symbolism and Composition in Maori Art', *Bijdragen tot de Taal-, Land-en Volkenkunde*, 128 (1972), 33–80.

Kaeppler, Adrienne L., *The Fabrics of Hawai'i (Bark Cloth)*. Leigh-on-Sea: F. Lewis, Publishers, 1975.

—— *"Artificial Curiosities," Being an Exposition of Native Manufactures Collected on the Three Pacific Voyages of Captain James Cook, R.N.* Honolulu: Bishop Museum Press, 1978.

—— 'Exchange Patterns in Goods and Spouses: Fiji, Tonga, and Samoa', *Mankind*, 11/3 (1978), 246–52.

—— 'Hawaiian Tattoo: A Conjunction of Genealogy and Aesthetics', in Arnold Rubin (ed.), *Marks of Civilization*. Los Angeles: University of California Press, 1988: 157–70.

—— 'Art and Aesthetics', in Alan Howard and Robert Borofsky (eds.), *Developments in Polynesian Ethnology*. Honolulu: University of Hawai'i Press, 1989: 211–40.

—— 'Poetics and Politics of Tongan Barkcloth', in *Pacific Material Culture: Essays in Honour of Dr. Simon Kooijman*. Leiden: Rijksmuseum voor Volkenkunde, 1995: 101–21.

—— *From the Stone Age to the Space Age in 200 Years: Tongan Art and Society on the Eve of the Millennium*. Nuku'alofa: Vava'u Press, 1999.

Kamakau, Samuel Manaiakalani, *Ka Po'e Kahiko: The People of Old*. Honolulu: Bishop Museum Press, 1964.

—— *The Works of the People of Old*. Honolulu: Bishop Museum Press, 1976.

—— *Tales and Traditions of the People of Old*. Honolulu: Bishop Museum Press, 1991.

Kirch, Patrick Vinton, 'Ethno-archaeological Investigations in Futuna and Uvea (Western Polynesia): A Preliminary Report', *Journal of the Polynesian Society* 85/1 (1976), 27–69.

Kjellgren, Eric (ed.), *Splendid Isolation: Art of Easter Island*. New York: Metropolitan Museum of Art, 2001.

—— (ed.), *Adorning the World: Art of the Marquesas Islands*. New York: Metropolitan Museum of Art, 2005.

Kleinschmidt, Theodor, 'Theodor Klein-schmidt's Notes on the Hill Tribes of Viti Levu, 1877–78', *Domodomo*, (Fiji Museum Quarterly), 2/4 (1984), 146–90.

Koch, Gerd, *Die Materielle Kultur der Ellice-Inseln*. Berlin: Museums für Volkerkunde, 1961.

Kooijman, Simon, *Tapa in Polynesia*. Honolulu: Bishop Museum Press, 1972

Larsson, Karl Erik, *Fijian Studies*. Goteberg: Etnografiska Museet, 1960.

Lavondes, Anne, 'L'art polynésien: origins et évolution', *Archeologia* (Paris), 46 (May 1972), 19–26.

Lee, Georgia, and Stasack, Edward, *Spirit of Place: The Petroglyphs of Hawai'i*. Los Osos, Calif.: Easter Island Foundation, 1999.

Linton, Ralph, *The Material Culture of the Marquesas Islands*. Honolulu: Bishop Museum Press, 1923.

—— *Archaeology of the Marquesas Islands*. Honolulu: Bishop Museum Press, 1925.

Loeb, E. M., *History and Traditions of Niue*. Honolulu: Bishop Museum Press, 1926.

McEwen, J. M., 'Maori Art', in A. H. McLintock (ed.), *An Encyclopaedia of New Zealand*. Wellington: R. E. Owen, 1966: ii. 408–29.

MacGregor, Gordon, *Ethnology of the Tokelau Islands*. Honolulu: Bishop Museum Press, 1937.

McKern, W. C., *Tongan Archaeology*. Honolulu: Bishop Museum Press, 1929.

Mallon, Sean, *Samoan Art and Artists*. Nelson: Craig Potton Publishing, 2002.

—— and Pereira, Pandora Fulimalo, *Speaking in Colour: Conversations with Artists of Pacific Island Heritage*. Wellington: Te Papa Tongareva, 1997.

Malo, David, *Hawaiian Antiquities*. Honolulu: Bishop Museum Press, 1951.

Mead, Margaret, *Social Organization of Manu'a*. Honolulu: Bishop Museum Press, 1930.

Mead, Sidney M., 'An Analysis of Form and Decoration in Polynesian Adze Hafts',

Journal of the Polynesian Society, 80 (1971), 485–96.

—— (ed.), *Te Maori: Maori Art from New Zealand Collections*. New York: Harry N. Abrams, Inc., 1984.

—— Birks, L., Birks, H., and Shaw, E., *The Lapita Pottery Style of Fiji and its Associations*. Wellington: Polynesian Society Memoir No. 38, 1973.

Metraux, Alfred, *Ethnology of Easter Island*. Honolulu: Bishop Museum Press, 1940.

National Museum of New Zealand, *Taonga Maori: Treasures of New Zealand Maori People*. Sydney: Australian Museum, 1989.

Neich, Roger, *Material Culture of Western Samoa*. Wellington: National Museum of New Zealand, 1985.

—— *Painted Histories: Early Maori Figurative Painting*. Auckland: University Press, 1994.

—— *Carved Histories: Rotorua Ngati Tarawhai Woodcarving*. Auckland: University Press, 2001.

Pendergrast, Mick, *Te Aho Tapu: The Sacred Thread*. Honolulu: University of Hawai'i Press, 1987.

Pule, John, and Thomas, Nicholas, *Hiapo: Past and Present in Niuean Barkcloth*. Dunedin: Otago University Press, 2005.

Rose, Roger G., *Symbols of Sovereignty: Feather Girdles of Tahiti and Hawai'i*. Honolulu: Bishop Museum Anthropology Department, 1978.

—— *Hawai'i: The Royal Isles*, introd. Adrienne L. Kaeppler. Honolulu: Bishop Museum Press, 1980.

Rosenthal, Mara Elena, 'Realms and Ritual: The Form and Rise of Civitas and Urbs in Southeastern Viti Levu, Fiji', Ph.D. thesis, University of Chicago, 1991.

Salmond, Anne, 'Te Ao Tawhito: A Semantic Approach to the Traditional Maori Cosmos', *Journal of the Polynesian Society*, 87/1 (1978), 5–28.

Shore, Bradd, 'Mana and Tapu', in Alan Howard and Robert Borofsky (eds.), *Developments in Polynesian Ethnology*. Honolulu: University of Hawai'i Press, 1989.

Skinner, H. D., 'Origin and Relationships of Maori Material Culture and Decorative Art', *Journal of the Polynesian Society*, 33 (1924), 229–43.

—— *Comparatively Speaking: Studies in Pacific Material Culture 1921–1972*. Dunedin: University of Otago Press, 1974.

Starzecka, Dorota Czarkowska, *Hawai'i: People and Culture*. London: British Museum, 1975.

—— (ed.), *Maori Art and Culture*. London: British Museum Press, 1996.

Steinen, Karl von den, *Die Marquesaner und ihre Kunst*, 3 vols. Berlin, 1925–8.

Stevenson, Karen, 'Dispelling the Myth: Tahitian Adornment and the Maintenance of a Traditional Culture, 1767–1819', Ph.D. dissertation, University of California, Los Angeles, 1988.

Stokes, John F. G., *Heiau of the Island of Hawai'i: A Historic Survey of Native Hawaiian Temple Sites*, ed. Tom Dye. Honolulu: Bishop Museum Press, 1991.

Tamati-Quennell, Megan, *Pu Manawa: A Celebration of Whatu, Raranga and Taniko*. Wellington: Museum of New Zealand Te Papa Tongarewa, 1993.

Taonga Maori Conference, *Taonga Maori Conference, New Zealand, 18–27 November*. Wellington: Department of Internal Affairs, 1990.

Teilhet, J. (ed.), *Dimensions of Polynesia*. San Diego: Fine Arts Gallery, 1973.

Thode-Arora, Hilke, *Tapa und Tiki: Die Polynesien-Sammlung des Rautenstrauch-Joest-Museums*. Cologne: Rautenstrauch-Joest-Museums, 2001.

Van Tilburg, Jo Anne, *HMS Topaze on Easter Island: Hoa Hakananai'a and Five Other Museum Sculptures in Archaeological Context*. London: British Museum Department of Ethnography, Occasional Paper 73, 1992.

—— *Easter Island: Archaeology, Ecology, and Culture*. Washington, DC: Smithsonian Institution Press, 1994.

Valeri, Valerio, *Kingship and Sacrifice: Ritual and Society in Ancient Hawai'i*. Chicago: University of Chicago Press, 1985.

Verin, P., *L'Ancienne Civilisation de Rurutu*. Paris: ORSTOM Mémoires 33, 1969.

Wardwell, Allen, *The Sculpture of Polynesia*. Chicago: Art Institute, 1967.

Further Reading for Micronesia

Alkire, William H., *Lamotrek Atoll and Inter-Island Socioeconomic Ties*. Urbana, Ill.: University of Illinois Press, 1965.

—— *An Introduction to the Peoples and Cultures of Micronesia*. Menlo Park, Calif.: Cummings Publishing Co., 1977.

Ashby, Gene (ed.), *Micronesian Customs and Beliefs . . . by the Students of the Community College of Micronesia*. Eugene, Ore.: Rainy Day Press, 1983.

Ayres, William S., 'Pohnpei's Position in Eastern Micronesian Prehistory', *Micronesica*, 2 (1990), 187–211.

Bourgoin, Philippe, 'Hermits and Kaniets', *Tribal Arts*, 4/1 (1997), 64–79.

Burrows, Edwin Grant, *Flower in my Ear: Arts and Ethos of Ifaluk Atoll*. Seattle: University of Washington Press, 1963.

Cordy, Ross, *The Lelu Stone Ruins (Kosrae, Micronesia)*. Asian and Pacific Archaeology Series 10. Honolulu: University of Hawai'i, 1993.

Davenport, William A., 'Marshall Islands Navigational Charts', *Imago Mundi*, 15 (1960), 19–26.

—— 'Marshall Islands Cartography', *Expedition*, 6/4 (1964), 10–13.

Duperrey. L, *Mémoire sur les opérations géographiques faites dans la campagne de la corvette de Sa Majesté 'La Coquille' pendant les années 1822, 1823, 1824, et 1825*. Paris: Huzard-Coucier, 1827.

Feldman, Jerome, Rubinstein, Donald H., and Mason, Leonard, *The Art of Micronesia*. Honolulu: University of Hawai'i, 1986.

Fischer, Jack L., *The Eastern Carolines*. New Haven: Human Relations Areas Files Press, 1966.

Force, Roland W., 'Palauan Money: Some Preliminary Comments on Material and Origins', *Journal of the Polynesian Society*, 68/1 (1959), 40–44.

Furness, W. H., *The Island of Stone Money: Yap of the Carolines*. Philadelphia: Lippencott and Co., 1910.

Gillilland, Cora Lee C., *The Stone Money of Yap: A Numismatic Survey*. Washington, DC: Smithsonian Institution Press, 1975.

Grimble, Arthur F., *Tungaru Traditions: Writings on the Atoll Culture of the Gilbert Islands*, ed. Harry Maude. Honolulu: University of Hawai'i Press, 1989.

Hezel, F. X., *The First Taint of Civilization: A History of the Caroline and Marshall Islands in Pre-colonial Days, 1521–1885*. Honolulu: University of Hawai'i Press, 1983.

Hijikata, Hisakatsu, *Gods and Religion of Palau*, ed. Hisashi Endo. Tokyo: Sasakawa Peace Foundation, 1995.

Hockings, John, *Traditional Architecture in the Gilbert Islands: A Cultural Perspective*. St Lucia: University of Queensland Press, 1989.

Jernigan, E., 'Lochukle: A Palauan Art Tradition'. Ph.D. dissertation, University of Arizona, 1973.

Kaeppler, Adrienne L., 'The Decorative Arts in the Marshall Islands', in E. H. Bryan, Jr. (ed.), *Life in the Marshall Islands*. Honolulu: Pacific Scientific Information Center: 164–72.

Keate, George (ed.), *An Account of the Pelew Islands*. London: G. Nicol, 1803.

Kiste, Robert C., and Marshall, Mac, *American Anthropology in Micronesia*. Honolulu: University of Hawai'i Press, 1999.

Koch, Gerd, *Materielle Kultur der Gilbert-Inseln*. Berlin: Museum für Völkerkunde, 1965.

Krauss, Rosalind, 'Giacometti', in William Rubin (ed.), *'Primitivism' in 20th Century Art*. New York: Museum of Modern Art, 1984.

Kubary, J. S., *Ethnographische Beitrage zur Kenntnis des Karolinen Archipels*, pts. 1 and 3. Leiden: P.W. M. Trapp, 1889, 1895.

LeBar, F. M., *The Material Culture of Truk*. New Haven: Yale University Publications in Anthropology, 1964.

Lessa, William A., *The Ethnography of Ulithi Atoll*. Report of the Pacific Science Board, National Research Council, 1950.

—— 'Divining Knots in the Carolines', *Journal of the Polynesian Society*, 65 (1959), 188–204.

Luomala, Katharine, 'Micronesian Mythology', in Maria Leach (ed.), *Funk and Wagnall's Standard Dictionary of Folklore, Mythology, and Legend*. New York: Funk & Wagnalls, 1949–50.

Lütke, Frédéric, *Voyage autour du monde: Exécuté par ordre de sa Majesté l'Empereur Nicolas I, sur la corvette Le Seniavine*. Paris: Firmin Didot, 1835.

McKnight, R. K., 'Shell Inlay Art of Palau', *Micronesian Reporter*, 12/2 (1964), 10–14.

Mason, Leonard, 'Micronesian Culture', in *Encyclopedia of World Art*. New York: McGraw-Hill, 1964: ix, 915–30.

Maude, H. E., *The Evolution of the Gilbertese Boti*. Wellington: Memoirs of the Polynesian Society, 1963.

Miles, Richard, *The Prints of Paul Jacoulet*. Pasadena, Calif.: Pacific Asia Museum, 1982.

—— 1989 *The Watercolors of Paul Jacoulet*. Pasadena, Calif.: Pacific Asia Museum in association with Meilinki Enterprises, 1989.

Morgan, William N., *Prehistoric Architecture in Micronesia*. Austin: University of Texas Press, 1988.

Murdoch, George M., 'Gilbert Islands Weapons and Armor', *Journal of the Polynesian Society*, 32 (1923), 174–5.

Osbourne, Douglas, *The Archaeology of the Palau Islands*. Honolulu: Bishop Museum, 1966.

Palau Museum, *Palau Museum Bat. Koror,*

Palau: Palau Museum, 1969.

Parmentier, R. J., 'Diagrammatic Icons and Historical Processes in Belau', *American Anthropologist*, 87/4 (1985), 840–52.

—— Review of *The Art of Micronesia*, *Pacific Studies*, 14/4 (1991), 178–82.

Petersen, Glenn, 'Ponapean Matriliny: Reproduction, Exchange, and the Ties that Bind', *American Ethnologist*, 9/1 (1982), 129–44.

Riesenberg, Saul H., and Gayton, A. II., 'Caroline Island Belt Weaving', *Southwestern Journal of Anthropology*, 8 (1952), 342–75.

Robinson, David, 'The Decorative Motifs of Palauan Clubhouses', in S. Mead and B. Kernot (eds.), *Art and Artists of Oceania*. Mill Valley, Calif.: Ethnographic Arts Publications, 1983.

Rubinstein, Donald, 'The Social Fabric: Micronesian Textile Patterns as an Embodiment of Social Order', in D. W. Ingersoll Jr. and G. Bronitsky (eds.), *Mirror and Metaphor: Material and-Social Constructions of Reality*. Lanham, Md.: University Press of America, 1986.

Segal, Harvey Gordon, *Kosrae: The Sleeping Lady Awakens*. Kosrae: Dept. of Conservation and Development, 1989.

Smith, DeVerne Reed, 'The Palauan Storyboards: From Traditional Architecture to Airport Art', *Expedition*, 18/1 (1975), 2–17.

Steager, P. W., 'Where Does Art Begin in Puluwat', in S. Mead (ed.), *Exploring the Visual Art of Oceania*. Honolulu: University of Hawai'i Press, 1979.

Thilenius, Georg (ed.), *Ergebnisse der Südsee-Expedition 1908–1910*, ii: *Ethnographie, B. Mikronesien*. Hamburg: Friederichsen, De Gruyter & Co.

—— Vol. 1. *Inseln um Truk (Centralkarolinen ost): Lukunor-Inseln und Namoluk; Losap und Nama; Lemarafat, Namonuito oder Onoun; Pollap-Tanatam*, by A. Krämer, 1935.

—— *Nauru*, by P. Hambruch, 1914–15.

—— Vol. 2. *Yap*, by W. Muller, 1918.

—— Vol. 3. *Palau*, by A. Krämer, 1917–29.

—— Vol. 4. *Kusae*, by E. Sarfert, 1919.

—— Vol. 5. *Truk*, by A. Krämer, 1932.

—— Vol. 6. *Inseln um Truk: Polowat, Hok und Satowal*, by H. Damm, 1935.

—— Vol. 7. *Ponape*, by P. Hambruch and A. Eilers, 1936.

—— Vol. 8. *Inseln um Ponape: Kapingamarangi, Nukuor, Ngatik, Mokil, Pingelap*, by A. Eilers, 1934.

—— Vol. 9. *Westkarolinen: Songosor, Pur, Merir, Tobi, and Ngulu*, by A. Eilers, 1935.
—— Vol. 10. *Zentralkarolinen: Lamotrek-Gruppe, Oleai, Feis*, by A. Krämer; *Ifaluk, Aurepik, Faraulip, Sorol Mogemog*, by H.-Damm, 1937.
—— Vol. 11. *Ralik-Ratik (Marshall-Inseln)*, by A. Krämer and H. Nevermann, 1938.
Thompson, Laura, *The Native Culture of the Marianas Islands*. Honolulu: Bishop Museum Press, 1945.
Treide, Barbara, *In den weiten des Pazifik Mikronesien*. Wiesbaden: Dr. Ludwig Reichert Verlag, 1997.
Van Tilburg, Jo Anne, 'Anthropomorphic Stone Monoliths on the Islands of Oreor and Babeldaob, Republic of Belau (Palau), Micronesia', *Bishop Museum Occasional Papers*, 31. Honolulu: Bishop Museum, 1991.
Wavell, Barbara, 'From Sacred to Souvenir: The Squatting Figure as a Motif in Micronesian Art', *Tribal Arts*, 7/3 (2002), 62–75.

A series of inventories of Pacific collections was carried out, primarily under the auspices of UNESCO:

Bolton, L. M., *Oceanic Cultural Property in Australia*. Sydney: UNESCO, 1980.
—— and Specht, Jim, *Polynesian and Micronesian Artefacts in Australia: An Inventory of Major Public Collections*. Sydney: The Australian Museum.
—— Vol. i, Micronesia, 1984.
—— Vol. ii, Eastern Polynesia, 1984.
—— Vol. iii, Fiji and Western Polynesia, 1985.
Gathercole, Peter, and Clarke, Alison, *Survey of Oceanian Collections in Museums in the United Kingdom and the Irish Republic*. Paris: UNESCO, 1980.
Kaeppler, Adrienne L., and Stillman, Amy Ku'uleialoha, *Pacific Island and Australian Aboriginal Artifacts in Public Collections in the United States of America and Canada*. Paris: UNESCO, 1985.
Neich, Roger, *Pacific Cultural Material in New Zealand Museums*. New Zealand National Commission for UNESCO, 1982.
Schumann, Yvonne Schumann, *Museum Ethnographers' Group Survey of Ethnographic Collections in the United Kingdom, Eire and the Channel Islands*. Liverpool: Museum Ethnographers' Group, 1986.

Museums and Websites for Polynesian and Micronesian Art

The British Museum
Great Russell Street
London WC1, England
www. thebritishmuseum.ac.uk/index.htm

Pitt Rivers Museum
University of Oxford
South Parks Road
Oxford, England OX1 3PP
www.prm.ox.ac.uk

Cambridge University Museum of Archaeology and Anthropology
Downing Street
Cambridge, England CB2 3DZ
www.museum.archanth.cam.ac.uk/index.htm

National Museums Scotland
Chambers Street
Edinburgh, Scotland EH1 1JF
www.nms.ac.uk/worldcultures.aspx

Ethnologisches Museum
Arnimalee 27, Dahlem
14195 Berlin, Germany
www.smb.spk-berlin.de/mv

Institut für Ethnologie
Theaterplatz 15
Göttingen, Germany
www.gwdg.de/ethno/sammlg.ltm

Museum für Völkerkunde
Johannisplatz 5–11
04103 Leipzig, Germany
www.mvl-grassimuseum.de/

Museum für Völkerkunde
Rothenbaumchaussee 64
20148 Hamburg, Germany
www.voelkerkundemuseum.com/

Museum für Völkerkunde
Japanischen Palais
Dresden, Germany
www.voelkerkunde-dresden.de/site.php?g-start&css-fc

Museum für Völkerkunde
Neue Burg
A-1010 Wien
Vienna, Austria
www.ethno-museum.ac.at

Musée Quai Branly
37, quai Branly
Paris 7, France
www.quaibranly.fr/index.php?id=1151

Museum of Anthropology and
Ethnography
3 Universitetskaya nab
St Petersburg, Russia
www.kunstkamera.ru/en

Bernice Pauahi Bishop Museum
1525 Bernice Street
Honolulu, Hawai'i 96817
www.bishopmuseum.org/research/
cultstud/html

Auckland War Memorial Museum
The Domain
Private Bag 92018
Auckland, New Zealand
www.aucklandmuseum.com

Te Papa Tongarewa (National Museum of
New Zealand)
Cable Street
Wellington, New Zealand
www.tepapa.govt.nz

Canterbury Museum
Rolleston Avenue
Christchurch, New Zealand
www.canterburymuseum.com

Otago Museum
419 Great King Street
Dunedin, New Zealand
www.otagomuseum.govt.nz/pacific-
cultures.html

Australian Museum
6 College Street
Sydney, Australia
www.amonline.net.au/anthropology/
index.cfm

Fiji Museum
Suva, Fiji
www.fijimuseum.org.fj

Museum of Tahiti and her Islands
Papeete, Tahiti
musee@mail.pf

Smithsonian Institution
Department of Anthropology
10th and Constitution
MRC 112, PO Box 37012
Washington, DC 20013-7012
www.nmnh.si.edu/anthro

American Museum of Natural History
Central Park West at 79th Street
New York, New York 10024
www.amnh.org/javascript/pub-col.htm

Field Museum
Roosevelt Road at Lake Shore Drive
Chicago, Illinois 60605-2496
www.fieldmuseum.org/research-collections/
anthropology

Metropolitan Museum of Art
1000 Fifth Avenue
New York, New York 10028
www.metmuseum.org

Peabody Museum of Archaeology and
Ethnology
11 Divinity Avenue
Harvard University
Cambridge, Massachusetts 02138
www.peabody.harvard.edu

Peabody Essex Museum
Salem, Massachusetts 01970
www.pem.org

The Pacific Arts Association
www.pacificarts.org/index.html

List of Illustrations

The author and publisher would like to thank the following individuals and institutions who have kindly given permission to reproduce the images listed below.

1. Detail of an interior support figure (*poutokomanawa*) of the Māori house Te Hau-ki-Turanga (48), carved by Raharuhi Rukupo in 1842. Wood, full figure height 250 cm, width 40 cm. The house is owned by the Rongowhakaata Tribe. Photo Brian Brake. Image reproduced by courtesy Brian Brake Estate/Rongowhakaata Charitable Trust/Museum of New Zealand Te Papa Tongarewa (B.070335). This house is subject to a Treaty of Waitangi claim.

2. Ivory hook with female figures and glass beads, from Tonga, late 18th century. Whale ivory, glass beads, fibre, height 12.2 cm. Reproduced by permission of University of Cambridge Museum of Archaeology and Anthropology (1955.247)

3. Headrest or stool from the Society Islands, late 18th century. Wood, height 14.5 cm. Auckland War Memorial Museum (31545), New Zealand.

4. Stone figure from Ra'ivavae, Austral Islands, 18th century. Height 160 cm (figure 99 cm). Pitt Rivers Museum, University of Oxford (PRM 1886.1.1427).

5 Wooden male figure of Rongo from Mangareva, late 18th century. Wood, height 108 cm. Musée d'Histoire Naturelle et d'Ethnographie, La Rochelle (H 4498).

6. Hawaiian feathered cloak of chief Kalani'ōpu'u, late 18th century. Made of *'o'o* and *'i'iwi* feathers on an *olonā* netted backing. Bishop Museum, Honolulu (1968.167, image SP 203391).

7. Detail of a *masikesa*, Fijian barkcloth, in the style of Cakaudrove, before 1854. Whole sheet 223.5 x 274.3 cm. Fiji Museum, Suva.

8. Flywhisk with Janus-figured wood handle, coconut-fibre whisk, Austral Islands, late 18th or early 19th century. Length 80 cm. Musée du Quai Branly, Paris (SG.84.369). © 2006 Musée du Quai Branly/photo Hughes Dubois/Scala, Florence.

9. Feather headdress, *c*. early 19th century, Marquesas Islands. Red seeds on a fibre and wood base, surmounted by rooster feathers, tailfeathers of tropicbirds, and human beard hair. Height 45 cm. Peabody Essex Museum, Salem, Massachusetts (E17750, E5097, E4069, E19937)/photo Jeffrey Dykes.

10. Meetinghouse, *bai*, at Melekeok, Belau, rebuilt *c*.1990. Photo Adrienne Kaeppler.

11. Interior of the *bai* at Melekeok, Belau, rebuilt *c*.1990, showing the 'storyboard' rafters. Photo Adrienne Kaeppler.

12. Girdle from Nauru, late 19th century. Pandanus leaves, frigate bird feathers, shark teeth, shell, and coral. Staatliche Ethnographische Sammlung Sachsen, Museum für Völkerkunde, Leipzig (Mi.474).

13. Man from Satoan, Caroline Islands, *c*.1890s. Photograph by Thomas Andrew. Museum of New Zealand Te Papa Tongarewa, Wellington (B.017493).

14. Tattooed musicians and dancers in the Marshall Islands. *Vue dans les iles Radak* [Marshall Islands]. Coloured lithograph after a drawing by Louis Choris. From *Voyage pittoresque autour du monde* (Paris, 1820–22), plate XIX. Mark and Carolyn Blackburn Collection, Honolulu.

15. Presentation of fine mats at a wedding

in Rotuma, 1989. Photo Jan Rensel, Honolulu.

16. *6 Tahitians, 2 in Leningrad, 4 in Papeete*, Collage by Cook Island artist Jim Vivieaere, 1996. Photograph and postcard mounted on matting, 40 x 28.5 cm Courtesy of the artist and Rangihiroa and Adrianne Panoho, Auckland.

17. *The Ridge to Reef*, watercolour of a Belauan village by Belau artist Charlie Gibbons, 1973, 70.5 x 99 cm. Belau National Museum.

18. Tongan *lakalaka* performed for the 80th birthday of King Tupou IV. Nuku'alofa, Tonga, 1998. Photo Pesi Fonua

19. *Belle de Yap et Orchidées, Ouest Carolines*, 1934, by Paul Jacoulet. Ink and colour on paper, 39.4 x 30.2 cm. Pacific Asia Museum, Pasadena, California (acc.1981.117.4).

20. *Paulaho, King of the Friendly Islands, Drinking Kava*. Drawing, 18.5 x 25 cm, by John Webber, from Cook's third Pacific voyage, 1777. Mark and Carolyn Blackburn Collection, Honolulu.

21. *Girls Preparing Kava, Sāmoa*, by John La Farge, 1891. Watercolour on paper, 26 x 19.7 cm. Museum of Fine Arts, Boston, William Sturgis Bigelow Collection (26.783).

22. Fijian *tanoa*, bowl for mixing *yaqona*, before 1884. *Vesi* wood (*Intsia bijuga*), width 96.8 cm. Fiji Museum, Suva.

23. Double container of two turtles from Fiji, early 19th century. Wood, length 80.8 cm. The Field Museum, Chicago, Illinois (273955, image A97325).

24. Fijian water vessel, 19th century. Clay, height 11.5, length 18.5, width 13 cm. Musée d'Histoire Naturelle et d'Ethnographie, Lille (NNBA.3597).

25. Two priests' inspirational *yaqona* dishes in the form of a man and a flying duck, early 19th century. *Vesi* wood. Human: length 34.7 cm; duck: length 40.2 cm. Fiji Museum, Suva, Fiji.

26. Macao artist known as 'Spoilem'. Three Pāluans, a young man, known as 'Kockywack', and two young women, one of whom holds a shell-inlaid container, 1791. Oil on canvas, 97 x 66 cm. Wissenschaftliches Kulturarchiv, Institut fur Ethnologie der Universität Göttingen (inv. Bikat 47)/photo Harry Haase.

27. Shell-inlaid container from Belau, late 18th century. Inlaid wood, height 21.5 cm. Château-Musée. Boulogne-sur-Mer (10.221).

28. Two patterned baskets (*kete whakairo*), New Zealand Māori. Department of Anthropology, Smithsonian Institution, Washington, D. C. /photos James DiLoreto, Smithsonian Institution.

(a). Collected on the US Exploring Expedition, 1840. Flax fibre (*Harakeke*), length 65 x 38 cm. (E3779).

(b) Made by Eva Anderson, 1991. Kiekie (*Freycinetia Banksia*), length, 37 x 24 cm (E431929).

29. Two Tongan baskets with *manulua* designs, collected during Cook's voyages, 18th century.

(a) Basket in the form of a bucket with lid. Coconut-fibre sennit, wood, shell beads, height 44.5 cm (Oc1978, Q.836)

(b) Basket of coconut leaf midribs, black dyed creeper, coconut-fibre sennit cord handle, height 21 x 50.5 cm (Oc1977, Q.7) © copyright the Trustees of the British Museum, London.

30. Bowl known as 'Te Riukaka' from Te Puke in the Bay of Plenty, New Zealand, 18th century. Wood, length 62 cm, width 28.6 cm, depth 19.7 cm. Auckland War Memorial Museum (47188).

31. Two wooden treasure boxes, *wakahuia* (above height 25.1, length 76.7, width 25.5 cm) and *papahou* (below height 10, length 38.8, width 14.9 cm), late 18th century. Museum of New Zealand Te Papa Tongarewa, Wellington (OL000003 and WE000864).

32. Housefront of a carved *pātaka* named Te Potaka from Te Kaha, Māori, New Zealand, 18th century. Te Whanau-a-Apanui tribe. Wood, 246 cm. Auckland Institute and Museum (22063).

33. Bone chest, Māori, New Zealand, c.18th century. Wood, height 93 cm. © copyright the Trustees of the British Museum, London (Oc1950.11.1).

34. Male figure with small figures carved in relief known as A'a, Rurutu, Austral Islands, late 18th or early 19th century. Wood, height 117 cm. © copyright Trustees of the British Museum, London (Oc, LMS 19).

35. Wood sculpture of a Tongan goddess, late 18th century. Height 33 cm. Auckland War Memorial Museum (32652).

36. Godhouse, *fare atua*, with 'Oro figure in place, from the Society Islands, late 18th or early 19th century. Godhouse: wood, height 31.5, length 87 cm; 'Oro figure: coconut-fibre sennit. © copyright Trustees of the British Museum, London (Oc, LMS 120).

37. Godhouse, *bure kalou*, from Fiji, mid 19th century. Coconut-fibre sennit and reeds, height 68 cm. Reproduced by Permission of University of Cambridge Museum of Archaeology and Anthropology (Z3976).

38. Log idiophone from the Cook Islands, early 19th century. Wood, length 90 cm, diameter 35 cm. Peter the Great Museum of Anthropology and Ethnography (Kunstkamera), Russian Academy of Sciences, St Petersburg (736/232).

39. Drum with pandanus-leaf sleeve and sharkskin membrane, early 19th century. Ra'ivavae, Austral Islands. Height 133.4 cm. De Menil Collection, New York.

40. Drum with human images and sharkskin membrane. Hawai'i (late 18th century). Wood, height 48 cm. Canterbury Museum, Christchurch (E150.1185).

41. Fijian noseflute with incised designs, collected on the US Exploring Expedition, 1840. Bamboo, length 70 cm. Department of Anthropology, Smithsonian Institution, Washington, D. C. (E29902)

42. Māori flute, *putorino*, late 18th century. Wood and vegetable fibre, length 53 cm. Château-musée, Boulogne-sur-Mer (999.3.44).

43. Māori shell trumpet. Shell, wood, fibre, gum, length 25.2 cm, 18th century. Reproduced by Permission of University of Cambridge Museum of Archaeology and Anthropology (1925.374).

44. Bowl from Kaniet, 18th century. Wood, sennit, length 53.5 cm, height 19 cm, width 11.5 cm. Rautenstrauch Joest Museum, Cologne (15361)/Rheinisches Bildarchiv.

45. Wooden bucket for fishing equipment from Tokelau, early 20th century. Bishop Museum, Honolulu (1977.468 image SP16812).

46. Carved figure, height 86 cm, *c.*1700, from a doorway of a Māori storehouse,

pātaka, from the Hauraki gulf, Ngati Paoa tribe. Museum of New Zealand Te Papa Tongarewa, Wellington (WE000484).

47. Canoe prow, *tauihu*, and front section showing rafter patterns of the war canoe Te Toki a Tapiri, built *c.*1836 for Te Waka Tarakau of Ngati Kahungunu near Wairoa in Hawkes Bay. Wood, *paua* shell and *muka*, length of whole canoe 24m, height of prow 56.5 cm. Auckland War Memorial Museum (150). From Gilbert Archey, *Whaowhia, Māori Art and its Artists* (Auckland; William Collins, 1977).

48. Interior of Māori meetinghouse, Te Hau-ki-Turanga, carved by Raharuhi Rukupo of Rongowhakaata, 1840–42. Owned by Rongowhakaata Tribe. Reproduced courtesy of Rongowhakaata Charitable Trust/Museum of New Zealand Te Papa Tongarewa (MA_I.028475). This house is subject to a Treaty of Waitangi claim.

49. Drawing showing parts of the Māori meetinghouse. From Roger Neich, *Painted Histories: Early Māori Figurative Painting* (Auckland University Press, 1994), p.248.

50. Central housepost, *poutokomanawa*, from a Māori meetinghouse in Tikapa, Waiapu Valley, mid 19th century, depicting the Māori carver Iwirākau, showing facial and thigh tattoo. Height 300 cm. Auckland War Memorial Museum (163).

51. Māori lintel, *pare*, from an island village in the Hauraki swamps, *c.*1850. 235 x 84 x 40 cm. Auckland War Memorial Museum (6189).

52. Rear wall of the interior of Rongopai meetinghouse at Waituhi, New Zealand (1887). Rongopai Marae Trust/Museum of New Zealand Te Papa Tongarewa (MA_B.016598, MA_B.016599).

53. Māori entranceway, *Whakamarama* ('To be Enlightened') by Māori artist Ross Hemera, 1998. *Totara* wood, aluminium, copper, oil stain, wax, 1088.5 x 666.8 x 27 cm. Courtesy the artist/Museum of New Zealand Te Papa Tongarewa (1998-0027-1).

54. Hawaiian figure, probably representing Lono, late 18th century, from a cave on Maui, height 91.4 cm. Bishop Museum, Honolulu (D2772)/photo © 1993 David Franzen, Kailua, Hawaii.

55. Hawaiian figure of the war god Kūkā'ilimoku (early 19th century) and *pahu*

drum (late 18th century) of Kamehameha the Great. Bishop Museum, Honolulu (7654). Photo J. Halley Cox and William H. Davenport.

56. Hawaiian serving dish with human figures, late 18th century, with a Ni'ihau mat in the background. Wood, length 115.6 cm Bishop Museum, Honolulu (408). Photo J. Halley Cox and William H. Davenport.

57. Hawaiian figure of Keolo'ewa and a secondary figure, early 19th century. Wood, height 53.8 cm. Bishop Museum, Honolulu (4044, image SXC76877)/photo Seth Joel.

58. *Born the Night of the Gods... Akua Kālepa* presentation of eight Hawaiian god figures, by Rocky Jensen, 1989. Mixed media, including *koa* wood, feathers, ceramic, mother-of-pearl, each figure 182.9 cm. Courtesy the artist/photo Dennis Oda, *Star Bulletin* (22 January 1989), Honolulu.

59. Two wooden figures from Rapa Nui, *moai tangata* (above height 47.5 cm) and *moai papa* (below height 46.5 cm), before 1872. Musée de la Marine, Rochefort, France (*moai papa* 39EX29D; *moai tangata* 39EX28D)/photos P. Dantec.

60. Carved stone boulder with Makemake face and two birdmen, *c.*1500, Orongo, Rapa Nui. Photo Adrienne Kaeppler, 1984.

61. House mask from Mortlock Island, Caroline Islands, mid 19th century. Wood, paint, height 78.5 cm. Bishop Museum, Honolulu (05634; image SP203396).

62. Kawe, female figure from Nukuoro, 19th century. Breadfruit wood, height 220 cm, maximum width 79 cm. Auckland War Memorial Museum (38740).

63. Standing beside Queen Elizabeth II in 1953, Queen Sālote of Tonga wears a fine mat known as 'Lalanga 'a 'Ulukilupetea' to commemorate the event. Auckland Institute and Museum (image C12094).

64. Feathered overskirt (*sisi fale*) of sennit covered with red feathers, mid 18th century, collected during the second voyage of Captain James Cook. Pitt Rivers Museum University of Oxford (PRM.1886.1.1332).

65. Double wedding of Prince Tāufa'āhau and Prince Tu'i Pelehake, Tonga, 1947. Courtesy Tonga Traditions Committee.

66. Barkcloth wrapped wooden staff-god,

Rarotonga, Cook Islands, late 18th century. 347 x 165 cm. © Trustees of the British Museum, London (Oc1978.Q.845).

67. Hawaiian 18th-century barkcloth, 132 x 84 cm. Wissenschaftliches Kulturarchiv, Institut für Ethnologie der Universität Göttingen (Oz.589, Humphrey 29)/photo Harry Haase.

68. Hawaiian 19th-century barkcloth. Bishop Museum, Honolulu (image SXC77738)/photo Ben Patnoi.

69. Two Rapa Nui barkcloth sculptures, early 19th century.

(a) plant fibre, wood, pigments, 40 x 15.5 x 16 cm. © 2007 Harvard University, Peabody Museum (99-12-70/53543. T4290)

(b) barkcloth, modified and unmodified plant fibre, 47 x 18 x 10 cm. © 2007 Harvard University, Peabody Museum (99-12-70/53542.T615)

70. Barkcloth headpiece from Rapa Nui, early 19th century. Barkcloth, modified and unmodified plant fibre, cordage, orange, black, 10.4 x 26 x 30.5 cm. © 2007 Harvard University, Peabody Museum (99-13-70/53541.T419).

71. *Tama Ali'i*, 1992, by Samoan artist Fatu Feu'u. Lithography and woodcut 65 x 75 cm. Courtesy the artist.

72. Barkcloth from Niue, late 19th century. 228 x 186 cm © Trustees of the British Museum, London (Oc1953,+.3).

73. Barkcloth poncho from Niue and detail, late 19th century. Bishop Museum, Honolulu (1972.338.01; image SP203392).

74. Part of *Pulenoa Triptych*, 1997. Lithograph by Niue artist John Pule, 77 x 75 cm. Courtesy the artist.

75. Tui Nadrau dressed for a ceremonial presentation of barkcloth, Fiji. Drawing by Theodore Kleinschmidt, 1877. © Museum für Völkerkunde, Hamburg.

76. Māori cloak of flax, with *taniko* border, *kiwi* feathers and coloured wool decoration, 19th century. © copyright Trustees of the British Museum, London (Oc1854,1229.133).

77. Ceremonial cloth from Fais Island in the Western Carolines, early 19th century. Length 147 x width 35 cm. Peter the Great Museum of Anthropology and Ethnography (Kunstkamera), Russian

Academy of Sciences, St. Petersburg (711/16).

78. Woman wearing dress mats, early 20th century, Marshall Islands. Photograph, © Hamburg Museum, Hamburg, Germany.

79. George Nuku, tattooed in 2003 by Haki Williams of Ngati Tuwharetoa. Photo Kerry Brown.

80.(a) Tattooed chief from the Marshall Islands. *Larik Chef du groupe de îles Romminoff.* Coloured lithograph after a drawing by Louis Choris. From *Voyage pittoresque autour du monde* (Paris, 1820–22), plate I. Mark and Carolyn Blackburn Collection, Honolulu.

(b) Tattooed woman from the Marshall Islands. *Femme du groupe des isles Saltikoff.* Coloured lithograph after a drawing by Louis Choris. From *Voyage pittoresque autour du monde* (Paris, 1820-22), plate V. Mark and Carolyn Blackburn Collection, Honolulu.

81. Micronesian jewellery, late 19th and early 20th centuries. Smithsonian Institution, Washington D.C./photos James DiLoreto.

(a) Shell belt from Pulusuk, Caroline Islands (E411089); ear ornament of coconut shell and seashell. Chuuk (E414588).

(b) Coral necklace with turtle shell pendant, Arno, Marshall Islands (E205196); shell necklace, Arno, Marshall Islands (E205194); coral necklace with teeth, Yap (398171); necklace of red beads and teeth, Kiribati (EL222); coral and shell necklace, Chuuk (E401633).

82. Stamps, designed by Gotz, from French Polynesia commemorating the International Festival of Tattoo, April 2000. Office des Postes et Télécommunications, French Polynesia.

83. Tattooed man from the Marquesas Islands, from *Voyage autour du monde sur la Nadjedja et la Neva*, 1813. Musée de la Chartreuse, Douai (Collection Berthoud)/ photo Daniel Lefebvre.

84. Wooden arm with tattoo designs from the Marquesas, mid 19th century. Length 62 cm. Collected by Robert Louis Stevenson. Peabody Essex Museum, Salem, Massachusetts (E16063)/photo Jeffrey Dykes.

85. Tattooed Hawaiian chief in feathered cloak and helmet. Lithograph (17.8 x 8.4 cm) after a drawing by Jacques Arago, 1819. Private collection.

86. Portrait of a New Zealand Man, 1769. Pen and wash drawing, 39.4 x 29.8 cm, by Sydney Parkinson from Cook's first voyage. British Library, London (Add.23920, f.54).

87. George Nuku in a traditional Māori challenge gesture of sticking out the tongue, tattooed in 2003 by Haki Williams. Photo Kerry Brown.

88. Samoan young men dressed as *mānaia* wearing *tuiga* headdresses, c.1900. Photograph, Auckland War Memorial Museum (B8856).

89. Hawaiian feathered cloak and helmet, early 19th century. Courtesy of the, © American Museum of Natural History, New York (80.0/784)/photo A. Singer (image no, 335315).

90. Hawaiian feathered god figure, late 18th century, collected during Cook's third voyage. Height 104 cm. © Trustees of the British Museum, London (Oc,LMS 221).

91. Hawaiian feathered cape, late 18th century, collected during Cook's third voyage. Feathers on netted fibre backing, width 129 cm. Australian Museum, Sydney (H.104)/photo Gregory Millen.

92. Two Hawaiian necklaces, *lei niho palaoa*, of ivory and human hair, early 19th century. Hawaiian bracelet of turtleshell and bone, late 18th century. Bishop Museum, Honolulu (necklace 01319; bracelet 1304)/ photos © 1993 David Franzen, Kailua, Hawaii.

93. Dress worn by the 'chief mourner' at the funeral of a high chief in the Society Islands, late 18th century. Height 214 cm. © Trustees of the British Museum, London (Oc,TAH.78).

94. Headdress with tail feathers of the tropicbird and other birds from Rurutu, Austral Islands, early 19th century. Cane, coir, barkcloth, pearlshell, feathers, hair, height 115 cm, width 29 cm. © copyright Trustees of the British Museum, London (Oc,+.2011).

95. Māori pendants, greenstone on a flax cord, late 18th century. © Direction des Musées Dunkerque—Musée des Beaux-Arts/photo Claude Thériez.

96. Necklace of carved ivory pieces on

coconut-fibre sennit, Austral Islands, early 19th century. Musée d'Histoire Naturelle et d'Ethnographie, Lille (990.2.2061).

97. Headdress of feathers, pearlshell, and turtleshell, coir, fibre, Marquesas Islands, late 18th century, collected during Cook's second Pacific voyage. Height 42 cm. Pitt Rivers Museum, University of Oxford (PRM 1886.1.1340).

98. Necklace with carved ivory figures on coconut-fibre sennit from Fiji, late 18th or early 19th century. Length 52 cm; largest figure height 9.6 cm. Reproduced by permission of University of Cambridge Museum of Archaeology and Anthropology (Z.2752).

99. Serrated club from Mangaia, Cook Islands, late 18th century. Wood, 75 cm. © The Field Museum (Fuller Collection), Chicago (A97177).

100. 'U'u club from the Marquesas Islands, late 18th or early 19th century. Wood, height 138.6 cm. Mark and Carolyn Blackburn Collection, Honolulu.

101. Tahitian gorget of feathers, coconut fibre, shark teeth, dog hair, and shell on a sennit and wicker base, width 70 cm, late 18th century. © World Museum Liverpool, National Museums Liverpool (R.I.57.73).

102. Incised Tongan club, late 18th century, collected during Cook's voyages. Wood, 111 cm. Mark and Carolyn Blackburn Collection, Honolulu.

103. Three Māori handclubs, *patu*, of whalebone (*patu paraoa*, 39.6 cm), basalt (*patu onewa*, 36.3 cm), and wood (*wahaika*, 41.2 cm), late 18th or early 19th century. Museum of New Zealand Te Papa Tongarewa, Wellington (ME005007, ME014091, WE000510).

104. Warriors from Kiribati, early 20th century. Photograph Augustin Krämer, from *Hawaii, Ostmikronesien und Sāmoa* (Stuttgart, 1906).

105. Pacific Sisters Fashion Show at the 1996 Pacific Festival of Arts in Apia, Sāmoa. Photo Adrienne Kaeppler.

106. 'Wild Victoria', a gown made from New Zealand flax strips by Linda Lepou. Photo courtesy Drum Productions Ltd.

107. *Meddo* stick chart, 104 x 73.6 cm, Marshall Islands, mid 19th century. Collected by Robert Louis Stevenson.

University of Pennsylvania Museum, Pennsylvania (P3297).

108. Mounted Chuuk canoe prow depicting two frigate birds with meeting beaks, 19th century. Wood, height 123 cm. Museum für Völkerkunde, Berlin/photo Bildarchiv Preussischer Kulturbesitz (40.008.574-1).

109. Marshall Islands canoes. *Vue d'une ile dans le groupe Krusenstern* [Marshall Islands]. Coloured lithograph after drawing by Louis Choris. From *Voyage pittoresque autour du monde* (Paris, 1820-2), plate XIV. Mark and Carolyn Blackburn Collection, Honolulu.

110. Weather charm, Yap, late 19th or early 20th century. Wood mounted on stingray spines. Bishop Museum, Honolulu (1967. l071.001)/photo Joe Solem.

111. Entrance to the Nan Dauwas section of Nan Madol. Photo William S. Ayres.

112. Computer-generated model of the ruins of Nan Madol, by William S. Ayres.

113. Feasthouses and courtyard, Lelu, Kosrae, from Frédéric Lütke, *Voyage autour du Monde*, (1835). Smithsonian Institution, Washington D.C. (neg.96-1136).

114. Drawing of a reconstructed interior of feasthouse, Lelu, Kosrae. From William N. Morgan, *Prehistoric Architecture in Micronesia* (1988), p.112. Copyright © 1988 University of Texas Press.

115. Meetinghouse from Yap with stone valuables. Photograph, 1884. Alexander Turnbull Library, Wellington (Henry Rundle Collection PA1-q-073-63)

116. Kiribati meetinghouse (*maneaba*). Photograph, 1897, by Joseph Strong. Pitt Rivers Museum, University of Oxford (PRM 1998.161.12.2).

117. Belau meetinghouse, *bai*, refurbished in the mid-20th century, Airai, Belau. Photo Adrienne Kaeppler.

118. Sculpture of Dilukai from a *bai* housefront in Belau, 19th century, collected by Augustin Krämer, 1908-10. Wood, paint, kaolin, 65.2 x 96.5 cm. Metropolitan Museum of Art, New York. The Michael C. Rockefeller Memorial Collection Purchase, Gift of Nelson A. Rockefeller, by exchange, and Nelson A. Rockefeller Gift, 1970 (1978.412.1558a-d). Photograph © 1984 The Metropolitan Museum of Art.

119. Engraving of House of Taga, Tinian, Marianas Islands, from Lord George Anson, *A Voyage around the World in the Years*

1740–1744 (London, 1748), plate XXXIV.
By permission of the Syndics of Cambridge
University Library (Hanson.a.7, plates
volume).

120. Drawing of a reconstruction of the
House of Taga, Tinian. From William N.
Morgan, *Prehistoric Architecture in Micronesia*
(1988), p.147. Copyright © 1988 University of
Texas Press.

121. Drawing of the interior layout of a
Tikopia house. From Raymond Firth, *We,
the Tikopia* (London: Allen & Unwin 1936),
p.77. Reproduced by permission of Taylor
& Frances Books UK.

122. Two drawings of star mounds, Sāmoa.
From David J. Herdrich, 'Towards an
Understanding of Samoan Star Mounds',
Journal of the Polynesian Society, vol. 100
(1991), pp. 383 and 404.

123. Drawing of Tongareva *marae*. From
Peter Bellwood, 'Archaeological Research
in the Cook Islands', *Pacific Anthropological
Records*, no. 27 (1978), p. 174. © Bishop
Museum, Honolulu.

124. Offering stand from Mangareva,
18th century. Wood, 180 x 68 x 60 cm.
Musée du Quai Branly, Paris (17800.
g.inv: 71.1929.14.921). Musée de l'Homme.
Gift of Louis Capitan. © 2006 Musée du
Quai Branly/photo Patrick Gries/Bruno
Descoings/Scala, Florence.

125. *Îles Sandwich, vue du Morai du Roi a
Kayakakoua, sur l'île Owhyhi*, by Jacques
Arago. [*Heiau* at Kailua, Hawai'i]. Mark and
Carolyn Blackburn Collection, Honolulu.

126. New Zealand war canoe showing
mounted prow and stern pieces. Wash
drawing (29.4 x 47.5 cm) by Sydney
Parkinson, 1770, from Cook's first voyage
to the Pacific. British Library, London
(Add.23920, f.49).

127. Canoe prow, Māori, 18th century. Wood,
length 135 cm. Whakatane Museum and
Gallery (MP 644). Courtesy of the Trustees
of the Ngati Awa Research and Archives
Trust.

128. War canoe sternpost, 1831, carved
for the Ngati Raukawa canoe *Te
Whangawhanga*, at Koputaroa. Māori.
Canterbury Museum, Christchurch
(E158.936)/photo Brian Brake, by
permission of the Trustees of the Brian
Brake Estate.

129. War canoe from Ra'iatea, Society
Islands, showing human figures mounted

on the prow and stern. Wash drawing (29.4
x 47.5 cm) by Sydney Parkinson, 1769, from
Cook's first voyage to the Pacific. British
Library, London (Add.23921, f.21).

130. Ahu Naunau ceremonial site at
Anakena, Rapa Nui, 1200–1600 CE.
Photograph Christian Arevalo Pakarati.
Courtesy Easter Island Statue Project,
University of California, LA.

131. Fish petroglyph from ceremonial site
14-563 at Tongariki, Rapa Nui. Drawing
by Christian Arevalo Pakarati. Courtesy
Easter Island Statue Project, University of
California, LA.

132. Hawaiian petroglyph field. Part of site
E 3-1 of Kaeo Trail, Puako, Hawai'i. From
Georgia Lee and Edward Stasack, *Spirit of
Place: The Petrographs of Hawaii* (1999), p.17.
Courtesy Easter Island Foundation Books.

133. Petroglyph boulder, Tipaerui, Tahiti.
Photograph, 1926, by Kenneth P. Emory,
Bishop Museum, Honolulu (Bk.33:52 image
SP12233).

134. Tongan neckrest, *kaliloa*, in the form
of a club with legs and inset with ivory
stars and crescent moons, late 18th century.
Wood, whale ivory, length 110.5 cm.
Auckland War Memorial Museum (31810).

135. Incised bowl with linked human
figures. *Tamanu* wood (*Callophyllum*),
length 65 cm. Ra'ivavae, Austral Islands,
early 19th century. Canterbury Museum,
Christchurch (E149.651).

136. (a) Stone food pounder from the
Society Islands, height 19.7 cm.

(b) Stone coconut grater from the
Marquesas Islands, length 48 cm. Both
18th century. Mark and Carolyn Blackburn
Collection, Honolulu.

137. Ceremonial house with stone god
images covered with mats. Fakaofo,
Tokelau, oil on canvas (25.4 x 36.8 cm)
by Alfred Agate on the US Exploring
Expedition 1838–42. National Academy of
Design Museum, New York. Gift of James
D Smillie, 1902 (12-P)

138 *Ole Tausala. 'E le iloa ala o vae"*, 1999.
Print by Samoan artist FatuFeu'u. Photo
Adrienne Kaeppler.

Chronology for Polynesia and Micronesia[1]

*c.***4000–5000** BCE Austronesian-speaking peoples, the ultimate ancestors of Polynesians and Micronesians, leave their homelands in South-East Asia, or perhaps Taiwan.

*c.***1500** BCE 'Lapita cultural complex', characterized by pottery with distinctive decoration and-anthropomorphic images, arrives in Fiji.

*c.***500–1000** BCE First inhabitants arrive in the Marianas Islands, Belau, and Yap.

*c.***900–950** BCE People carrying the Lapita cultural complex (including distinctive pottery and adzes) and speakers of the 'remote Oceanic' branch of Austronesian arrive in Tonga and 850–900 BCE in Sāmoa.

*c.***700** BCE First inhabitants arrive in 'Uvea and Futuna.

*c.***650** BCE Transition to ancestral Polynesian culture begins to evolve in Tonga and *c.*200–300 BCE in Sāmoa. Lapita pottery is transformed into Polynesian Plainware.

*c.***100** CE First inhabitants arrive in Eastern Micronesia, Fefan, Pohnpei, and Kosrae.

*c.***200** CE 'Marianas Redware' pottery established in the Marianas Islands.

*c.***700–800** CE Polynesians established in Marquesas and Society Islands, which then become major dispersal points to other islands.

*c.***800** CE Polynesians established in Rapa Nui (Easter Island), Hawai'i, and the southern Cook Islands.

*c.***950** CE 'Aho'eitu descends from the sky to become the first Tu'i Tonga. His descendants become the royal families of Tonga.

*c.***1000** CE Monumental burial and ceremonial sites established by the ancestors of the present dynasties of Tonga.

*c.***1100** CE Polynesians established in Aotearoa (New Zealand), giving rise to the art style known as *Nga Kakano* (The Seeds).

*c.***1200–1600** CE Monumental stone statues erected on ceremonial sites in Rapa Nui.

*c.***1200–1820** Construction and use of Nan Madol, the 'Venice of the Pacific', in Pohnpei.

*c.***1300** Long-distance voyaging in Polynesia appears to cease.

*c.***1300–1500** *Te Tipunga* (The Growth) Maori art style flourishes in Aotearoa.

*c.***1400** Orongo ceremonial centre established on Rapa Nui.

*c.***1500** Birdman rituals, and the god Makemake, extend beyond Orongo and overlap with the monolithic stone tradition on Rapa Nui.

*c.***1500–1800** *Te Puawaitanga* (The Flowering), the classic Māori art style and culture, evolves in Aotearoa.

1521 Magellan visits the Marianas Islands.

1595 Álvaro de Mendaña sights and names the Marquesas Islands.

*c.***1600** Origin of the oldest surviving Samoan fine mat, known in Tongan as 'Maneafainga'a' (now part of the treasures of the royal family of Tonga).

1615–15 Dutch explorers Isaac Le Maire and William Schouten visit the Tuamotu Islands, 'Uvea, Futuna, and the northern Tongan Islands.

1642–3 Dutch explorer Abel Tasman visits Tonga and New Zealand.

1668 Jesuit missionaries found the first permanent Christian mission in the Marianas Islands.

1700s Spanish colonization of Micronesia proceeds island by island and remains until 1900.

1722 Jacob Roggeveen visits Rapa Nui, Futuna, and Sāmoa.

1742 British explorer Commodore George Anson visits Tinian, Marianas Islands.

*c.*1758 Birth of Kamehameha (I).

1767 Captain Samuel Wallis on HMS *Dolphin* visits the Society and Tuamotu Islands. He collects a Tuamotu canoe, one of the earliest documented surviving objects from Polynesia, now in the British Museum.

1768 French explorer Louis-Antoine de Bougainville visits Society Islands, Sāmoa, and Tuamotus. He takes a Tahitian, Aoutourou, back to France.

1768–71 Captain Cook's first voyage to Polynesia; arrives in Tahiti, Society Islands, to observe the transit of Venus, and later visits New Zealand.

1769 Tupaia, a navigator priest from Ra'iatea, Society Islands, joins Cook's ship, pilots the vessel on its trip to Aotearoa (New Zealand), and speaks to the Māori in a dialect of their own language (Tupaia dies later on the voyage).

1769 French explorer M. de Surville visits New Zealand.

1771 Ethnographic artefacts/works of art from the Society Islands and New Zealand collected during Cook's voyage arrive in London and become part of public and private collections.

1771–3 French explorer Marion de Fresne attempts to take Aoutourou back to the Society Islands; but he dies on the way from smallpox. They visit New Zealand, Tonga, and Guam.

1772–6 Spaniards make three visits to Tahiti, and collect an extraordinary stone bowl now in the Museo Nacional de Antropología, Madrid.

1772–5 Cook's second voyage to the Pacific visits (in addition to the Society Islands and New Zealand) Tonga, Rapa Nui, and the Marquesas Islands. While in Rapa Nui, a Tahitian on board, Mahine, speaks to the Rapanui in a dialect of their language and obtains an extraordinary carved human hand, which he gives to Reinhold Forster, who presents it to the British Museum. While in the Society Islands, Cook and others collect the first 'Tahitian Mourner's Costumes' that are now found in European collections. The Tahitian 'Omai' is taken on board and becomes a celebrity in England.

1776–80 Cook's third voyage to the Pacific returns Omai to his home and makes the first recorded visit of Europeans to Hawai'i in 1778.

1769–80 At least 2,000 objects are collected during the three voyages of Captain Cook; these eventually find their way into public and private collections in Britain and Europe.

1782 The Cook-voyage collection assembled by George Humphrey in England arrives in the Academic Museum of Göttingen, Germany, to become the foundation of the largest Cook-voyage collection in the world.

1783 English explorer Henry Wilson, on HMS *Antelope*, is shipwrecked in Belau. The chief's son, Lee Boo, is taken to England.

1789 The ship HMS *Bounty*, under Captain William Bligh, is seized by mutineers and taken eventually to Pitcairn. Bligh successfully navigates a longboat to Tofua in the Tonga Islands, and finally to Timor.

1796 The Tahitian Pomare dynasty of kings and queens comes into prominence and rules until 1879.

1797 The Missionary Society (later London Missionary Society—LMS) attempts to establish missions in the Society Islands, Tonga, and the Marquesas (all are failures).

1799–1802 First US whaling ships arrive in Polynesia. Objects collected on their trips are donated to the Peabody Essex Museum in Salem, Massachusetts, and other museums in New England.

1800 *Te Huringa* (The Turning) Māori art style evolves in Aotearoa. This was a period of rapid change, especially in the 19th century, and reflects the artistic intercultural dialogues with the West.

1802 Paramount chief I'amafana dies, initiating warfare among rival chiefly families of Sāmoa.

1803–6 First Russian voyage to Polynesia by Krusenstern; visits Marquesas and Hawai'i.

1806 The *Port au Prince* is captured by Tongans, and William Mariner is taken under the protection of chief Finau. He returns to England in 1811.

1806 Sale of the Leverian Museum in London, which was the origin of the Vienna Cook-voyage collection.

1810 Kamehameha completes the establishment of his authority over all the Hawaiian islands, and his dynasty reigns until 1873.

1814 Samuel Marsden, of the Church Missionary Society, establishes the first Christian mission in New Zealand (in the Bay of Islands).

1816 Russian explorer Otto von Kotzebue, with artist Louis Choris on board, visits the Marshall Islands; Choris makes numerous watercolour paintings.

1817 First printing press set up in Tahiti by LMS missionary William Ellis.

1819 *Tapu* system overthrown in Hawai'i by indigenous Hawaiians.

1820 First American missionaries arrive in Hawai'i.

1820 A Russian expedition, under the command of F. G. von Bellingshausen, visits Queen Charlotte Sound in New Zealand. Consequently, significant Māori collections are in Russian museums.

1828 Tongan Wesleyan missionaries arrive in Sāmoa; John Williams arrives in 1830 in the *Messenger of Peace*.

1830 Two Tahitian Christian missionaries arrive in Fiji.

1838–42 US exploring expedition under Captain Wilkes makes extended visits to Fiji, Sāmoa, and other islands in Polynesia and Micronesia.

1840 Treaty of Waitangi signed by Māori chiefs and representatives of the British crown.

1842 French Protectorate established in the Society Islands; Marquesas annexed by France.

1845 *Madonna and Child* carved in Whakapakoko style by a Māori artist, probably Pātoromu (Bartholomew) Tamatea.

1850s American missionaries on a series of ships called *Morning Star* begin Christianizing Micronesia.

1852 The Auckland Museum, with Māori and Pacific exhibitions, opens in Auckland, New Zealand.

1855 Trading network of J. C. Godeffroy and Sons of Hamburg, Germany, is set up in Sāmoa and later expands to Tonga and several other islands in Polynesia and Micronesia. Research and collections of Polynesian and Micronesian materials by Godeffroy employees taken to museums in Germany.

1864 Christianity introduced to Rapa Nui.

1865 The Dominion Museum opens in Wellington, New Zealand; followed by the Canterbury Museum, Christchurch, in 1867 and the Otago Museum, Dunedin, in 1868.

1868 HMS *Topaze* visits Rapa Nui and collects the first two large stone figures, both now in the British Museum.

1873 William Kanaina Lunalilo is the first elected King of the Hawaiian Islands. He is followed shortly after by elected monarchs King David Kalākaua (1874–91) and Queen Lydia Paki Lili'uokalani (1891–3).

1874 Chiefs Laupepa and Tupua Pulepule became joint kings of Sāmoa.

1877 Only *c.*110 people remain on Rapa Nui.

1877 Pomare IV of the Society Islands dies, ending a 50-year reign.

1880 Pomare V cedes Tahiti to France.

1889 Bernice Pauahi Bishop Museum is founded; first exhibits open in 1891.

1880s–1890s Germany takes control of much of Micronesia.

1890s Naturalistic designs introduced into Tongan *ngatu* (barkcloth).

1893 Queen Lili'uokalani abdicates the Hawaiian throne to avoid bloodshed.

1897 The Leeward group of the Society Islands are ceded to France.

1898 Hawai'i annexed by the United States.

1899 Western Sāmoa becomes a German colony.

1899 Parts of eastern Sāmoa become an American territory.

1900 The Kingdom of Tonga becomes a Protected State of Great Britain.

1907 New Zealand ceases to be a British colony and becomes part of the British Dominion.

1908–10 The (German) Hamburg Südsee Expedition carries out extensive research and collecting in Micronesia; the collections become part of German museums.

1914 New Zealand assumes control of Western Sāmoa at the declaration of the First World War.

1914 The *Mana* expedition arrives on Rapa Nui and initiates the island's first major archaeological survey; its collections become part of the British Museum and Pitt Rivers Museum.

1918–65 Queen Sālote Tupou III reigns in Tonga.

1920s A distinctive style of *siapo* (barkcloth) design originates in Leone, Tutuila, Sāmoa, resulting in well-known works by Kolone Fai'ivae Leoso and Mary J. Pritchard.

1920s Japanese influence and colonization in Micronesia begins.

1930s Portable 'storyboards' become an important artform in Belau.

1940s US influence and colonization

(usually as trust territories) begins in Micronesia.

1946 'Arts of the South Seas' exhibition held at the Museum of Modern Art, New York.

1947 New Zealand becomes an independent nation.

1948 The W. O. Oldman collection (formed in London) arrives in New Zealand and is divided among the museums.

1955 The Palau Museum opens.

1955 The National Museum of Fiji opens in Suva, incorporating objects collected and displayed in various venues in Suva since 1904.

1958 The Fuller collection is acquired by the Field Museum, Chicago.

1962 Western Sāmoa becomes an independent nation.

1962 Opening of the Pacific Hall at the Smithsonian's National Museum of Natural History.

1965–2006 King Tāufaʻāhau Tupou IV reigns in Tonga.

1967 'Sculpture of Polynesia' exhibit opens at the Art Institute of Chicago.

1970 Tonga and Fiji become independent nations.

1970 Jean P. Haydon Museum established in Pagopago, American Sāmoa.

1970 'From the Islands of the South Seas, 1773–1774' exhibition of the Forster collection from Cook's second voyage opens at the Pitt Rivers Museum, University of Oxford.

1971 'Hall of the Peoples of the Pacific', organized by Margaret Mead, opens at the American Museum of Natural History in New York.

1972 First Festival of Pacific Arts held in Suva, Fiji.

1970 Tonga and Sāmoa become members of the British Commonwealth of Nations.

1975 Hale Nauā III, Society of Hawaiian Artists, established in Honolulu.

1976 Long-distance canoe voyages resume in the reconstructed Hawaiian canoe *Hōkūleʻa*.

1978 'Artificial Curiosities' exhibition of Cook-voyage materials opens at the Bishop Museum.

1978 First contemporary native Hawaiian art exhibition, organized by Hale Nauā III Society of Hawaiian artists, opens at the Bishop Museum.

1979 'Art of the Pacific Islands' exhibition opens at the National Gallery of Art in Washington, DC.

1976 Second Festival of Pacific Arts held in New Zealand.

1981 Belau becomes an independent nation.

1981 The Alele Museum is established in the Marshall Islands.

1984 'Te Maori: Maori Art from New Zealand Collections' exhibition opens at the Metropolitan Museum of Art in New York; the exhibition travels to St Louis, Chicago, and San Francisco, before returning to New Zealand.

1985–6 Te Hokinga Mai, the 'Te Māori' exhibit, returns to New Zealand.

1985 Fourth Festival of Pacific Arts held in Tahiti, Society Islands.

1985 'Magnificent Voyagers' exhibition of collections from the US Exploring Expedition opens at the National Museum of Natural History, Smithsonian Institution.

1985 'Weavings from the Micronesian Islands' opens at the Metropolitan Museum of Art in New York.

1986 'The Art of Micronesia' exhibit opens at the University of Hawaiʻi Art Gallery.

1988 At the Fifth Festival of Pacific Arts in Townsville, Australia, Teve (a Marquesan dancer) unveils his full body tattoo, encouraging a renaissance in this art form.

1989 'Taonga Maori, Treasures of the New Zealand Maori People' exhibition opens at the Australian Museum, Sydney.

1989 'Traveling the Pacific' exhibition opens at the Field Museum of Natural History in Chicago, followed by 'Pacific Spirits: Life, Death and the Supernatural' which opened in 1990.

1990 Revival of Māori canoe-building.

1990 'Te Moemoe no Iotefa' (The Dream of Joseph) exhibition opens in New Zealand. This was the first travelling exhibition to include contemporary Pacific artists.

1992 Sixth Festival of Pacific Arts held in Rarotonga, Cook Islands.

1992 'Palau' exhibition opens at the Linden-Museum in Stuttgart, Germany.

1993 Asia-Pacific Triennale opens at the Queensland Art gallery, in Brisbane. Others follow in 1996, 1999, 2003, and 2006.

1994 'Bottled Ocean' exhibition of

contemporary Pacific art travels throughout New Zealand.

1995 First exhibition of contemporary Maori art opens at the Auckland Art Gallery.

1996 Seventh Festival of Pacific Arts held in Apia, Sāmoa.

1998 'Maori' exhibition opens at the British Museum, London.

1998 Te Papa Tongarewa, the new National Museum of New Zealand, opens in Wellington.

2000 Biennale of Arts of the Pacific, with entries from Polynesia and Micronesia, held in Noumea, New Caledonia.

2001 'Splendid Isolation: Art of Easter Island' exhibition opens at the Metropolitan Museum of Art, New York.

2004 Ninth Festival of Pacific Arts held in Belau.

2004 'Paradise Now?' exhibition of contemporary Pacific art opens at Asia House in New York.

2004 'Nā mea makamae: Hawaiian Treasures' exhibition opens at the Smithsonian Institution's National Museum of Natural History.

2005 'Adorning the World: Art of the Marquesas Islands' exhibition opens at the Metropolitan Museum of Art.

2006 Tongan King Tāufa'āhau Tupou IV dies, ushering in a new era of democratic reform.

2006 'Pasifika Styles' exhibition and festival opens at the Museum of Archaeology and Anthropology in Cambridge.

2006 Works of art are created by George Nuku, Filipe Tohi, and others at the Museum of Archaeology and Anthropology, Cambridge, and at the Sainsbury Center for the Visual Arts at the University of East Anglia.

2006 'Life in the Pacific in the 1700s' exhibition of the Cook and Forster collections from the Institut für Ethnologie, Göttingen, opens at the Honolulu Academy of Arts, Honolulu, and travels to the National Museum of Australia, Canberra, as 'Cook's Pacific Encounters'.

2006 'Pacific Encounters: Art & Divinity in Polynesia 1760–1860' exhibition opens at the Sainsbury Centre for Visual Arts at the University of East Anglia, England.

2006 'Power and Taboo' exhibition opens at the British Museum, London.

2007 The Hawaiian canoe *Hōkūle'a*, in company with the newly built Micronesian canoe *Maisu*, visit Majuro in the Marshall Islands, and Satawal in the Carolines; the canoes then move on to Yap, which *Maisu* makes its permanent home.

2007 Head of State of Sāmoa, Mālietoa Tanumafili II dies, ushering in a new era, in which the head of state is elected to four-year terms.

1. During the past few years, there has been major rethinking in the archaeological timeline for the first settlements in the Pacific Islands. Most of the dates are now thought to be considerably later than was previously the case. The timeline here presents the latest thinking, and is quite different from dates in the published literature. For help in preparing this chronology, I would like to thank David Burley, Janet Davidson, Peter Gathercole, Roger Green, Steven Hooper, Jacob Love, Roger Neich, Karen Stevenson, Jo Anne Van Tilburg, and Jennifer Wagelie.

Index